DATE DUE

GAYLORD 234 PRINTED IN U. S. A.

To Renew Books
PHONE (510) 253-2233 OR 254-0200 X361

THE LEGACY

T H E L E G A C Y

*TRADITION AND INNOVATION
IN NORTHWEST COAST
INDIAN ART*

Peter L. Macnair
Alan L. Hoover
Kevin Neary

Published in co-operation with
The Royal British Columbia Museum

Douglas & McIntyre
Vancouver/Toronto

University of Washington Press
Seattle

88 89 90 5 4

Published in Canada by
Douglas & McIntyre Ltd., 1615 Venables Street
Vancouver, British Columbia V5L 2H1
ISBN 0-88894-418-7

Published in the United States of America by
The University of Washington Press
Seattle, Washington
ISBN 0-295-96166-X

Canadian Cataloguing in Publication Data

Macnair, Peter L.
 The legacy

Originally published: Victoria, B.C. : British
 Columbia Provincial Museum, 1980.
Bibliography: p.

1. Indians of North America – British Columbia –
Art – Exhibitions. 2. Indians of North America –
Northwest coast of North America – Art – Exhibi-
tions. I. Hoover, Alan L. II. Neary, Kevin.
III. title.
E78.B9M29 1984 709'.01'109711 C84–091097–5

Printed and bound in Hong Kong.

CONTENTS

Most exhibitions have but one life. They are conceived and brought forth for the edification of the public. When their life is over they are returned to the storage shelves and in many cases forgotten. Thanks to frequent requests for public appearances, this was not the fate of The Legacy.

This exhibit is the result of a decade's work that began in 1970 when approximately 90 artifacts were assembled, for a display to represent the current state of Northwest Coast Indian art. The original Legacy was funded by a grant from the British Columbia Government's First Citizen's Fund. Peter Macnair, Curator of Ethnology, the late Wilson Duff, professor of anthropology at the University of British Columbia, and museologist Gloria Webster, toured the province commissioning and acquiring the finest examples of contemporary work in wood, metal, and argillite. Andrea Laforet and Susan Anderson were responsible for collecting basketry and weaving.

The exhibit opened in Victoria at the British Columbia Provincial Museum in August 1971, remaining open to the public through December 1972. The response to the show was gratifying. It provided an opportunity for both the general public and native Indian people to become aware of the various tribal traditions of the past and their contemporary survival and re-discovery. The success of the exhibition suggested that it be shown to a larger audience. Funding was obtained from the Associate Museums Programme of the National Museums of Canada and, from 1975-1977, The Legacy was shown in cities across Canada. Prior to going on tour the exhibit was re-designed and brought up to date with additional examples of work commissioned and purchased from appropriate artists. After completing its tour of Canada The Legacy continued to be exhibited in British Columbia until spring 1980. Again funding was provided by the Associate Museums Programme of the National Museums of Canada, allowing The Legacy to be seen in Kamloops, the Queen Charlotte Islands, Hazelton, and Quadra Island, areas with large native Indian communities. In addition to travelling within the province, The Legacy was featured at the 1978 Commonwealth Games held in Edmonton, Alberta, at the Edinburgh Festival, and in the same year had an extended exposure in Yorkshire's Cliffe Castle Museum in Keighley. En route home, in 1982, it was on show in the Museum of Anthropology on the on the campus of the University of British Columbia, Vancouver, followed by a long showing at home in Victoria, for the first time in the form described in this catalogue.

The Legacy has refused to stay on our store-room shelves. This book will ensure that it remains accessible in printed form to a wide audience for many years.

The Legacy catalogue was produced by the British Columbia Provincial Museum; funding for publishing the first edition was provided by the Friends of the Provincial Museum and the Edinburgh Festival Society Limited.

R. Yorke Edwards
Director
British Columbia Provincial Museum

I have never believed that the arts mean just the arts of Europe. I had the opportunity early in my life, often through exhibitions, to come into contact with other cultures and other traditions and this gave me a continuing interest.

One of the more encouraging developments of recent years has been a growing availability to a wider public of all forms of art from all kinds of places. Sadly the indigenous arts of many countries have declined in our century, both in their quality and in their integrated role as part of a society's daily life. Happily this decline has been challenged in British Columbia. The work of many younger artists in traditional forms renews and reinterprets a splendid tradition in a way that gives great hope for the future.

This year, it is both a pleasure and an honour for the Edinburgh International Festival to bring the work of these artists and their predecessors to the attention of a European audience. We in the Festival Society are most grateful for the cooperation of the Government of British Columbia and the Director of the British Columbia Provincial Museum, Victoria, and his staff in bringing about this exhibition. We in Edinburgh are also delighted to find so striking a way of opening our new City Art Centre.

John Drummond, Festival Director.
May 2, 1980.

A C K N O W L E D G E M E N T S

The Legacy: Continuing Traditions of Canadian Northwest Coast Indian Art was produced by the British Columbia Provincial Museum. The contemporary collection was commissioned through a grant from the First Citizen's Fund and through funding for special events provided by the British Columbia Ministry of the Provincial Secretary and Government Services. The production and transportation of the exhibition was funded through the latter source as well.

Assistance with transportation costs and arrangements was received from the Cultural Affairs Division of the Canadian Department of External Affairs. Special thanks are extended to Ann Chudleigh, Griselda Bear, Hugh Davidson, and Jacques Monpetit of that Department for their help.

The Legacy catalogue was produced by the British Columbia Provincial Museum; funding for publishing was provided by the Friends of the Provincial Museum and the Edinburgh Festival Society Limited.

A very special thanks is extended to the Thomas Burke Memorial, Washington State Museum, Seattle, for the loan of mask 25.0/2 and to the University of British Columbia's Museum of Anthropology for the loan of the bent bowl A8435.

Valuable advice on many matters, some of them still contentious, was provided by Mr. Bill Holm. Several nervous breakdowns were avoided due to the kindness and knowledge of Mrs. Gloria Cranmer Webster. Thank you Gloria. Information for documentation was also provided by the Heiltsuk Cultural Education Centre. Valuable and timely assistance in other matters, for which we are most grateful, was provided by Ede Ross, G. A. (Bud) Mintz and Jay S. Stewart.

Finally, we must extend our thanks to all of the artists from whom work was commissioned for this exhibition. Without exception, they were most cooperative and helpful in providing personal background and information about their works. We also thank them for the consistent excellence of the pieces which they produced for The Legacy; we feel that all of them provided us with their best work.

Peter L. Macnair
Alan L. Hoover
Kevin Neary

11

PHOTO CREDITS

All photographs are from the collection of the Royal British Columbia Museum unless otherwise noted. Ethnohistoric photographs from the Royal British Columbia Museum are identified with the prefix PN.

Peter L. Macnair

INTRODUCTION

THE SETTING

The northwest coast of North America forms a distinct ecological and cultural area extending from northern California to Yakutat Bay in Alaska. Its epicentre is in the northern part of this natural province and incorporates what is now British Columbia and southeastern Alaska. This focal section is largely a maritime environment, a myriad of islands large and small, exposed to the constant winds and waves of the north Pacific Ocean. The sea predominates. Forest is present but at the water's edge conifers form a thick, impenetrable jungle, repelling those who would enter it. For the most part, the thousands of miles of shoreline consist of endless rocky outcroppings plunging directly into the sea, covered with slippery seaweeds and jagged barnacles which threaten the seafarer. Here and there, gently sloping, boulder or shingle beaches, offer a safe landing and invite human occupancy but these compose perhaps one per cent of the littoral. Occasional sandy beaches stretch into the horizon but where these occur, especially on the Queen Charlotte Islands, constantly shifting sands and the rage of surf discourage human habitation.

Behind the scattered islands a coastal mountain barrier rises sharply from the sea to heights of two thousand metres. Deep fjords penetrate this range. Much of the shoreline of these enclosed waterways is inhospitable to human activity but these inlets lead inland to major rivers which drain the coastal range and interior plateau. These rivers play an all-important role in the yearly cycle of faunal and human activity in the area.

The climate on the coast is mild and wet. Rainfall, depending on locality, ranges between seventy-five and four hundred centimetres a year. Precipitation is caused by the moderating effect of the Japanese Current whose warm vapours blanket the coast year round, causing no real extremes of temperature. Some snow, especially in the far north, occurs in winter, but that season's worst effect is to turn the coast into a grey monochrome with rain and mist merging the landscape into an extension of the slate-coloured sea. Spring brings a soft verdancy as budding leaves and shoots assuage the dark green of conifers. Welcome summer sunlight delineates sea, forest and sky but it soon pales; autumn is brief and its rains herald a greying continuum which washes back into an almost omnipresent winter.

In pre-contact times, most of the coast was covered with climax forest. If one managed to penetrate the choking undergrowth above the tide-line, an essentially open habitat was revealed. Tall stands of timber deny sunlight, creating a coniferous parkland. Firs, hemlock, spruce, yew, and red and yellow cedar, are the species which predominate. Along the banks, flood plains, and deltas of rivers and streams, alder, maple, and cottonwood, are the important broad-leafed species. Where sunlight permits, flowers, shrubs and bushes flourish; more than two hundred varieties of these came to be important for the human inhabitants of the land.

The most abundant and significant fauna of the northwest coast were found in the sea. Anadromous fishes including five species of salmon, steelhead, and eulachon, head the list. They emphasize the delicate interplay between fresh and salt water that had such far-reaching effects on human culture in the area. Important ocean fishes were halibut, herring, cod, lingcod, flounder, sablefish, and various rockfish. A variety of molluscs – clams, cockles, mussels, limpets, and abalone – were readily available. Crustaceans and echinoderms were also abundant. Feeding on all of the above was a host of marine mammals. Seals, sea-lions, porpoises, sea otters, fur seals, killer whales and other species of whales abound.

Certain land mammals inhabited the coastal islands and mainland. Deer were relatively abundant and widespread as they could easily swim several miles from one island to the next. And they are hardy browsers, able to eat coniferous and deciduous shoots alike. Elk were found on Vancouver Island and the delta of the Fraser River. Mountain goat occupy the entire coastal range. Grizzly bear, black bear and cougar complete the larger mammals while many smaller fur-bearers, such as mink, marten, beaver, raccoon, and weasel, were present.

Major river estuaries attracted migrating waterfowl, notably ducks, geese, brant, and swans. Other avifauna inhabited the area the year round; these included ravens, crows, eagles, gulls, and a range of shorebirds.

Until about twelve thousand years ago, the entire area was covered with glacial ice. It extended inland to the Rocky

Mountains and was among the last in North America to retreat. The archaeological record is still very much in its infancy on the Northwest Coast but significant radiocarbon dates have been established, giving man considerable antiquity there. One of the oldest sites, found in the southern part of the area, is in the Fraser River Canyon and indicates human occupation some eighty-five hundred years ago. Other sites approaching this age are slowly being revealed.

THE TRIBES

How people entered and mastered the coastal environment is still open to discussion and further research, but at least it can be safely said that they entered North America from Asia via the Bering Land Bridge. Whether they reached the region in question from the south (which was ice-free much earlier), by land along now-inundated coastal lowlands, from the interior by river valleys or even, just possibly, by sea from Beringia, is perhaps not at issue here. That they have been in and have mastered the coastal environment for many millenia is. They must have come in successive waves for five disparate language stocks are found. Gradually these people adapted to a maritime environment, developing a culture that was essentially similar throughout the Northwest Coast. Yet their widely-differing languages betray their separate origins.

Anthropologists prefer to differentiate them on the basis of language and promote the term and concept "linguistic group" instead of "tribe" or "nation,"

expressions which imply a far-reaching political organization that did not exist. Generally these indigenous inhabitants simply referred to themselves as "people" but the vagaries of historical fate have settled names from a confused variety of origins. However for the purpose of this presentation the less-cumbersome term "tribe" will be used. Ranging from north to south, these tribes and the territory they occupied are as follows:

TLINGIT
In southeastern Alaska from Yakutat Bay to the mouth of Portland Inlet.

HAIDA
The Queen Charlotte Islands and, in late prehistoric times, southern Prince of Wales Island.

TSIMSHIAN
The lower reaches of the Nass and Skeena Rivers and the coast from Portland Inlet to Milbanke Sound.

NORTHERN KWAKIUTL
Milbanke Sound to Rivers Inlet.

SOUTHERN KWAKIUTL
Rivers Inlet to Salmon River (in historic times to Campbell River) on Vancouver Island and including the upper reaches of Douglas Channel and Gardner Canal.

BELLA COOLA
A Salishan-speaking enclave confined to the upper reaches of Dean and Burke Channels.

WESTCOAST (NOOTKAN)
The west coast of Vancouver Island from Cape Cook to Port Renfrew.

COAST SALISH
The Strait of Georgia from Campbell River to and including Puget Sound.

THE SOCIETY
The culture developed by these people can be considered as one of the richest and most distinctive in the world. In North America they were surpassed perhaps only by the cultures of Mexico. In terms of this continent, excluding Mexico, they had the highest concentration of population anywhere; more than fifty thousand people occupied the narrow coastline. In demographic terms, this concentration must be seen as unique because it was achieved without an agricultural base.

The rich and varied maritime environment required a sophisticated technological response. But technological mastery was not enough; elaborate rituals were developed to assure the return of an abundant food resource. By far the most important source of food on the Northwest Coast was the salmon. It was the focal point of the economy of the area. Hatched in fresh-water streams and rivers, young fry of the five species—spring, coho, sockeye, pink and chum—descend the rivers, usually in their first year, to mature in the ocean. Depending on the species, they returned in countless millions after three through seven years at sea. Although spawning salmon were found in the rivers from early spring through late fall, the first appearance of a species in the new year called for a sacred ritual. This ritual occurred in varying forms all over the coast and required specialized handling of the first-caught fish by trained ritualists.

Just as the salmon was the primary faunal resource, the ubiquitous red cedar

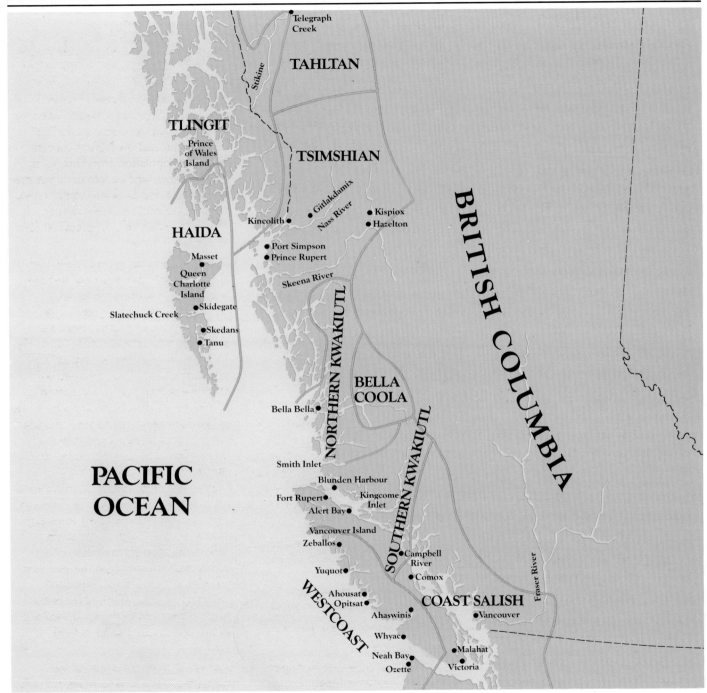

was pre-eminent among the flora. A giant among coastal conifers in more ways than one, it offered both its bark and its light, lustrous, fragrant, decay resistant, and tractable wood. The fact that it split so straight and cleanly was its greatest merit. An inventory of the material effects of any typical northwest coast household easily indicates the ascendancy of this tree. Houses, canoes, containers, totem poles, ceremonial paraphernalia, mats, blankets, capes: all these and more were made from the red cedar.

As woodworkers, the people of the Northwest Coast were unequalled anywhere else in North America. Working with red cedar and, to a lesser extent, yellow cedar, hemlock, yew, maple, alder and cottonwood, the craftsman coaxed the wood into an astonishing variety of shapes. Every man was a carpenter of sorts and with adze, chisel, knife, wedge and hammer, he could control the red cedar enough to fashion utilatarian objects such as planks, fish-drying racks, roasting spits, and the like. However many months of apprenticeship were required before a carver could skilfully handle a finishing adze, a tool which could produce a subtle variegated finish on a cedar plank for an item of furniture or to accept a finely painted design.

In ancient times, the blades of adzes and chisels were preferably made of nephrite, a kind of jade that was traded widely up and down the coast from sources such as the Fraser River. Bone and shell were sometimes substituted and the incisor teeth of beaver made adequate knife blades. However, some centuries before

European discovery, iron blades were in use on the coast. The iron probably occurred as fittings or as implements on wrecked oriental vessels which drifted onto the coast by way of the Japanese Current. We know that iron was in use on the coast before the arrival of the European, for the first explorers reported finding a few metal blades.

The ultimate expression of the woodcarvers' art is of course found in the plethora of ceremonial objects that exist today mainly in museum collections. This legacy suggests, at least in part, that within historic times a relatively few consummate artists practiced their craft. We can say this with some confidence because scholars are beginning to identify regional, local and even personal styles and this research suggests that the contributing artists were not that numerous.

The artist in Northwest Coast society worked in a variety of media but essentially within two traditions: he carved three-dimensional objects and he painted two-dimensional designs. Occasional masterpieces find these two traditions combined in an ultimately intellectual expression. Both traditions have their regional variants and the practiced eye can usually identify these local nuances.

Not only was the wood of the tree used but branches, bark and roots as well. Women who gathered the inner bark of yellow cedar beat it to a surprising softness which they then wove into capes, skirts, and blankets for clothing. Spruce roots were gathered and split many

times until a fine strand was prepared. This was employed to weave watertight baskets and broad-brimmed hats which repelled both rain and sun. From flexible cedar branches, men made tough cedar withes which, when twisted together, made strong ropes.

Apart from the trees mentioned above, Indians on the Northwest Coast recognized several hundred plants and used more than two hundred of them for food and perhaps as many for medicinal purposes. Their availability was largely seasonal but means of preserving the fruit, berries, roots, bulbs, and rhizomes of many plants, as well as marine algae and tree cambium, were discovered. Other delicacies like tender sprouts were consumed immediately.

The basic social unit in Northwest Coast society was the autonomous local kin group, one which recognized familial solidarity and which laid claim to specific resources and territories. One or several of these kin groups might occupy a common winter village but these villages in turn were essentially independent of one another within the overall tribe. On the northern coast, the Tlingit, Tsimshian, and Haida practised matrilineal descent, that is inheritance was reckoned through the female line. To the south, among the Wakashan and Salishan speakers, inheritance was essentially bilateral with perhaps a slight paternal bias. In other words, children inherited equally from both parents. Throughout the area, primogeniture was usual: the eldest male received the most important privileges held by the kin group.

Each local kin group had a set of jealously guarded privileges which served to identify them and to indicate their common origins. For example, one lineage of the Nimpkish (a Kwakiutl village group) relate the following story: Long ago when the world was young, a giant halibut lived at the mouth of the Nimpkish River. One day he swam ashore and transformed himself into a human. He proceeded to build himself a house and with some difficulty raised the four main houseposts. With his adze, he fashioned the huge beams that were to be placed atop the vertical posts but once they were finished, he was unable to lift them into place. As he sat lamenting, he heard a sound behind him and turned to see a Thunderbird alight on a high rock. This supernatural bird offered assistance and, grasping a beam in his talons, flew into the sky and put the beam in place. Then he descended and took off his Thunderbird mask and costume, that is he transformed into a man, and announced that he would be the younger brother of the first man. He caused his Thunderbird costume to fly back into the heavens from whence it came and began to build a house for himself. These two "first men" became the progenitors of one of the Nimpkish families and those who believed themselves descended from that pair to this day have the right to display the Thunderbird and monster halibut as their crests. These may be applied as house-frontal paintings or used to decorate settees, dance blankets, painted screens, and the like. All local kin groups on the Northwest Coast have such origin myths and many of these refer to distinctive geographic features; today the Nimpkish can point out the rock upon which the Thunderbird first landed. Privileges other than origin myths claimed by the local kin group include the right to names, songs, dances, and other ceremonial prerogatives.

Kin group ownership also entered the economic sphere. Fishing stations, stretches of beach, berry patches, cedar groves, mountain ranges, were all claimed by the local kin group. Thus when families left their permanent winter villages for the river salmon fishery, they claimed exclusive use of certain pools and stretches of river which they and their relatives alone could use. If a whale was washed up on a beach, it would, without question, belong to the ranking leader of the kin group who claimed that stretch of beach. Other resource-use areas were similarly entitled.

Generally speaking, members of a local kin group were ranked in relation to one another. Among certain tribes this was more evident than others. Two classes could be seen to exist, nobles and commoners, of which the latter were much more numerous. But the line which divided the two was not always distinct and there could be mobility in either direction between the two. Kin group leaders are referred to as chiefs and it was they who made important decisions such as when to move to a new resource area. They were consulted on the matter of marriage by those below them. They granted permission for lower-ranking members or outsiders to exploit a given resource area at any given time.

Marriages between kin groups were sought as a means of establishing lasting alliances throughout an extended territory. As such they achieved mutual social and economic advantage. Spouses of similar rank were always desired for the nobility, for such arrangements between equal groups brought mutual prestige and advantage which would devolve upon any children born to the married couple. Among the Southern Kwakiutl, a bride price was expected but the woman in the transaction brought a wealth of privileges in the form of songs, dances, and economic considerations which were held and sometimes used by her husband for prospective offspring. In time the bride's family had the option of redeeming her (with interest) and if this was done (in all it might take several decades), the woman was free to leave her husband and return to her own kin group. If she wished, she could remarry. Usually though, if the repayment was made, she remained with her husband but was recognized as a noble and independent woman.

Both prestige and economic considerations were important in marriage. In fairly recent times, some Southern Kwakiutl men married two or three women in rapid succession in order to amass an abundance of ceremonial prerogatives. One, still current, story relates how several days of feasting took place and how during this time many songs, masks, and dances, were displayed as the bride's dowry. Once these had all been exhibited, the groom piled his newly acquired masks, rattles, and other treasures in his canoe and promptly

departed, leaving his bride and an unconsummated marriage on the beach behind.

But economic considerations were also important in establishing widespread ties through marriage. Such events released a plethora of foods and goods immediately into the community but some peoples viewed this dimension in long-range terms. The Coast Salish sought to affiliate with other villages in order to have maximum contacts in case of a localized failure of a food resource. If, for example, a salmon run did not materialize, or if local shellfish were diseased, one could legitimately journey to one's affinal relatives and there obtain food in exchange for material goods. Such a system was in a state of constant dynamics so that obligations seemed to balance out over time.

Those aspects of coastal Indian society that we have touched upon so far—economic and social—and those not yet discussed at length—political, ceremonial, and religious—are intimately bound-up and expressed within a single institution known as the potlatch. The word itself derived from the Chinook jargon (a lingua franca which developed after European contact and which was spoken all over the coast) and it means simply "to give." However it is much more complex than that phrase implies. A potlatch was an event at which an individual celebrated his claim to certain privileges by displaying them publicly in front of invited guests and by then feeding and paying those guests for their attendance. Their acceptance of payment validated his claim and permitted him to proclaim those privileges any time in

the future. A typical example would be as follows: A new chief wishing to honour a deceased forebear might erect a totem pole in memory of that departed relative. On the pole would be carved the figures depicting crests of the deceased, crests which the incumbent would now claim. Guests attending the pole raising would acknowledge his inheritance, if it was valid, by accepting gifts of material goods which were distributed after the event.

Much emphasis has already been placed on the long winter season which secluded the entire Northwest Coast. Storms frequently made travel by canoe impossible and people were forced to remain in their winter villages for days on end. As the weather closed in, the world did as well. It was a time for introspection.

It was at this time that the coastal people believed that spirits came in from their remote fastnesses in the heavens, the mountain tops, the sea, and the forest depths. They lurked around the village outskirts, their presence felt, their cries subconsciously noted.

So marked was the change of season that the Kwakiutl, for one, took on an entirely new set of names. These were to be used only during winter, that most sacred season, a time when the use of red cedar bark signified all that was holy. It was at this time that elaborate dance rituals were enacted, illustrating the adventures of novices who were captured by the spirits and returned in a crazed condition, requiring pacification by ritualists.

The most dramatic stagecraft seen among any theatrical tradition was seen

at this time. Monstrous birds seeking human flesh strutted and hopped in the fire-light. Women were burned in a fire, only to become whole again. Mechanical devices abounded: salmon leaped through the air, giant frogs jumped across the floor, sea monsters came trumpeting out of the ocean. These re-enactments were intimately related to myth and, beyond that, had their origins in the individual spirit quest which survived well into historic times in the southern-most part of the region that concerns us.

EUROPEAN CONTACT

Despite their technological superiority, the first European explorers to reach the Pacific Northwest Coast were not insensitive to the artistic and social achievements of the native inhabitants. The outsiders soon learned they had to deal with a complex society, engaging in all matters of communication and commerce only through high-ranking chiefs. And, while surviving documents are brief and limited, they do provide information on native society and the sculptural and graphic arts practiced at the time. In light of our current understanding of these arts, the historic record provides some insightful observations.

As well as the written record, many artifacts were acquired; these formed the nucleus of important collections for burgeoning European museums. Captain James Cook, who landed at Friendly Cove on Vancouver Island in 1778, obtained significant carved objects which help to confirm the relative antiquity of the arts we so appreciate today.

Less than a decade after Cook's arrival, Captains Portlock and Dixon, engaged in exploration and the sea otter trade, observed the following:

"Many of these carvings are well-proportioned, and executed with a considerable degree of ingenuity, which appears rather extraordinary amongst a people so remote from civilized refinement. But then, we must consider, that this art is far from being in its infancy; a fondness for carving and sculpture, was discovered amongst these people by Captain Cook: iron implements were then also in use; and their knives are so very thin, that they bend them in a variety of forms, which answer their every purpose nearly as well as if they had recourse to a carpenter's tool chest." (Dixon, 1789:243)

Such early testimonials, when considered with collections of artifacts acquired contemporaneously, indicate the precepts of Northwest Coast carving and painting were well-established long before the arrival of the European. The output of art flowered following the initial period of exploration and discovery. Increased availablity of metal blades and a stimulated native economy resulted in an outpouring of carvings which reflected the heritage and position of high-ranking chiefs, many of whom became rich beyond anticipation through their control of trade with the newcomers. Totem poles and other crest art appeared in increasing numbers, indicating an expression of new wealth and improved technology.

The intruders – European and Yankee fur traders – initially sought sea otter pelts which were sold at huge profits in China. But, by 1835, the sea otter had been hunted to near extinction so certain coastal tribes sought to supplement their trading positions with other goods. About 1840 the Haida began to cultivate potatoes which they offered in exchange for trade goods; other tribes assumed this practice somewhat later.

Another response was to produce art for sale. About 1820 the Haida began to carve curios from argillite, a black carbonaceous shale found in the Skidegate Inlet area. These found a ready market among visiting seamen and are among the first art items produced by Northwest Coast Indian artists for the market. Somewhat later, other coastal tribes followed the Haida example, although their curios were produced from familiar organic materials, mainly wood. Significantly it was the model totem pole which became the archetype of art produced for sale among other tribes although small dishes and bowls were also popular. The Kwakiutl perfected this craft and from the hands of a few carvers literally hundreds of model wooden poles flooded the market, and were eagerly purchased by collectors.

ART IN THE CULTURE

Art pervaded all of Northwest Coast Indian culture. Even the most utilitarian objects such as spoons, fish clubs, and paddles were decorated. The two-dimensional art is founded on a system of rules which order design organization. Sculptural art demands that anatomical features be carved in certain ways, giving rise to distinct tribal styles. Both these artistic traditions will be discussed at length in the following sections and the manner in which they are presented seeks to provide a greater appreciation of the art through an understanding of form. Hopefully those readers wishing to explore the art further will gain some ability to recognize regional, tribal and personal style as a result of this presentation.

Art served two main purposes in coastal Indian life. On one hand it is a crest art – a totem pole, dancing headdress, house-frontal painting, or decorated blanket signalling the owner's mythic origins. This was most highly developed among the northernmost tribes where inheritance was through the female line, although it was also entrenched among the Southern Kwakiutl. Crest art was emphasized during potlatches and feasts and as such verified and validated the social system.

On the other hand, art made the supernatural world visible. The incredible array of creatures – human, animal and mythic – that inhabit the minds and landscape of Northwest Coast people are realized through the medium of dance dramas. The skill evident in plastic and graphic arts is only part of a continuum which extended into theatre. Movement in dance can be likened to the flow of line in two-dimensional art. In flickering firelight, the bold sculptural planes of carvings alternately gathered shadow and reflected light as performers circled the dance floor. And it was the

23

artist's role to render fantastic the creatures of both the real world and the mythic cosmos.

THE TRAGEDY OF DECLINE

As the European presence on the Pacific Northwest Coast grew, various pressures were applied to Indian society. Both deliberately and unwittingly, they displaced and disrupted traditional life. In 1862 a horror of unexpected magnitude struck. Until that date, the native population had been gradually reduced by diseases such as measles, mumps, chicken pox and tuberculosis, not to mention alcohol and gunpowder. But in 1862 a traveller from San Francisco landed in Fort Victoria, suffering from smallpox. Within two years this sickness spread throughout the area, killing a third of the population. Northern tribes trading at Fort Victoria contracted the disease, and as they made their way homeward they began to die, confused and terrified. They were attacked by other groups along the way, who in turn fell ill. Unscrupulous but certainly enterprising traders entered decimated villages and pulled blankets off corpses before moving on to healthy villages where they traded the infected goods.

As the native population began to decline, increasing numbers of settlers moved into the area. In certain of the moderate, fertile valleys on the south coast these settlers cleared land and were soon able to farm successfully. But one cannot farm the thin acid soil of the exposed northern coast, so settlers there were forced to turn to lumbering, fishing and, in some cases, mining. Following settlement, authorities soon decided that Indian affairs required formal administration. British Columbia, which joined Canadian confederation in 1871, agreed that administration of native peoples be assumed by the Federal authority. In time the province was divided into agencies, administered by representatives of the Indian Commissioner.

Throughout this period of control, native people were subjected to frontal attacks by both missionaries and administrators. Many aspects of traditional culture were discouraged, especially as authorities believed the native people were doomed to extinction. However, many clung tenaciously and defiantly to parts of traditional culture. The most serious assault began in 1884 when Canadian authorities enacted legislation prohibiting the potlatch. By denying this institution, all aspects of traditional culture – social, political, religious, ceremonial, economic, and artistic – were weakened. Initially, attempts by authorities to prosecute under this law met with little success. However in 1922, a particularly zealous Indian Agent at Alert Bay was successful in gaining convictions. As a result, twenty-two Southern Kwakiutl were jailed for participating in events that reflected, glorified and confirmed their ancient heritage.

The legal and demographic pressures upon Northwest Coast society caused the disintegration or loss of many aspects of traditional culture. One area which suffered was the art. Among some tribes, knowledge of the structure and meaning of the art was lost entirely; for others it was tenuously maintained; and for a few it remained viable, although in the hands of only a few practitioners. However today the art is in a state of vigorous revival. This rebirth is stimulating the memory of dormant ritual. Thus the art is providing a vehicle for the return of singing, dancing, feasting, and potlatching. While some contemporary artists have inherited the legacy of their ancestors through an unbroken line, the majority had to gain theirs through lengthy and careful analysis of museum specimens or through instruction from craftsmen trained outside the tribal group.

Today the art remains an important force in the lives of Indian people in British Columbia, Canada. It is here that the artistic tradition refused to die and it is here that it has recently achieved spectacular regeneration. In order to appreciate the accomplishments of contemporary British Columbia Indian artists, the finest classic examples of painting and sculpture from the collection of the British Columbia Provincial Museum have been selected to indicate the epitome of form and style in traditonal Northwest Coast Indian art. These are followed by examples from the hands of present-day artists, whose creations demonstrate that the vigorous traditions of the past remain viable today.

THE LEGACY PART TWO

Peter L. Macnair

TWO-DIMENSIONAL DESIGN

Northern Two-dimensional Art
Southern Two-dimensional Art

Painting on the Northwest Coast is essentially a tradition of surface decoration. Two-dimensional design is found throughout the area and is guided by a set of clearly defined principles. While both tribal and individual variation occurs in this artform, it is much more closely integrated than sculpture, where tribal differences are often striking and easily recognized. In fact, it is frequently difficult to distinguish between Tlingit, Haida, Tsimshian, and some Northern Kwakiutl graphic design. The similarity between examples of these is such that they can be considered areal style representing the *Northern Province*.

Style was much more diverse in the *Southern Province* although a precontact conformity is suspected. Within the historic period the two-dimensional art created by tribes in this area began to change, in great part, because of influences from the north. Most profoundly affected were the Southern Kwakiutl who assimilated most of the forms and conventions of their northern neighbours. Less influenced were Westcoast artists although other factors caused change in their work. Coast Salish two-dimensional art did not alter significantly in this period, possibly because knowledgeable practitioners did not survive the nineteenth century.

Understanding Northwest Coast two-dimensional art has long been a challenge to the uninitiated. Certain early observers were able to decipher and appreciate some of the simpler flat designs and any present-day viewer with an uninhibited curiosity can distinguish at least some of the elements which characterize Northwest Coast two-dimensional design. But at its subtlest and most abstract, the art can defy even the most accomplished scholar.

The anthropologist Franz Boas made pioneering contributions to an ordered description of graphic design (1897:123-76; 1927:183-298) as did Haeberlin (1918:258-64) and Adam (1936:8-9). The museum collector C. F. Newcombe also struggled to describe the art but his efforts were never published. It was not until the release of Bill Holm's scholarly contribution in 1965, *Northwest Coast Indian Art: An Analysis of Form*, that the rules of the art, as defined and practiced by traditional Northern painters, were revealed in a formal, intelligible presentation. Holm defines the elements of graphic design and indicates the prescribed way in which these must be used. His vocabulary enables us to comprehend and interpret the symbolic intent of this art. To understand it, his descriptive terms must be introduced and then applied to typical examples.

NORTHERN TWO-DIMENSIONAL ART

Holm reveals that the *formline* is the basis of Northern two-dimensional art. Usually rendered in black, this flowing line is filled with tension as it turns within a given space, swelling and contracting at certain critical points. It serves to create an outline of the creature represented although the ease with which the intended body can be recognized varies considerably. In part, the artist's inclination and talent accounts for this but, as will be seen, there are degrees of abstraction, culminating in graphic designs which are virtually unintelligible.

In Northern examples, three colours are typically found and are ranked in the following order: black, red, and blue (in early times green or blue-green appeared in place of blue). Frequently only the first two are present. Black functions as the *primary colour* (figure 1a), defining the formline. As the *secondary colour*, red indicates what the artist considers less-important details: cheeks, tongues, hands, feet, and torso (figure 1b). In the majority of examples, tertiary spaces are left unpainted but these may be decorated with the *tertiary colour* blue (figure 1c), shallowly carved, or hollowed and painted blue as in figure 2a. The designs on the long sides of this typical chest are found, with little basic variation, on hundreds of bent boxes and chests used as containers by Northwest Coast Indians.

Pigments were derived from natural sources: lignite or charcoal, producing black; ochres, a brownish-red; and copper minerals, a green or blue-green. In historic times, the earthy brownish-red was replaced by a brilliant vermilion and it is this variant which is most familiar on museum specimens. The vermilion was introduced in powdered form, in neatly folded paper packets imported from China. This colour became available early in the nineteenth century when ships engaged in the sea otter

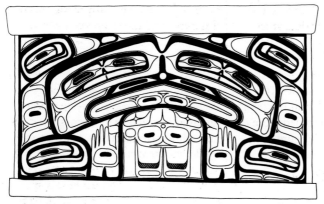

Figure 1a. Primary formline design (from chest 1295).

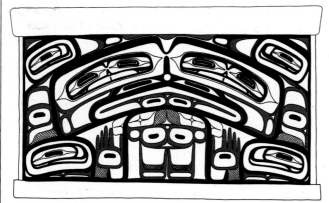

Figure 1b. Secondary formline designs (from chest 1295).

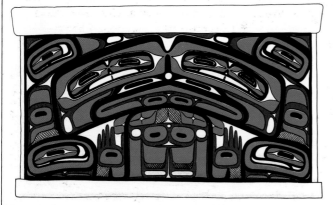

Figure 1c. Tertiary design elements (from chest 1295).

trade returned to the Northwest Coast from the Orient. Similarly the subtle greens and blue-greens were succeeded by an ultramarine blue, obtained by pulverizing cubes of blueing, a laundry preparation introduced in the historic period.

Pigments were mixed with a medium derived from dried salmon eggs. The eggs were placed in a thin cedar-bark pouch and then chewed; the resulting mixture of saliva and egg oil was then spit into a container and the colouring agent added. The cedar-bark receptacle retained the membranous parts of the salmon eggs, assuring a smooth consistency to the medium.

Paint brushes (figure 3) had a cylindrical wooden handle which was spatulate at one end. Into this, porcupine hairs were inserted, bound, and trimmed off at an angle, facilitating the preferred stroke which involved drawing the brush toward the artist's body. This motion is, of course, in keeping with the continuity and flow of the formline.

The distinguishing characteristic of the formline is that it is continuous. While it may diminish, at no point does it terminate; therefore the eye or hand can trace it back via an unbroken route to the point of origin. Integral motifs of the black formline are two predominant and easily recognizable elements, the *u-form* (figure 4) and the *ovoid* (figure 5). As parts of the *primary formline* they serve to define distinctive anatomical features such as ears and joints. But they may also appear, often in combination, as secondary elements; as such they are represented in red. Enclosed within

formline ovoids are other distinctive ovoid elements. While they float unattached, they are nevertheless part of the primary design, as their colour indicates. Certain of these have been defined by both Boas and Holm as *salmon-trout's-heads* (figure 6). They may vary considerably in outline and detail; often these differences are useful indicators in attributing a work to a certain school or even to an individual artist. The master painter can render these freehand but to create the acceptable form, especially if it is to be repeated opposite in a bilaterally symmetrical design, *templates* are used. Half the ovoid is carefully traced onto a folded piece of cedar bark. When opened (figure 7) it provides the outline of a perfectly balanced ovoid. The proper features of this ovoid include steep sides which expand outwards slightly as they flow upward from rounded bottom corners, a gently upward-curving top and usually a slightly concave bottom. Several of these ovoid templates, varying in size, are used to create both formline ovoids and salmon-trout's-heads. U-forms and eyelid lines may also be achieved using similarly created templates. There is a great intellectual potential in this art, once the rules are fully mastered. And, despite the constraints of the rules, certain master artists sought to challenge them, displaying a brilliant intelligence that leaves the knowledgeable viewer in awe of the result. Thus we find examples where red is substituted for the usual primary formline colour, where overpainting occurs, where massive, usually angular, formline blocks dominate a given quarter of a design panel, and where no colour exists, thinly incised lines defining the formline instead.

The most easily understood two-dimensional renderings are those termed by Holm as *configurative designs* which depict an animal in silhouette and in near natural proportions. They are recognized mainly because they do not

Figure 2a. Haida chest 1295.

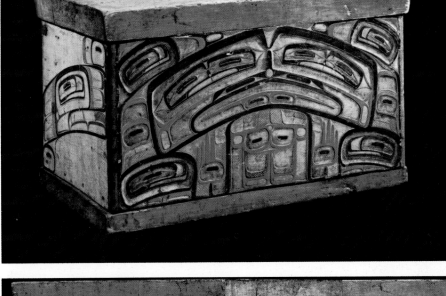

Figure 2b. Haida chest 1295–front. *Figure 2c.* Haida chest 1295–side. *Figure 2d.* Haida chest 1295–back. *Figure 2e.* Haida chest 1295–side.

Figure 3. Haida paint brush 6532.

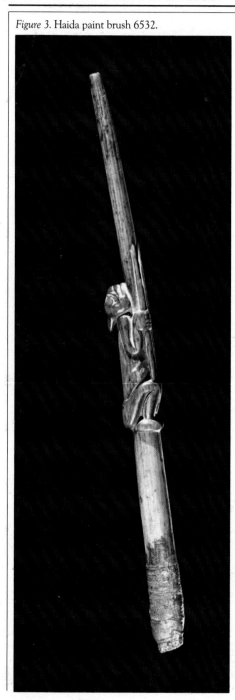

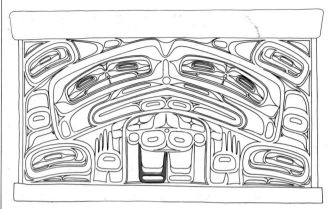

Figure 4. U-form (from chest 1295).

Figure 5. Ovoid (from chest 1295).

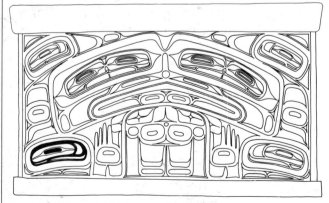

Figure 6. Salmon-trout's-head (from chest 1295).

Figure 7. Ovoid template 640.

in black formline hooves. While some distortion remains, the profile view approaches naturalistic proportions.

When the artist seeks to extend a design so that it more or less completely fills the field, he may distort, rearrange or even eliminate certain anatomical features. Yet if the animal represented is still recognizable because the essential relationship of its parts is maintained, an *expansive design* is produced. This is seen in the Haida copper (figure 9) which features a beaver. The head, shown in frontal view, is much larger than the remaining elements. Only the front appendages are shown; the shoulder, leg and foot are clearly defined.

attempt to fill the design field entirely. Anyone familiar with North Pacific fauna has little difficulty in identifying the birds or land and sea mammals so rendered. These make immediate statements about the owner's crest affiliation and are most frequently found painted on spruce-root hats, applied on cloth dance shirts and blankets, rendered on dance aprons, and even translated into woven form in the celebrated Chilkat blanket. In the configurative example painted on a spruce-root hat (figure 8), a mountain goat is portrayed. The animal's head appears both in frontal view and as two profiles, the curve of the hat's crown assists in this impression. Significant indicators of the goat are the horns and the blunt hooves. Seen as a side view, the naturally proportioned formline body is evident with formline ovoids indicating shoulder and hip joints. Interestingly, the legs are rendered in red, an unusual variation, and terminate

Figure 8. Haida spruce-root hat 9498.

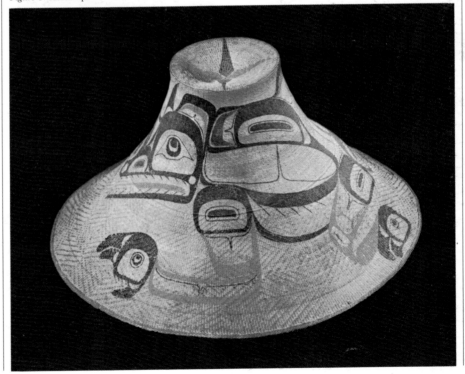

31

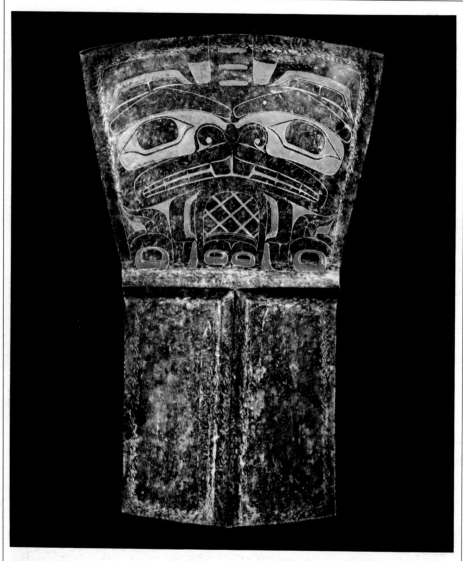

Figure 9. Haida copper 1396.

ducing a *distributive design*. Here the anatomical features are so completely rearranged within a given space that the creature is not identifiable. The Haida bent bowl (figure 10 a – e) serves as a good example of this. Collected privately about 1850, there was no record made of the creature represented. When accessioned into the British Columbia Provincial Museum collection in 1927, a tentative attribution was made, suggesting a sea bear was intended by this design. While a mammal is undoubtedly featured, its specific identity remains uncertain, primarily because the anatomical details are distributed so they completely fill each panel of the dish and secondly because no salient features are defined.

In certain truly accomplished examples of Northern flat design, great subtlety is achieved when the artist eliminates colours from the two-dimensional rendering. The formline is less evident, especially when compressed in a distributive manner as on the sides of the Haida bent bowl (figure 11 a–d). Incised lines often broken, serve to define the basic formline structure, reflecting an inherent tension and movement. The end panels of this piece show that a bird is represented, possibly a hawk. At one end is the head, a recurved beak indicated by the vertical element which splits the mouth in half. Further evidence that a bird is intended can be seen at the opposite end; two formline ovoids indicate the tail joint while above them three u-forms suggest feathers. Centrally, and at the bottom, two claws, folded

No evidence of body or rear legs is seen and the remaining area is taken up by a cross-hatched tail.

While distortion and elimination are features of this design, the artist considers them necessary to fit the figure into the rectangular upper half of this shield-shaped object. Yet certain salient features such as the prominent incisors and scaly, cross-hatched tail are introduced to assist in our identification of this as a beaver.

The greatest intellectual challenge facing the Northern artist comes when pro-

inwards and tucked up, can be seen, further confirming identification as bird. But the two rectangular side panels defy accurate analysis. Both are similar and consist essentially of formline u's and ovoids which suggest wings and feathers but these details cannot be absolutely attributed. The example stands as a masterpiece of the graphic designer's art.

The majority of two-dimensional designs represent crests, indicating prerogatives and ancestry of specific individuals. However there are a few rare examples of *narrative painting* in traditional art; these are usually associated with shamanism. They decorate the shaman's paraphernalia – robes, aprons, mats, and drums – and probably indicate spirit helpers who aided the practitioner in his quest for power and who return to assist him during curing rites. While

no information about the function of this tambourine drum (figure 12) was recorded, it is assumed to be the property of a shaman. The design is painted inside, in part to prevent its obliteration when beaten, but also perhaps because it faced the user, directing its power towards him. The main figure in this painting appears to be a shaman, whose ribs and pelvis are shown in x-ray form and who wears an apron. Beside him is an expansively rendered creature, probably a spirit helper. Two flights of arrows threaten the standing shaman. The foregoing description is entirely subjective but considered simply as a painting, there is no doubt of its narrative intent, an example rare in Northwest Coast graphic art.

As indicated earlier, a few innovative artists openly challenged the rules of Northern two-dimensional art. Without breaking these completely, they sought to alter them in ways that permitted individual expression. One manner of achieving this was to reverse the ranking of colours so that the formline was rendered in red. A number of such examples exist (see figure 13a) yet they are rare enough to be considered a unique class of painting.

Figure 10 a. Haida bent bowl 4114.

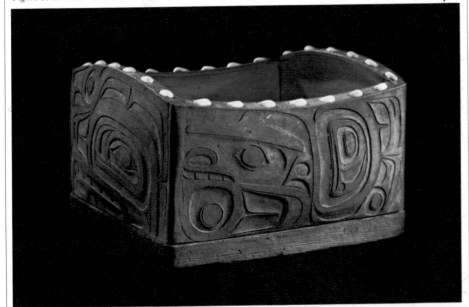

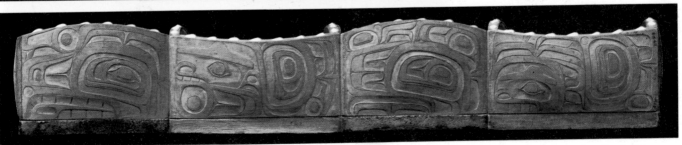

Figure 10b. Haida bent bowl 4114. *Figure 10c.* Haida bent bowl 4114. *Figure 10d.* Haida bent bowl 4114. *Figure 10e.* Haida bent bowl 4114.

In certain singular but powerful examples, so many atypical things appear to be taking place that the viewer is left perplexed and frustrated. Yet with an understanding of the principles of form, even the most confusing designs can be dissected and their prototypes identified. The best example of this appears on a decorated bent bowl, figure 13a, where a knowledge of the rules and a familiarity with form will help unlock the secrets of this intellectually challenging piece. A detailed analysis follows:

Cursory examination reveals the artist has isolated one quarter of each panel by edging it with a massive, simple, angular formline element in a colour opposite to that of the dominant design. Other unusual things occur: at two points on figure 13b and 13d, black secondary formline ovoids rely upon the red primary formline for completion. While the primary formlines are red, the salmon-trout's-heads within them are black, emphasizing their roles as eyes and joints.

But what about the designs themselves? At first glance, figure 13b appears to be highly abstract. The most easily read element is that contained within the black quadrant; a joint, leg, and foot

Figure 11 a. Haida bent bowl 14678.

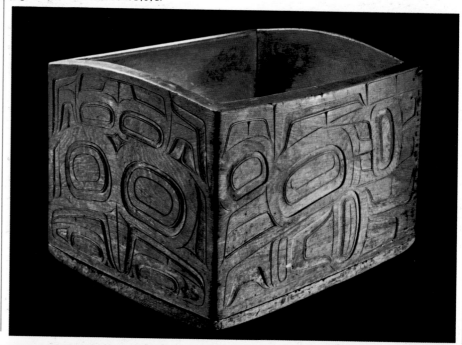

are obvious. But if the design field is divided in half vertically, it becomes apparent that the left side is one half of a standard chest or box panel. The relationship becomes clear when it is compared to the left half of figure 2d.

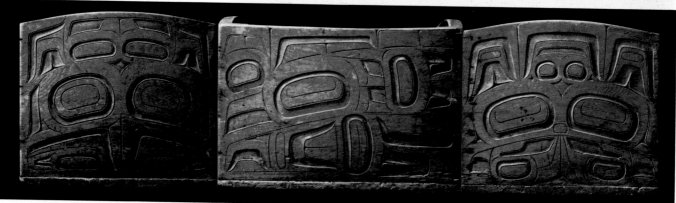

Figure 11b. Haida bent bowl 14678.

Figure 11c. Haida bent bowl 14678.

Figure 11d. Haida bent bowl 14678.

Figure 12. Haida tambourine drum 10630.

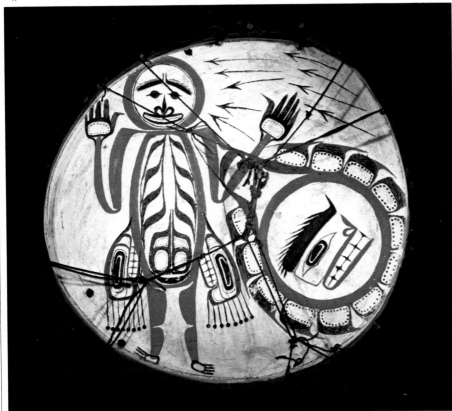

Finally, the problematic formline design in the upper right corner of this first panel is a variant of the red formline element found to the left of the main face on figure 2b. Further analysis shows that the latter is approximately one half of the red formline design found in the lower centre section of figure 2b. This design represents the torso of the creature whose face is defined by the black primary formline.

A similar analysis of figure 13c reveals more secrets. The design within the lower left quadrant is by now a familiar device. It is a profile representation of a torso as confirmed by its presence and function in figure 2d and figure 13b. The red primary design filling the remaining space is clearly one half of a bilaterally symmetrical design. If a mirror image is added on the right, the head, wing and tail of a bird are revealed. A claw, rendered in black, is placed within the u-form ear, a convenient and available space (figure 13c).

Figure 13d can be analyzed in the same way. In this case the field is quartered horizontally by the massive formline element (termed an *ultra-primary* by Bill Holm). If the profile formline face is mirrored it creates a frontal view and a bird's head becomes obvious; it's similarity to the bird's head on figure 11b is immediately apparent. The meaning of the four elements shown in figure 13e is obscure. Possibly they relate to one or all of the first three panels. At least they can be considered variations on a single element. The interested viewer can hold a small mirror to their edges and enjoy the doubled form which results. Remembering that the concave or flat side of the ovoid is the *bottom*, with the mirror these can be transformed into fluked tails, paired fins or whatever else the viewer wishes to interpret. These are not random, meaningless images; the four relate in basic form to one another and obviously had some significance to their creator.

The above example epitomizes the intellect of the Northwest Coast artist. Confronted by seemingly limiting rules, he is able to challenge and to manipulate them in a manner that nonetheless maintains their integrity. Surely this is a mark of genius.

Another expression of the above abstraction is found in a bent bowl in the collection of the American Museum of Natural History, New York (illustrated in Boas, 1927:fig. 287; Wardwell, 1978:plate 73). On each of the four sides, the lower quarter panel is painted solid black and on top of this are formline elements in red. The remaining three quarters of each panel feature red formline designs as in figure 13a.

In fact, one panel on each of these bowls is so remarkably similar in basic layout to the other that the two must somehow be connected in space and time.

SOUTHERN TWO-DIMENSIONAL ART

In precontact times, the tribes occupying the southern British Columbia coast – the Southern Kwakiutl, West-coast and Coast Salish – practiced a two-dimensional art which was distinct from that of the Northern Province but with which it probably had ancient connections. Little has survived to indicate the archaic Southern Kwakiutl style but important early ethnographic specimens were acquired from the Coast Salish and Westcoast peoples. Style on these examples has been confirmed by important archaeological discoveries in the homelands of these two groups. Included in an examination of the art found in this Southern Province is

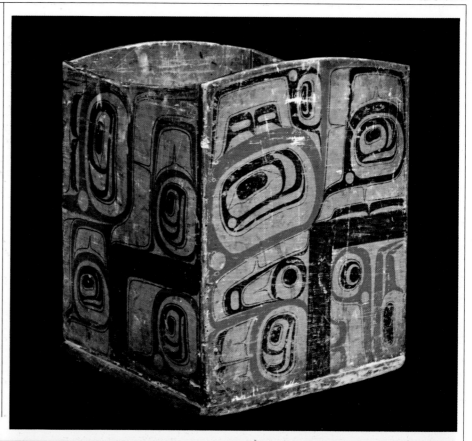

Figure 13 a. Haida bent bowl A8435.

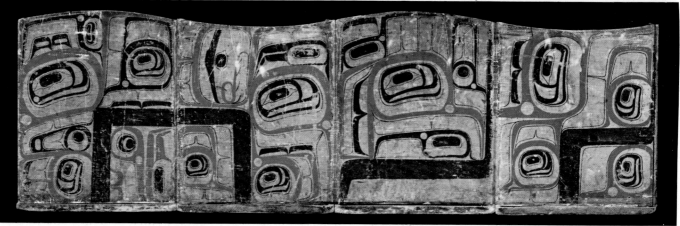

Figure 13b Haida bent bowl A8435 *Figure 13c* Haida bent bowl A8435 *Figure 13d* Haida bent bowl A8435 *Figure 13e* Haida bent bowl A8435

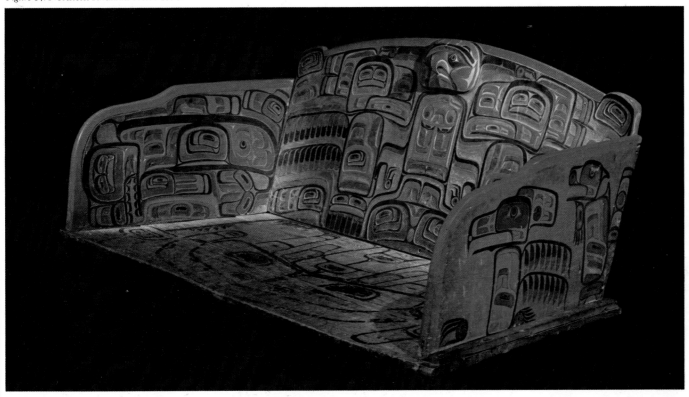

Figure 14. Northern Kwakiutl settee 1856.

the flat design of the Northern Kwakiutl. They occupied the interface between Northern and Southern areas and while their painting style, especially that created before about 1865, is essentially Northern, their role in initiating certain changes in the south encourages consideration with the latter. Archaic Northern Kwakiutl examples are relatively rare in museum collections. The best specimens from this period are decorated burial boxes and these were not widely or legally acquired.

Probably about 1865 certain changes in Northern Kwakiutl design began to occur. The majority of pieces produced from this time onwards seem to have been manufactured at the village of Bella Bella and appear to represent the output of that village-specific school of painters. Some of these were sold as decorative pieces to white men. Thin formlines typified this Bella Bella school. Another distinguishing trademark (admittedly found elsewhere on the northern coast but not as consistently) is the parallel hatching found within enclosed secondary and tertiary elements. Almost invariably, this parallel hatching slants from upper right to lower left, regardless of to which side of a bilaterally symmetrical design it is applied. Cross-hatching, elsewhere relatively common, is virtually unknown in these Bella Bella examples. The chief's settee in figure 14 displays the characteristic details described above. Interestingly, this settee has a counterpart in the Berlin Museum (see Appendix I, No. 1856).

Little is known about Southern Kwakiutl two-dimensional art at the time of European contact. Captain George Vancouver visited and described a Southern Kwakiutl village at the mouth of the Nimpkish River in July 1792.

His staff botanist Archibald Menzies noted that the housefronts were adorned with paintings. These are illustrated in a panoramic engraving of the village published in Vancouver (1798, Vol. 1: plate V). The illustration remains an enigma because the geometric designs may simply be a creation of a European artist or engraver unable to fathom the complexities of native flat design. On the other hand, they may be relatively accurate, displaying an affinity to certain archaic Westcoast styles.

Figure 15. Southern Kwakiutl box drum 1972.

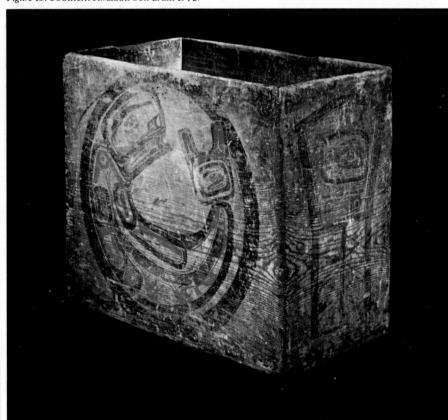

Whatever the precontact tradition, we know that within the historic period, Northern flat design permeated south to northern Vancouver Island and the adjacent mainland of British Columbia and that by 1880 a Southern Kwakiutl variant of Northern painting was well established. In the hands of most Southern Kwakiutl artists, the painting style was loose and obviously freehand. In the early twentieth century, additional colours were added to the three utilized by Northern artists. While many elements of the Northern style were incorporated, the Southern Kwakiutl artist was not constrained by these; in fact he was inclined to invent new graphic elements if he was unable to fit more conservative ones into a given design field. Figure 15 shows a box drum which characterizes many of the above-described traits. An understanding of the formline ovoid and u-form is evident, yet these do not contain the inherent tension of the Northern examples. The circle which surrounds the killer whale is a rare motif in Northwest Coast art. An unusual and aesthetically innovative and successful effect is achieved by breaking the line of the circle with one fluke of the killer whale's tail, indicating the freedom the Southern Kwakiutl took with their borrowed style.

Objects collected by Captain James Cook from the Westcoast people show an elemental graphic tradition achieved by bold incising on flat surfaces. The most typical specimen so decorated is a whalebone club; such have been collected both ethnographically and archaeologically. Another characteristic of archaic Westcoast decoration is rows of dots, often in association with free-standing geometric elements. Some of the latter may be rounded to the point where they suggest u-forms, as on the model canoe illustrated in figure 16.

Some time after the mid-nineteenth century, certain Westcoast artists began to incorporate elements from the Northern formline system. While this did not become widespread, a few practitioners produced powerful images in this genre. At the same time, a

Figure 16. Westcoast model canoe 6600.

more conservative and distinctive Westcoast graphic style persisted, an example of which can be seen on the dance screen now in the American Museum of Natural History, New York, and illustrated in figure 17.

The most exciting confirmation of the antiquity of Westcoast graphic design is found in artifacts recovered from an archaeological site on the Pacific coast of Washington State. Traditionally the territory of the Makah, who are immediate linguistic and cultural neighbours of the Westcoast people, the precontact Makah village at Ozette was engulfed by a mud slide some time prior to the arrival of the white man. Until recently the buried site lay undiscovered, yet preserved in the constantly moist mud. In 1970, with the approval and co-operation of the Makah people, excavations commenced. To date more than 60,000 artifacts have been recovered, an extensive inventory of materials made from wood, bark, root, grass, bone, antler, stone,

and metal. Certain decorated objects from the site, such as boxes, clubs, planks, combs, and spindle whorls, indicate a close affinity with ornamented items collected by Captain Cook.

Elaborately carved and painted slat headdresses representing wolves and mythical Lightning Snakes (Haietlik) were popular items of dance regalia. Performers twist and leap for long periods; undoubtedly the lightweight construction makes it much easier to dance, especially since the head is often thrown back during the drama. The flat sides invited decoration and while some older design elements were utilized, newer forms were incorporated late in the nineteenth century. The Westcoast headdress illustrated in figure 18 demonstrates this later style. Here we can see the type of ovoid preferred by this tribal group; it is virtually symmetrical on either side of a horizontal axis. Basic u-forms are also present and curvilinear elements are introduced. One twentieth-century Westcoast

artist, Jimmy John whose career began about 1910, claims the curled elements, as seen on figure 18, were inspired by carved scrollwork decorating church furniture. Whatever the sources, these motifs are found in headdresses from the late nineteenth and early twentieth century. There were no colour restrictions placed on such flat designs. A sampling of several examples reveals the following colours in use: black, green, red, ultramarine blue, yellow, white, orange, gold, and silver.

The graphic art of the Coast Salish was not as widely applied to objects as it was by all of their northern neighbours. Yet a defined style is evident and enough examples have been collected throughout Coast Salish territory to indicate its diverse presence among that group. It was a conservative art, changing not at all from the point of European contact through to the 1890's when the last significant examples were probably produced.

Figure 17. Westcoast dance screen, Alberni, 1907, PN 7260.

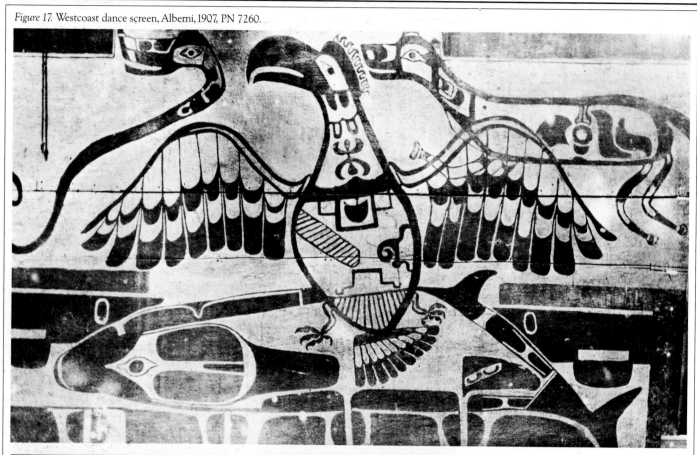

Figure 18. Westcoast headdress 13254.

Coast Salish art is closely associated with ritual; important ceremonial items, such as rattles of mountain sheep horn, show boldly incised designs. Utilitarian objects too were frequently decorated: fish clubs, combs, and spindle whorls provide the best and most prolific examples. The creatures depicted on such objects are assumed to relate to the supernatural helpers of successful fishermen, and skilled spinners and weavers.

Figure 19. Coast Salish spindle whorl 2454.

Figure 20. Coast Salish mountain sheep horn rattle 10694.

Close examination of Coast Salish graphic art suggests an archaic and perhaps pan-coastal tradition of flat design which may have formed the basis for the intellectualized forms of the north. *Crescents, v-forms* and *u-forms* are boldly incised but they are contained within what may be considered as an elemental, prototypic formline structure. These can be seen in the Coast Salish spindle whorl, figure 19, particularly on the split, supernatural creatures which flank the central human.

Other devices found in Coast Salish flat design include concentric circles. Often these function as joints, as can be seen on the sheep horn rattle illustrated as figure 20. If we permit ourselves to accept the probable antiquity of Coast Salish flat design elements, we can see these concentric circles as the precursors of the Northern ovoid.

THE LEGACY PART THREE

Peter L. Macnair

SCULPTURE

Haida
Tsimshian
Northern Kwakiutl
Bella Coola
Southern Kwakiutl
Westcoast
Coast Salish

Figure 21. Major anatomical features found on Northwest Coast masks.

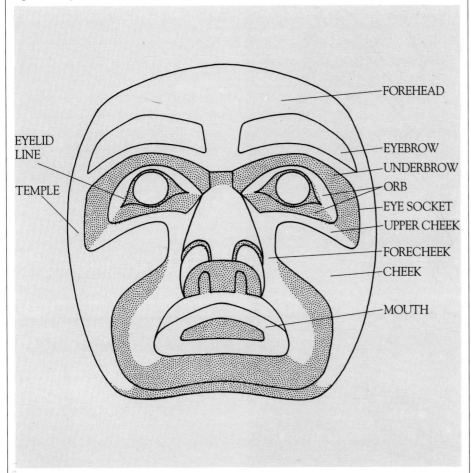

EYELID LINE

TEMPLE

FOREHEAD

EYEBROW

UNDERBROW

ORB

EYE SOCKET

UPPER CHEEK

FORECHEEK

CHEEK

MOUTH

It is perhaps easier for us to respond to Northwest Coast sculpture than to flat design, because much of the former is concerned with the human face. We are compelled by the faces represented on totem poles, headdresses, rattles, and masks, perhaps because in them we recognize ourselves. Masks created by coastal Indians express the full range of human emotions. Expressive as they might be, hanging on a museum or gallery wall, masks assume an intense character when used by a skilled dancer. Human face masks range from realistic portraits, intended to represent actual individuals, to stylized renderings of mythical ancestors.

Each coastal tribe developed its own distinctive sculptural style. A detailed discussion of these can be found in Holm (1972). While local and individual variation is possible, the underlying form is often enough to allow correct attribution of an undocumented piece. In order to compare tribal styles, it is best to use humanoid face masks because they are immediately identifiable as human and thus pose no iconographic problems, their anatomical features are easily classified and compared, and they are found universally on the coast. Masks representing land and marine mammals, birds, insects, and mythical creatures, usually incorporate the sculptural forms described for the humanoid masks. However it is easier to avoid such examples in order to present a precise comparison.

In most cases, representations of the human visage on masks are handled similarly on monumental sculpture. Photographs of typical human faces on totem poles are included to emphasize this similarity, despite the difference in scale. In order to compare and analyze sculptural styles a schematic face with relevant terms is helpful (figure 21).

HAIDA SCULPTURE

Little has been recorded about the way in which Haida masks were conceived and used although Haida family histories indicate many dance prerogatives, which include the use of masks, were acquired through intermarriage with Tsimshian, Kwakiutl and Tlingit neighbours during the historic period. This is confirmed by the fact that such dances retain the names used by the tribal group from which they were borrowed. Such adoption is further verified when Haida crests are considered. Certain

45

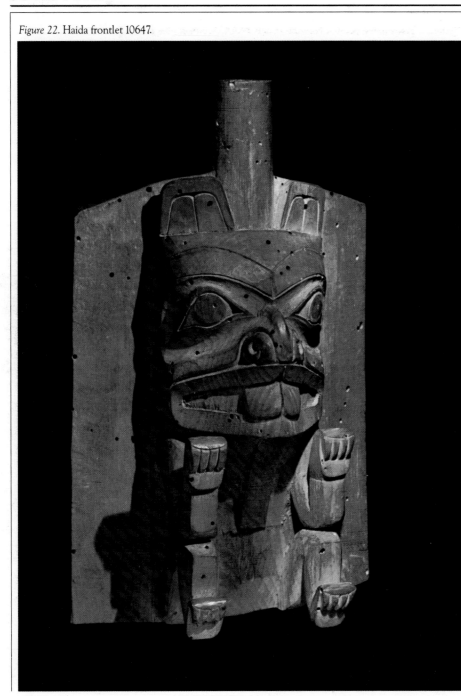

Figure 22. Haida frontlet 10647.

crests, such as the Grizzly Bear, Wolf, Mountain Goat, Black Bear, and Beaver obviously reflect an outside source because these animals are not indigenous to the Queen Charlotte Islands where the Haida live.

Haida humanoid masks are among the most difficult to attribute, particularly because they tend to be naturalistic. As such, they may be confused with Tlingit, Tsimshian, and Northern Kwakiutl examples. A more readily distinguishable variant of classic Haida sculpture is seen on totem poles, mountain goat horn spoons, speaker's staffs and some headdress frontlets. In these we find a two-dimensional design applied to a half-cylinder which is then carved in shallow relief. A comparison of the unpainted frontlet (figure 22) and the totem poles *in situ* (figure 23) reveals this dramatically.

In such carvings, the eyebrows cover more than half of the forehead; the eye-socket is usually ovoid and smoothly concave; the eyelid line is carved in prominent relief; a flat, sloping cheek is evident; and the lips are thick and broad. While the headdress frontlet illustrated in figure 22 represents a beaver, the face is handled essentially in a humanoid fashion with the exception of the nostrils and of course the incisor teeth.

Careful examination of the sculptural handling of facial elements on the rattle in figure 24 and two mountain goat horn spoons (figures 25 and 26), confirm the classic Haida forms as described for the headdress frontlet above.

Certain Northwest Coast artists felt challenged to explore the relationship

between sculpture and flat design. In a few exceptional examples, the two are subtly combined and may introduce another favourite device, *visual punning* or *double meaning*. The animal-form bowl, illustrated in figure 27 serves as an example. The heads at either end of this bowl display all the characteristics of Haida sculpture. But the flat design field between the two must be considered, for the great accomplishment of this piece lies in its double meaning. If the eagle head on the left is obscured, the central u-shaped form is clearly a pectoral fin, sweeping back from the whale's head. However, if the whale's head is covered, the central design becomes an upswept eagle's wing, shown folded against the bird's body. Visual punning found in Northwest Coast art is frequently so obvious that the untrained viewer tends to see only the secondary meaning. In other examples, such as in figure 27 the intent is subtly hidden and the object demands the careful and uninhibited attention of the observer to be fully discovered and understood.

TSIMSHIAN SCULPTURE

Tsimshian sculpture functions mainly as crest art and as such indicates the ancestry of the owner. Crests are displayed on totem poles, chief's staffs, and on frontlets—the carved wooden plaques which are part of elaborate dancing headdresses. More than six hundred Tsimshian crests have been recorded; many are variations on a single creature such as "Raven," "Prince Raven," "White Raven," "Raven of the Sky," "Super-

Figure 23. Haida totem poles at Ninstints village, 1901, C. F. Newcombe photo, PN 837.

natural Raven," "Raven of Copper," and so on.

Masks were common among the Tsimshian and were use in ceremonies called *naxnox*. Usually human in form, these masks were used to dramatize lineage-owned names which translate, for example, as "Proud," "Quarrelsome," "Liar," "Conceited Woman," "Mocking Others," "Lazy," and "Always Crying."

Figure 24. Haida rattle 9729.

Tsimshian sculpture is refined and sensitive, expressing a smoothly transitional flow between facial features. Eyebrows are arched and relatively thin. The forehead slopes back. The orbit is open and softly rounded, the eyelid is incised but lacks a defining line around the edges. As Holm (n.d.) describes it, "the upper cheek, forecheek and cheek planes intersect to form a truncated, rounded pyramid. The mouth is fairly wide and the lips thin. In many examples the chin is short from top to bottom, particularly on totem poles (figure 28) and some of the massive masks (figure 29). On flatter and smaller carvings (figures 30, 31, 32), sculptural form creates a serene countenance, indicating the artist is intimately aware of human anatomy. The stylized realism which results gives an impression of skin pulled tightly over muscle and bone.

NORTHERN KWAKIUTL SCULPTURE

Well-documented examples of Northern Kwakiutl sculpture are not widely represented in museum collections. Many surviving specimens were obtained in the community of Bella Bella, but this is only one of eight local villages which flourished in the 1850's.

Most Northern Kwakiutl humanoid masks were used in the ritual known as *dloowalakha* which roughly translates as "once-more-come-shining-down-from-heaven." In this ceremony, the performer, an individual of high rank, is believed to be taken into the heavens by spirits. When returned to earth, glistening with

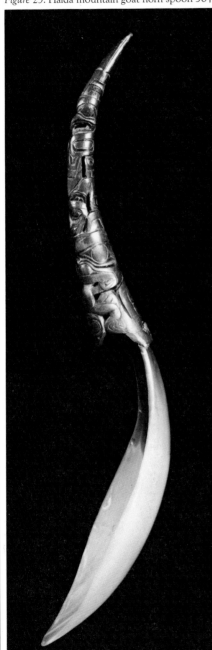

Figure 25. Haida mountain goat horn spoon 364.

a heavenly aura, he wears a mask representing the creature, often in human form, who lifted him into the sky. A variation of this dance survives widely among the Southern Kwakiutl.

Northern Kwakiutl humanoid sculpture incorporates elements used by surrounding tribes and naturalistic examples may be difficult to ascribe. Yet a typical Bella Bella model emerges; its distinctive features are illustrated in figure 33.

In this example the eyebrows are sharply angled, expanding towards the temple. The orbit is well defined and within it lies a large, rather flattened and leaf-shaped orb. Examples from this sub-school show a painted, not carved, eyelid line placed high in the orbit. Finally, the mouth projects noticeably forward and the upper lip arches prominently above an essentially horizontal lower lip.

BELLA COOLA SCULPTURE

The Bella Coola adapted to an inner coastal/riverine environment and assumed much of their ceremonialism from Kwakiutl neighbours. Most Bella Coola masking is concerned with a demonstration of animal and human ancestors who originate in various parts of the Bella Coola cosmology: the earth; two levels of sky; a land underground; and a land under sea.

Without question, a Kwakiutl influence pervades Bella Coola sculpture. Yet classic Bella Coola sculpture remains distinctive; in a single word, it is best described as "bulbous." The forehead

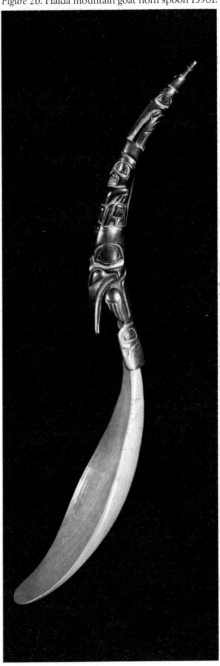

Figure 26. Haida mountain goat horn spoon 13981.

Figure 27. Haida animal form bowl 410.

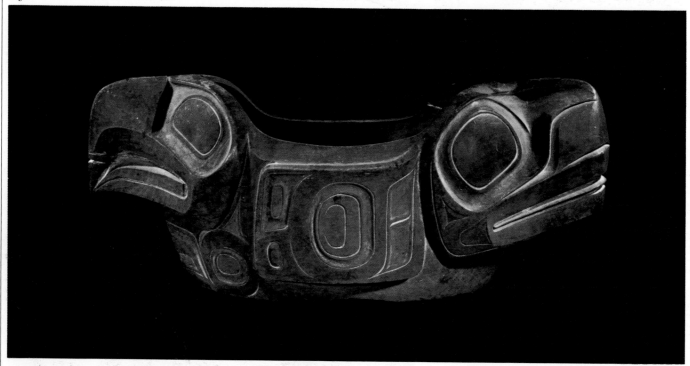

sweeps back sharply from heavy, projecting eyebrows which are moderately angled. A pronounced, leaf-shaped orb is evident with carved eyelid line defining rather small eyes on the upper half of this. Protruding lips are typical with upper and lower distinctly separate. Usually the chin recedes, almost to the point of being non-existent. Surface painting consists of solid u-forms both following and crossing carved planes. The triangular areas between the u-forms are often painted white and may distract the unwary viewer into considering them positive elements rather than negative space, as in figure 34. That these conventions were repeated in monumental sculpture can be seen in figure 35.

SOUTHERN KWAKIUTL SCULPTURE

Dance dramas achieved their ultimate theatrical expression among the Southern Kwakiutl. A huge assemblage of masks, rattles, drums, painted screens, and mechanical devices are used with magical effects in the flickering light of crackling fires. The important dance series is the *tséyka* or Red Cedar Bark Dance in which performers re-enact the adventures of Bákhbakwalanooksiwey, a ferocious cannibal spirit, and his voracious retinue of human-eating birds. The central performer is the *hamatsa* or cannibal dancer who, after a long and sequestered initiation, returns to society inspired by the cannibal monster. Initially in a frenzy for human flesh, the hamatsa is, in time, tamed to near normalcy by healing attendants.

Following the appearance of the cannibal dancer, masked performers representing various mythical birds of heaven enter the ritually cleansed dance house to indicate their association with the hamatsa. Dances in this series are ranked: those of lesser order follow, many employing masks or theatrical props. Paraphernalia associated with the tseyka have red cedar bark attached to indicate the sacred quality of this material.

Separate from the tséyka is a secular dance series, the *tlásulá*. Similar to the Northern Kwakiutl dloowalalakha the tlásulá features a dancer in chiefly regalia who suddenly rushes from the dance house. Attendants follow the performer outside, then return holding his headdress and dancing blanket in hand. They announce that their chief has been spirited away. In time another performer enters the house, his mask representing the creature or animal who transported the original dancer away.

Southern Kwakiutl sculpture is easily distinguished and evolved to what can be considered its classic form in the late nineteenth century. Heavy eyebrows, an angular orbit and well-defined orb represented as a truncated cone, characterize this art. The eye dominates the orb; pupil and eyelid line are accented by engraved cuts. Prominent nostrils, a stylized mouth with continuous lips and a minimal chin, complete the major sculptural features. Most noticeable is the use of paint, usually covering all surfaces. Separate colours define anatomical features such as eyesockets, cheeks and temples, and are confined to these. The painted eye with eccentric pupil is especially distinctive of Southern Kwakiutl painting on sculpture. The tséyka rattle shown as figure 36 illustrates all the above characteristics, while the majority of them may be found also on the tlásulá sun transformation mask, figure 37. The classic Southern Kwakiutl sculptural forms are also clearly seen on the totem poles illustrated in figure 38.

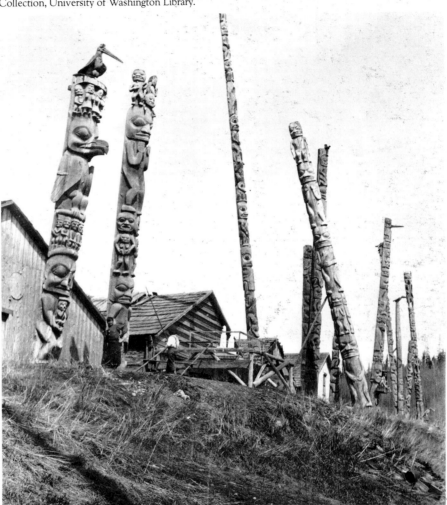

Figure 28. Tsimshian totem poles at Kitwancool village, G. T. Emmons photo, 1910, Photography Collection, University of Washington Library.

WESTCOAST SCULPTURE

The focal Westcoast ritual is the *tloquana*, which dramatizes the capture of initiates by wolves. In time, participants who have been spirited away return from a supernatural state and are pacified. The majority of masks associated with this depict wolves, mythical serpents, and the like. Humanoid masks appear to be used on ceremonial occasions where they represent ancestors.

Figure 29. Tsimshian mask 14308.

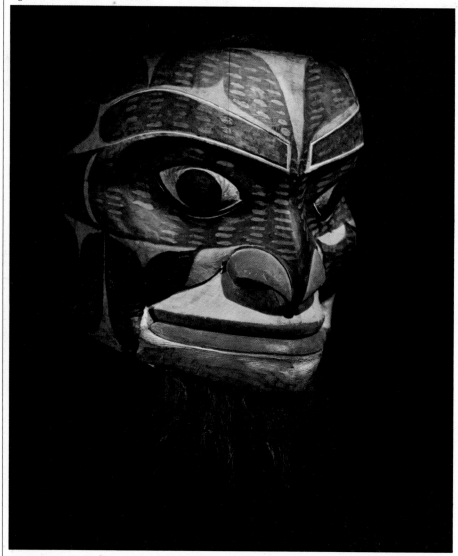

slightly swelling plane sweeps down to the mouth. The latter is placed well back from a prominent nose and the chin and lower jaw are minimal. Disparate geometric designs painted on the face as shown in figure 39 were favoured in this period. While somewhat flattened, the human face on the totem pole illustrated in figure 40 shows these same conventions.

COAST SALISH SCULPTURE

Coast Salish sculpture is confined to a few houseposts, grave markers and one class of mask. Humanoid faces are most clearly represented in monumental sculpture as shown in the housepost illustrated by figure 41. The pommel on the rattle handle, illustrated in figure 20 also provides an example. The flat, frontal alignment of forehead and cheek planes make this style easy to distinguish. Eyebrows show little arching and eyes are small with roughly engraved eyelid lines. The relationship between this and very low relief modelling on essentially flat surfaces as seen in figure 19 should be noted.

Sxwayxwey masks, as illustrated by figure 42, were used by the Coast Salish at life-crises rites: during the bestowal of names, at births, marriages and deaths.

An archaic sculptural tradition known as Old Wakashan is considered common to the linguistically-related Westcoast and Southern Kwakiutl people, but this style began to diverge early in the nineteenth century. Later, Westcoast sculpture assumed a classic form that is easily identified. In cross section, a humanoid mask is triangular; viewed directly, two vertical planes recede from a central axis. While the eyebrow is pronounced, no eyesocket is distinguished so that a flat,

Figure 30. Tsimshian mask 9694.

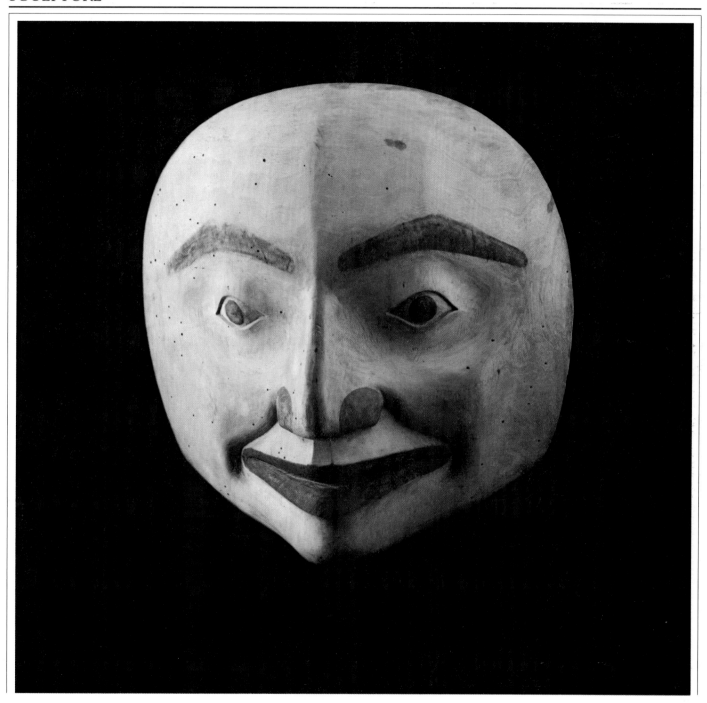

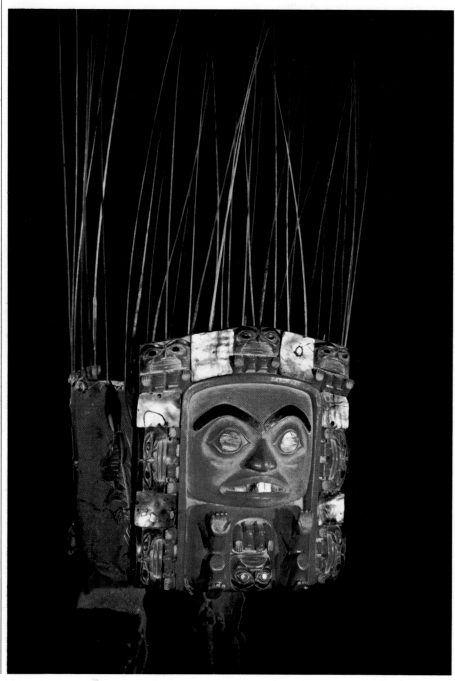

While the protruding cylindrical eyes set these masks apart from the typical sculpture described above, the remaining elements conform to the basic frontal alignment of planes. This example is additionally interesting, incorporating as it does, a secondary figure, parts of which are expressed both sculpturally and two-dimensionally to provide subtle double-meaning. Expressed explicitly, the "nose" of the main figure is also the head of a bird. As such, nostrils become eyes, eye-brows transform into a bilaterally split body to which legs and feet are attached. Five upright lines in the centre forehead represent the tail while similarly rendered elements on either temple signify wings.

Figure 31. Tsimshian frontlet 14310.

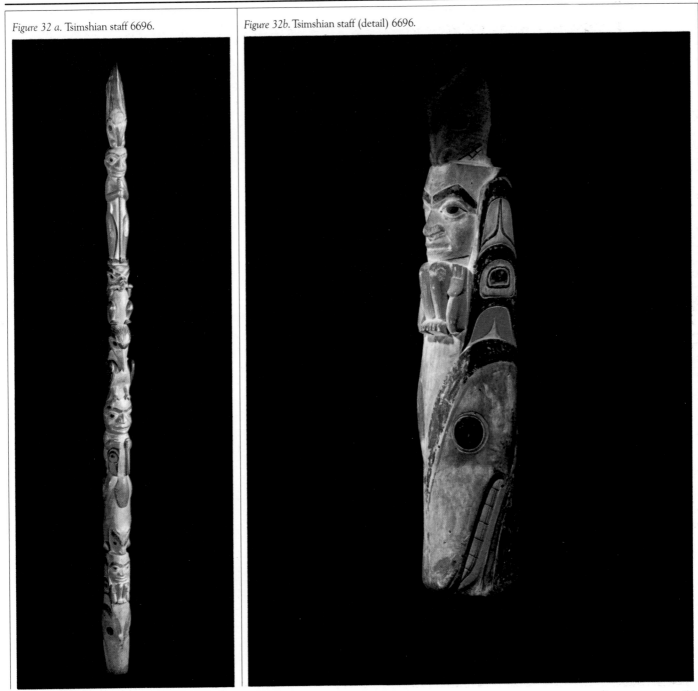

Figure 32 a. Tsimshian staff 6696.

Figure 32b. Tsimshian staff (detail) 6696.

Figure 33. Northern Kwakiutl mask 72.

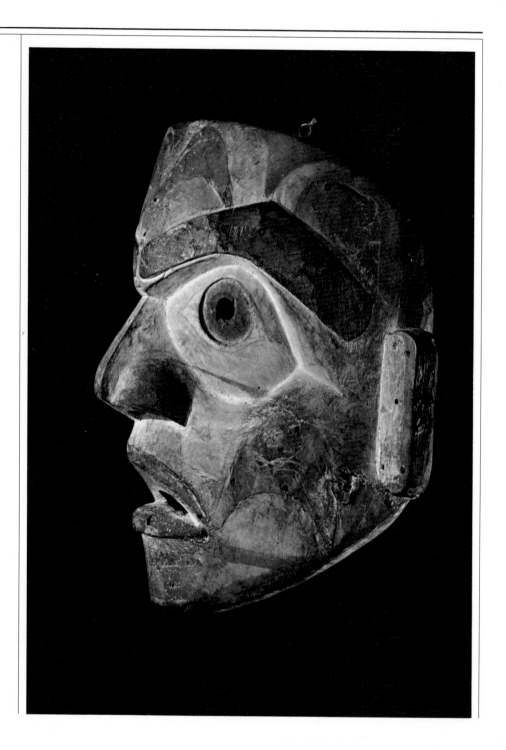

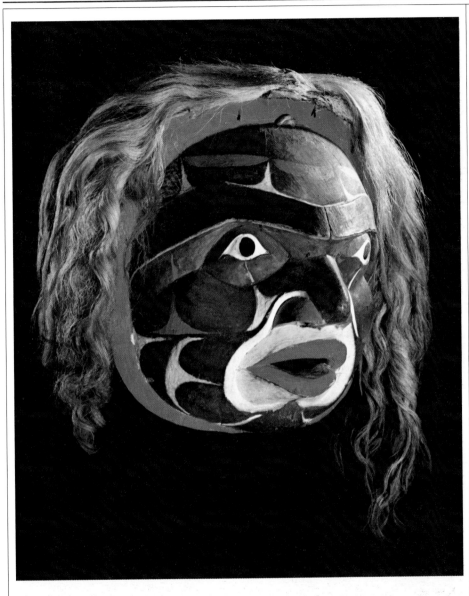

Figure 34. Bella Coola mask 2321.

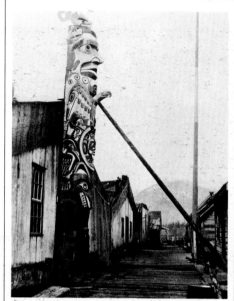

Figure 35. Bella Coola house front pole, PN 4571.

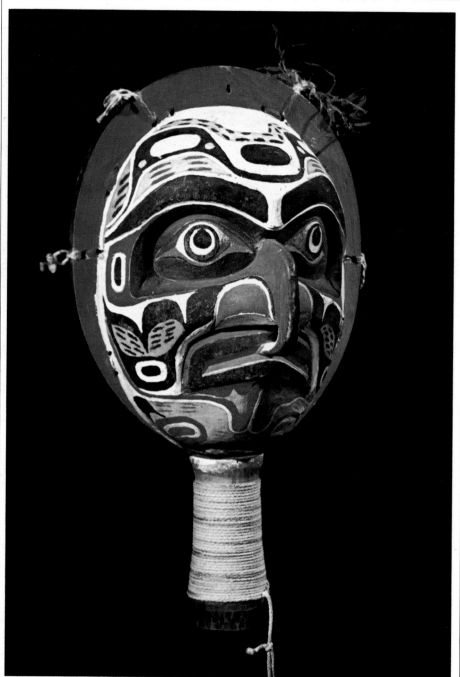

Figure 36. Southern Kwakiutl rattle 1924.

Figure 37. Southern Kwakiutl mask 1908.

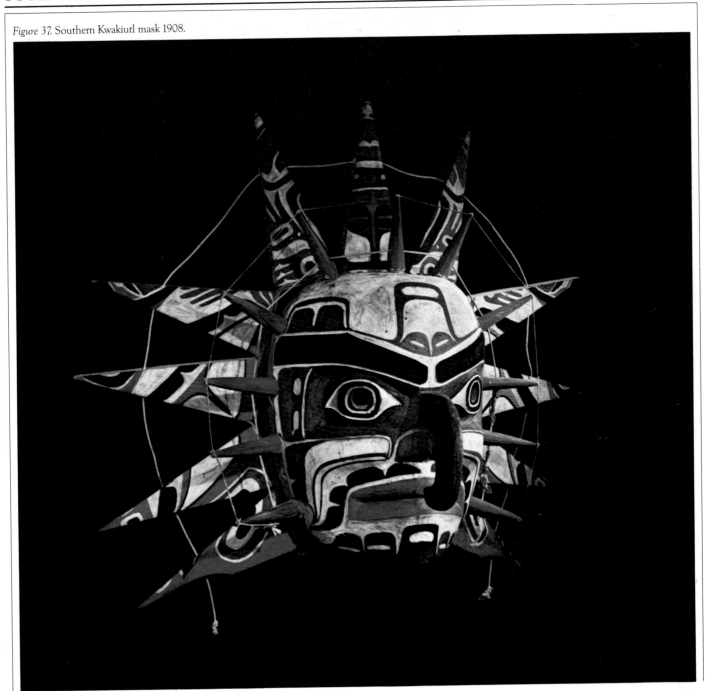

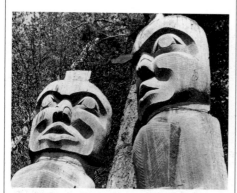

Figure 38. Southern Kwakiutl inside house poles at Gwayasdums village, W. Duff photo, 1955, PN 2151.

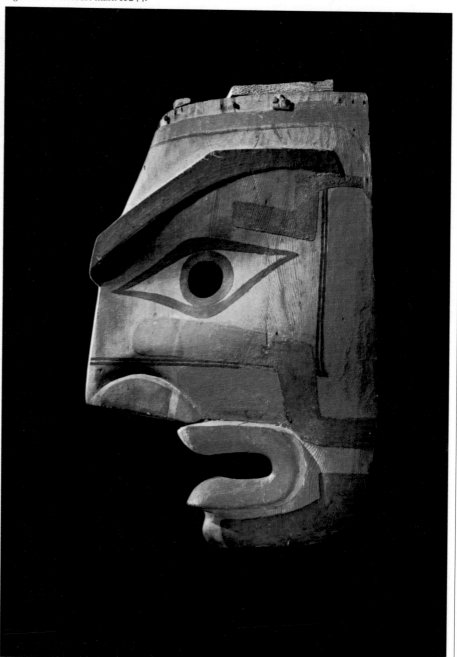

Figure 39. Westcoast mask 10244.

Figure 40. Westcoast house pole at a Clayoquot Sound village, C. F. Newcombe photo, 1903, PN 534.

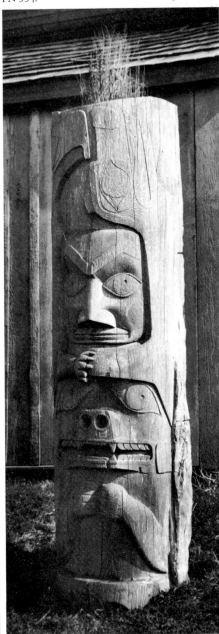

Figure 41. Coast Salish housepost at Quamichan village, Trio Crocker photo, PN 11742.

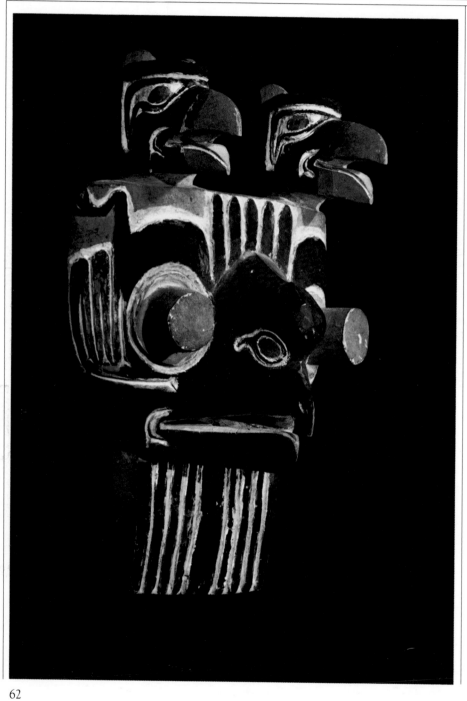

Figure 42. Coast Salish Sxwayxwey mask 2364.

THE LEGACY PART FOUR

Peter L. Macnair

ART AND ARTISTS IN A CHANGING SOCIETY

ART AND ARTISTS IN A CHANGING SOCIETY

Early visitors to the Pacific northwest coast were intrigued by the material culture of the indigenous inhabitants and sought to acquire "artificial curiosities" as mementos of their contact with exotic peoples. Initially, all objects acquired in trade were in use prior to disposal. However as time passed, the demand for souvenirs became so great that native artists began to produce items for direct sale to the white man. Some of these were simply newly made examples of objects which otherwise could have been put to customary use. Others had no function in native society; these were models and curio items, many made from non-traditional materials. Most models and curio items were made by artists fully aware of the structure of sculpture and flat design. However a few early pieces exhibit little understanding of form, suggesting that either apprentices or non-artists were responding to the new market.

Carvings in argillite were among the first and most enduring of Northwest Coast artforms produced exclusively for sale. Popularly called "slate," argillite is a dense black carbonaceous shale found on Slatechuck Creek on the Queen Charlotte Islands. In traditional times its use was the exclusive prerogative of the Haida people and continues to be so today. It has long been believed that argillite hardens upon exposure to air. This is not the case; artists who have recarved parts of century-old examples while undertaking restorations claim the old slate is no harder than that freshly quarried. The confusion seems to result from the fact that newly collected argillite may have a high water content and drying must be carefully controlled to prevent splitting. But the degree of moisture within a given piece of unworked slate appears to have no significant effect on relative hardness.

While there is some evidence that argillite was utilized prior to European contact, it was only after 1820 that it was worked in significant amounts. Virtually all works in this medium were produced for exchange – either by trade or sale. The subject and format of the carvings changed during the ensuing decades, in part as a response to buyer demand, in part as a reflection of pressures on Haida society, introduced religion, and political structure, being the significant examples.

For the first ten or so years of production, most carvings were of pipes ranging in shape from oval to horizontally elongate. The latter are called "panel pipes," a term which reflects their basic form. The dominant images on panel pipes from this period (1820-1835) are skilfully intertwined creatures from the Haida cosmos.

An easily recognized figure on the panel pipe illustrated in figure 43 is a whale with a raven on its back. This is Raven-fin, a mythical killer whale who, in ancient times, was transformed from a yew wood carving. While Raven-fin

Figure 43. Haida argillite panel pipe 14677.

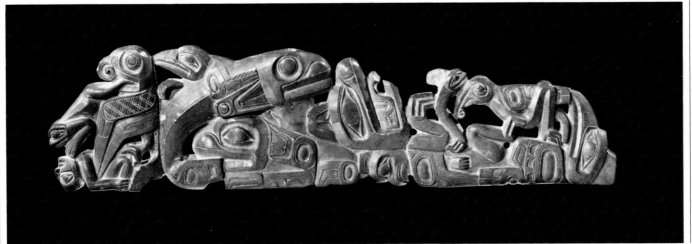

65

Figure 44. Haida model canoe 10598.

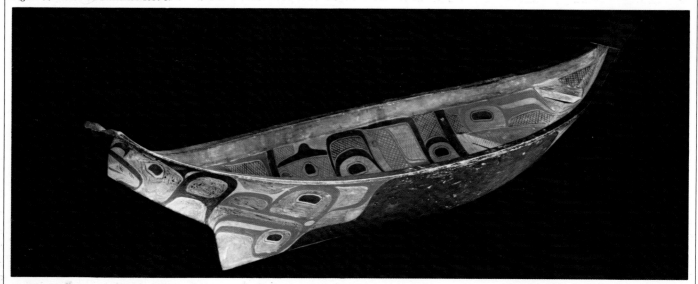

figures in legend, it also is a crest of the Raven clan and, as such, appears on totem poles and memorial carvings. It is probable that creatures depicted on commercial articles represent mythical episodes rather than personal crests. Also familiar on panel pipes from this period are insects. The first figure to the left of Raven-fin is considered to represent a butterfly. The coiled proboscis suggests this, as does the cross-hatching connoting wing scales. It must be noted entomological accuracy is not demanded of the Haida artist as can be seen in the rendering of the insect in the upper right of this carving. A grasshopper is intended, indicated by the large jumping leg. The wings are folded against the body and a proboscis extends from the head. It is here that the artist has taken some licence; grasshoppers have mandibles rather than proboscises. The latter is a visual indicator of "insect" rather than a strict anatomical representation of a given species.

Most argillite carvings produced in the 1820's were made by artists fully versed in classic Haida artforms. This can readily be seen in the panel pipe and is illustrated by the raised eyelid lines, concave eyesockets and dominant eyebrows. Both sculptural and two-dimensional elements conform to the strict and formal rules of Haida art.

Although they contained a hollowed bowl and drilled stem, most argillite pipes were not intended for smoking. They were simply aesthetically pleasing objects produced for sale. In precontact times the Haida cultivated a tobacco variety assumed to be *Nicotiana quadrivalvius.* This they chewed, preparing a mixture by first crushing tobacco leaves in a mortar and then adding lime from burnt clamshells. Commercial tobacco was introduced by Europeans at which time the Haida began to smoke, using clay trade pipes.

Probably as a result of buyer demand, the subject and format of argillite carvings began to change. By 1835 the panel pipe form was still in vogue but the familiar Haida figures were largely replaced by representations of the white man and his wondrous world. Ships, dogs, monkeys, horses, roosters, clothing, implements, fences, cabins, blockhouses, even the manners of the white man, were recorded with wry humour and astute insight. Other forms followed: plates, single vertical figures, clay pipe forms, and, by 1865, the ubiquitous model totem pole. By the end of the century, the model totem pole came to typify the art of argillite carving.

The production of models and replicas was another response to the market.

Models were especially popular because, in them, travellers were able to acquire accurate renderings of larger works which were unobtainable and difficult to describe. No doubt visiting seafarers admired and appreciated the form and seaworthy properties of the native dugout canoe; therefore, model canoes were valued souvenirs. In the example shown in figure 44 we can appreciate that its creator had an intimate knowledge of the form of the full-sized vessel. He was also a skilled artist, applying a masterly two-dimensional design, parts of which demonstrate the reversal of formline colour.

Figure 45. Haida settee attributed to Charles Edensaw, 1296.

The above two examples were produced for sale or trade by artists with an accomplished understanding of classic art forms. There can be no doubt that these artists produced items for ceremonial use as well as these charming objects for sale. While a distinctive personal style is evident in both the argillite panel pipe and the model canoe, their creators remain anonymous. However, as the nineteenth century drew to a close, certain well-known artists achieved reputations that spread beyond their own societies. In part this was because anthropologists and museum collectors were acquiring representative material culture in a systematic, scientific manner, recording the material, usage, and native terms for artifacts so obtained.

Certain master artists and craftspeople became important informants for these collectors, providing details of manufacture and use. As the work of these informants was frequently purchased, especially where models, copies or type examples were required, they quickly achieved renown outside their own village.

One of the first Haida artists to acquire an international reputation was Charles Edensaw (Tahaygen). Born at Skidegate about 1839, he eventually settled in Masset and succeeded his maternal uncle there. We know he reached artistic maturity before the Haida were fully Christianized and he must have created many traditional objects. Unfortunately few of his ceremonial pieces have sur-

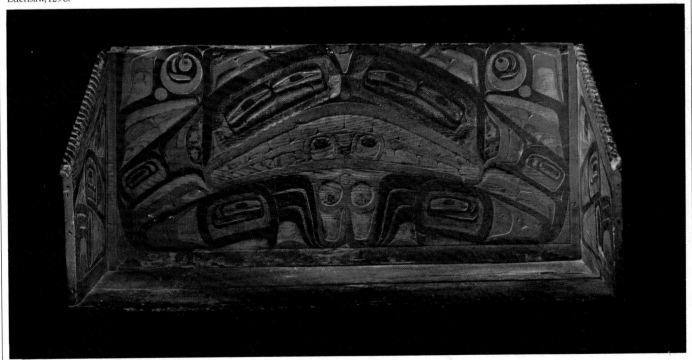

vived or have been positively identified. Edensaw's fame comes mainly from his work in non-traditional media: silver, gold and argillite. His work and reputation must be considered very carefully, for much of it, especially his two-dimensional design, is unique. Because of its innovative qualities, it is difficult to compare his work with that of his contemporaries and even with that of his traditional forebears. But it must be remembered that most of his identified output was produced for sale to non-Indians. It was in this context that Edensaw established his reputation. Collectors and anthropologists sought his work, in particular, when they recognized his authority on Haida art and culture.

Edensaw produced a series of crayon drawings and model houses and poles in wood, many of which are illustrated in John R. Swanton's *Contributions to the Ethnology of the Haida*, the only significant study of these people. He assisted Franz Boas in the latter's attempt to understand flat design; Edensaw offered an explanation of the superbly conceived distributive design painted on the bent bowl in the collection of the American Museum of Natural History (AMNH catalogue number 19-1233) and described earlier on page 35. According to Edensaw the design represents four episodes in the Raven myth. While Boas willingly enough quotes Edensaw's interpretation in his pioneering work *Primitive Art*, he nonetheless claims the artist's explanation is "entirely fanciful" (1927:275). While Edensaw's translation may not be correct, the native artist at

least had an understanding of the form of the art. It is evident that, while Boas was struggling to comprehend the art at its greatest intellectual abstraction, he was unable to elicit clear information on meaning because he had not fully mastered an understanding of form.

The chief's settee shown in figure 45 is offered as an attributed example of Edensaw's work which was made for native use. It was collected by C. F. Newcombe in 1900 from "Chief Edensaw of Masset" and was recorded as representing the Frog crest. There are elements in this design which suggest Edensaw's hand, especially when they appear together as in this example. The notable indicators include the perfectly circular salmon-trout's-heads near the upper corners on the back panel, the salmon-trout ovoids without a mouth within the shoulder and hip formline ovoids, and the profile faces on the upper inside corner of each side panel. All of these are Edensaw trade marks and when they appear in combination on a single piece, they strongly suggest Edensaw's personal style. Also, it should be noted that the formline mouth of the main creature is red, even though it flows directly from the rest of the primary formline design rendered in black. This breaking of the rule is also consistent with Edensaw's individual repertoire; several frogs and at least one sculpin painted on spruce-root hats by Edensaw also have red primary formline mouths as part of an overall black formline rendering.

Two major problems remain in the identification of this settee; both result from the fact that Newcombe's original field

notes on the piece have not survived. The catalogue entry by Newcombe indicates the seat was collected from "Chief Edensaw," but which Edensaw is not specified. In all probability this refers to Charles Edensaw for he was the only Masset chief by the name of Edensaw in 1900. More problematical is the design; Newcombe describes it as a frog and this indeed was one of Edensaw's principal crests. But it is not easy to see this as a frog, given the prominent teeth and the u-form ears. Whatever the design, there remains good stylistic evidence that this is a work produced by Edensaw, probably before 1880.

Edensaw's characteristic personal style is much easier to distinguish in objects made of precious metal and argillite. During the latter part of his career he preferred these materials. At this time his innovative genius came to full fruition. The best indicators of his personal style are seen in flat design and, as most of his sculpture includes graphic elements, it is not difficult to find Edensaw attributes if they are present, on either two- or three-dimensional objects.

The definitive analysis of the characteristics of Edensaw's two-dimensional design appear in an unpublished paper, *What Makes an "Edensaw"? (2-D Version)* produced by Bill Holm in 1967. The silver bracelet in figure 46 illustrates the maturing, highly developed style of the great Haida artist, and some of the distinctive features of his engraved designs are found in this example.

Applying Holm's definitions of Edensaw's style to this bracelet, it can be noted

Figure 46. Haida silver bracelet, Charles Edensaw, 9523

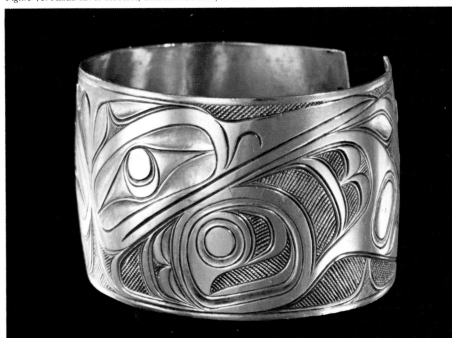

that the form lines are non-angular and are medium to narrow in weight; ovoids are flat or convex on the bottom; double engraved lines are prevalent; stacked u-forms with double inner u's are common. These attributes combine to produce a bold, flowing, and detailed engraved design, which surpasses all examples produced by Edensaw's peers.

Silver bracelets were made from coins, American silver dollars being the preferred alloy of Indian metalsmiths. The coins were heated, hammered into blanks, and then engraved with tools fashioned by the artist. Some authorities claim silver jewelry was made as early as 1800 although there is no hard evidence for this date. By 1880 silversmithing was certainly well established as an art

and observers remarked that the Haida were the undisputed masters of this craft.

Two silver bracelets in the National Museum of Man, Ottawa, (NMM catalogue numbers VII-B-103 a & b), collected in 1879, are undoubtedly from the hand of Charles Edensaw. One of these, VII-B-103b, is somewhat stiffer and simpler than the other, suggesting an earlier style and thus establishing Edensaw's use of the metal well before 1880.

Edensaw was so prolific, and jewelry such as his was so much in demand, that his bracelets were exchanged along the coast from Alaska to Vancouver Island. Tsimshian and Southern Kwakiutl artists copied his designs. His personal

nuances were often lost in the replicas, yet enough of his innovative and personal details survive in the imitations to enable us to say with certainty that they developed from Edensaw prototypes.

But this Haida master's main medium was argillite. Bowls, plates, compotes, boxes, model houses, single figures and model poles, were all produced by Edensaw from the lustrous black slate. Of these, the model poles are most common. Haida slate carvers introduced model poles about 1865; the early examples were accurate copies of large wooden poles that were part of Haida architecture. Like the monumental sculpture in figure 23, the replicas were half-cylinders in cross section, demonstrated one-to-one proportion of head to body, incorporated all of the classic elements of facial sculpture and exhibited flat, stylized appendages. As the century progressed argillite poles became more three-dimensional in form as we can see in the Edensaw example in figure 47.

If the major faces on this pole (raven, humanoid hawk, whale, bear) are studied carefully, they demonstrate the classic characteristics of columnar Haida sculpture as illustrated by figures 23, 25, 26. However there is a roundness and depth to them not seen in the older examples. Areas with two-dimensional designs feature classic Edensaw devices which can be compared with similar elements on the silver bracelet in figure 46. Distinctive are the weight of the rounded formlines; the flat-bottomed ovoids; and the double engraved lines. The wing of the humanoid hawk, folded

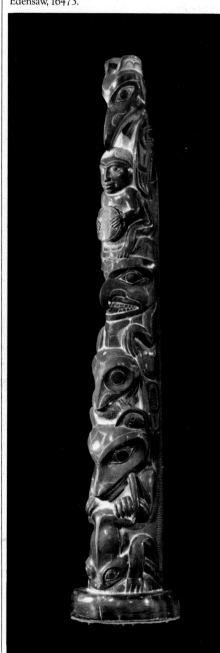

Figure 47. Haida argillite totem pole, Charles Edensaw, 16473.

under and below the creature's arms, is similar to the handling of the stacked u-forms with the double inner u's on the silver bracelet in figure 46.

There are other qualities about Edensaw's work which are difficult to define and describe. Yet, if all the faces on this pole are studied carefully, each can be seen to have an innate character–a vigour and personality seldom found on argillite poles made by most other artists. This depth of expression perhaps reflects the dilemma and tragedy Edensaw must have faced. In his lifetime the Haida were reduced to a low of 588 souls from the estimated 6000 alive at his birth. The onerous task of leaving a testimony to the past and a legacy for the future surely weighed heavily on him. The flowering of his art perhaps reflects the intensity of his feeling of loss. Little was he to know that his achievements stood to inspire a new generation of Haida artists some four decades after his death.

While Edensaw achieved paramount fame as an artist functioning in two societies, he had many peers, some of whose names and works have fortunately been recorded. Not all of these can be represented here, but one Masset contemporary, known as Charles Gwaytihl, produced a number of portrait masks and model figures of chiefs and shamans in wood. These are stylistically unique enough to warrant comment.

Gwaytihl's masks, some two dozen of which are found in various museum collections, are the epitome of realistic Haida portrait masks. Obviously derived from earlier nineteenth-century

examples, his sensitive representations of men and women, old and young, comprise a class of their own. Nearly all of his masks are articulated in some way; they are wonderfully crafted objects which include various movable eyes, eyelids, eyebrows, mouths, and lips. Obviously these were not made for use; the inside rigging of the changeable elements clearly shows that his masks could not be worn comfortably and manipulted at the same time. As a result they remain isolated, a clear example of what was once a viable artistic and theatrical tradition, but which by 1880 had been forcibly reduced to an art for sale. Despite his skill in wood, there is no indication Gwaytihl worked in argillite, thus suggesting a strong and independent personality.

The sample of his work illustrated in figure 48 clearly demonstrates the naturalistic qualities he could achieve. Heightened expression was attained by the jointed eyes which move from left to right and the eyebrows of animal pelt (the hair of which has long since fallen off) which rise quizzically when manipulated by strings.

Facial painting was a traditional means of decoration and served to identify crest affiliation at feasts and potlatches. A feathered wing is suggested by the design applied to this mask. The neatly parted and combed hair is a familiar device in Gwaytihl's art but the fact that it is painted brown intrigues many viewers and causes them to conclude the mask represents a white man. This may be the case but if so, one has to assume the outsider was accepted into Haida

Figure 48. Haida portrait mask, Gwaytihl, 10665.

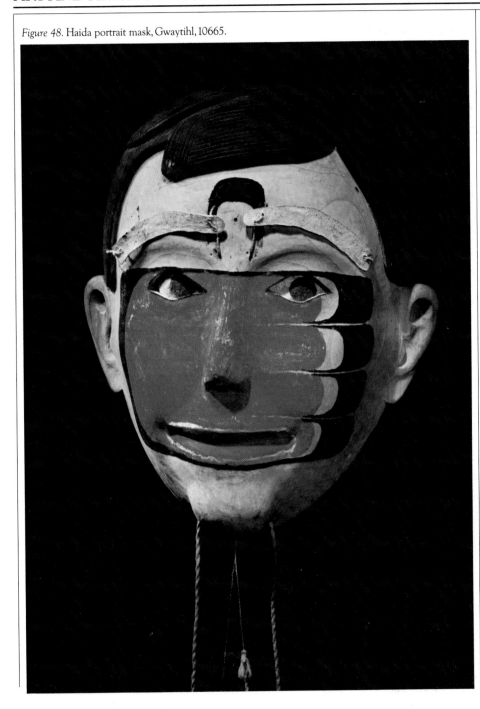

society, given the traditional facial decoration.

One limitation of this presentation which indicates both a shortcoming in Northwest Coast scholarship and historical accident is that named artists working in a traditional context have not emerged for all tribal groups on the Northwest Coast. It is assumed that as museum and archival records are examined carefully, names of specific Tlingit, Tsimshian, Bella Bella, Bella Coola, Westcoast and possibly Coast Salish artists will be revealed. In fact names and works of artists from these groups have recently been tentatively identified. Unfortunately no such individuals and objects have yet clearly emerged in the British Columbia Provincial Museum collection. As such, the work, both traditional and commercial, of named individuals from the above tribes cannot be presented here. One group remains, the Southern Kwakiutl, whose artistic and ceremonial traditions were continuously maintained, producing known artists who operated in both a traditional and commercial context.

The Southern Kwakiutl are perhaps unique among Northwest Coast groups in that they openly and steadfastly resisted attempts by authorities to alienate them from their traditional culture. Admittedly certain other tribes had some success in retaining the old ways but artistically at least, the Southern Kwakiutl were the most successful. Their fierce determination ensured the survival of the potlatch, despite tremendous pressure from authorities. As a result their art remained viable as did the

Figure 49. Southern Kwakiutl totem pole at Kalokwis village, carved by Charlie James, F. J. Barrow photo, 1933 or 1934, PN 1960.

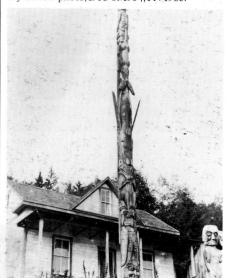

role of the artist in traditional society. More than two dozen Southern Kwakiutl artists who practiced when ceremony and ritual was at its zenith are still remembered and examples of their work identified. Three of these – Charlie

Figure 50. Southern Kwakiutl mask, Charlie James, 1954.

James, Mungo Martin, and Willie Seaweed – have been selected to represent this group. They all received training under the traditional apprenticeship system. Pupils under this system were usually selected because they were sons or nephews of established artists. They were encouraged from a young age to assist in the creation of masks, poles and other large objects. Obviously their early work reflected the style of their mentors but with artistic maturity came the need to handle carved and painted elements in a way that was personal and distinctive. This need now permits us to identify or attribute individual styles.

While Charlie James, Mungo Martin and Willie Seaweed were contemporaries, Charlie James (about 1868-1938) was the first to establish a reputation, both among and outside his people. His early work was produced for native use and included the entire range of ceremonial objects an artist might be expected to produce. A totem pole (figure 49) erected at the village of Kalokwis before 1910 is clearly his work. The Sísioohl

mask shown in figure 50 was collected from him and attributed to his hand. Interestingly, this mask is seen in a photograph taken in Alert Bay in 1912 (figure 51), demonstrating the importance of photographs in tracing the history of artifacts. The form and painted style of this mask is reminiscent of that shown on the totem pole in figure 49.

The last two or three decades of James' life seem given to producing art for sale and during this period he created literally hundreds of model poles which he sold to visitors. The majority of these were carved from yellow cedar and adorned using poster paints. Sometimes a coat of shellac would complete the piece. Most of them were signed, using either his white man's name or, alternately, his Indian name, Yakuglas. He took shortcuts in finishing most of his models; only on a few of them did he bother to carve out the orbits and define the orbs as he has in figure 52. He is fondly remembered by his own people as a traditional artist but the impression most others have of him is

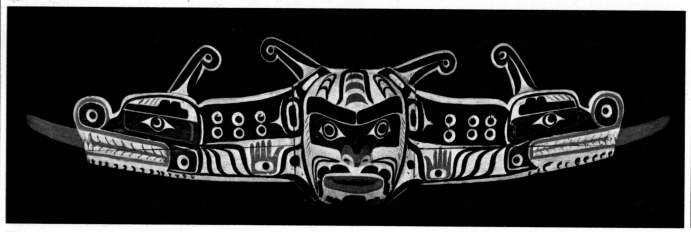

Figure 51. Interior of Southern Kwakiutl house at Alert Bay, W. M. Halliday photo, 1914, PN 2777.

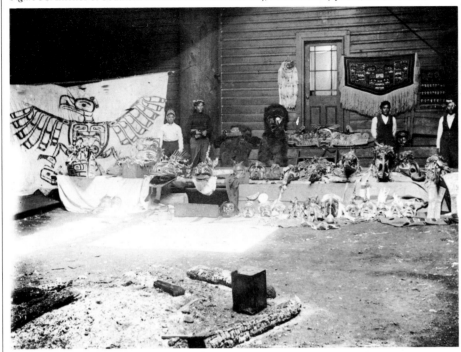

Figure 52. Southern Kwakiutl model totem pole, Charlie James, 6786.

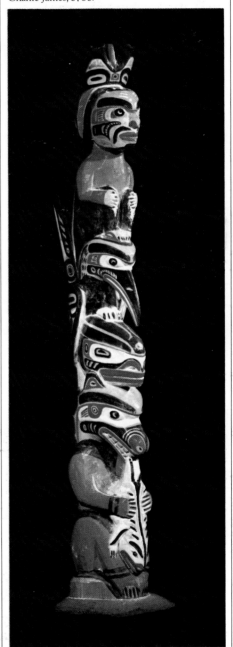

that he was a maker of curio items. A thorough study of his life and examination of museum records reveals that he was a legitimate artist who produced during the vigorous flowering of Southern Kwakiutl art.

Charlie James trained his stepson Mungo Martin (about 1881-1962) and the early work of the latter is difficult to distinguish from that of James. Martin was a man with a vast repertoire of songs, legends, arts, and knowledge, and was almost singularly responsible for the revival of Northwest Coast Indian art, for he brought it to wide public attention during the last two decades of his life.

About 1947 he travelled from his isolated home village of Fort Rupert to Vancouver, where, at the University of British Columbia, he oversaw the restoration of totem poles brought to that campus years earlier. In the seventh decade of his life he moved to Victoria where he was employed at the British Columbia Provincial Museum. Here he awakened a great public interest, constructing a new version of his traditional community house and creating and replicating more than two dozen totem poles.

He instructed several contemporary artists, many of whom went on to lead the contemporary revival. It can be said that the majority of artists represented in the following section were at least indirectly touched by his presence, for most of them in one way or another received

instruction from Mungo or his apprentices. In the 1920's, Mungo's stepfather Charlie James produced a series of paintings on paper which illustrated various Southern Kwakiutl legends. Rather crudely executed, they nonetheless indicate the artist was attempting a narrative expression for the commercial market. In the 1950's Mungo Martin revived this practice (see A. Hawthorn 1964:18-23), producing paintings such as that illustrated in figure 53. This depicts a mythical world beneath the sea in which land-based creatures could also exist. The beaked octopus, with sculpin above, are obviously inhabitants of the sea. But the Dzoonokwa carrying her child in a basket on her back is normally associated with the land. However, by painting fin-like elements on her temple and cheeks (compare these to similar designs on the octopus), the artist has conceived her as an ocean-dwelling counterpart of the more familiar Wild Woman of the Woods. This painting anticipates, in format and concept, the hundreds of silkscreen prints produced by contemporary Northwest Coast artists during

Figure 54. Southern Kwakiutl totem pole carved by Mungo Martin at Gwayasdums village, C. F. Newcombe photo, 1917, PN 42.

Figure 53. Southern Kwakiutl painting, Mungo Martin, 14501.

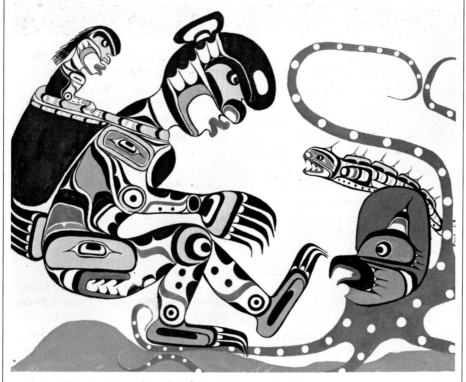

the 1970's. Again, this painting is a response to the commercial market. Mungo's output was limited, most of such renderings ending up in museum collections.

Mungo's career as an artist perhaps began before 1900. Around 1910 he carved his first totem pole, shown to the right of the community house in figure 54. The collector C. F. Newcombe noted that Mungo was a carver in 1914 and he is shown as the second man from the left in the 1912 photograph, figure 51. Appropriately, he holds an elbow adze in his hands.

One suspects that he adhered to the old rule of not producing things for his own use until very late in his career when he was living apart from his own people. A set of masks owned by him and representing the Animal Kingdom is

now in the collection of the British Columbia Provincial Museum. These masks are fully documented as to maker and none were carved by Mungo. Mungo had the right to nearly twice the number of masks represented in the collection but these were never made because he apparently could never afford to commission the remaining masks. This would appear to verify the traditional proscription of not making masks for one's own use.

However, these limitations were overlooked when Mungo was preparing for the opening of his ceremonial house, to be erected beside the Museum in Victoria (figure 55). He required a set of cannibal bird masks and chose to make his own, replacing those sold earlier. The complex Crooked Beak of Heaven mask, illustrated in figure 56, replaced one carved in 1938 for Mungo by the artist George Walkus (figure 57). The original was sold in 1948 and is now in the collection of the Denver Art Museum (see Feder 1965: colour plate 43). Whether Mungo worked from photographs or memory in creating his new version of the mask is uncertain. Whatever the case, in concept and detail the two are remarkably similar, indicating his willingness to subjugate some of his own design preferences. One noticeable change which indicates Mungo's personal choice is that his pupil is attached to the circle defining the iris. When painting both circular and ovoid eyes, Mungo consistently joined these which resulted in a bold relieving crescent in white within the eye. The nuances of eye construction are in fact

Figure 55. Mungo Martin house, Thunderbird Park, Victoria, PN 14437.

an important indicator for comparing the work of Mungo Martin's contemporaries. As will be seen, differences between them exist, with any given artist handling the form consistently throughout his mature career. Another characteristic of Mungo's work is that he preferred not to apply the red inner eyelid line. Incidentally the fact that the black eyelid line is not present on the small, rear-facing raven is not deliberate. We assume that in the rush to finish this mask, that line was simply neglected.

The most significant Southern Kwakiutl artist to emerge in this transitional period was Willie Seaweed, or Hiłamas, a Nakwaktokw chief from the village of Blunden Harbour. Born about 1873, he began to establish his reputation before the turn of the century working under the tutelage of his older half-brother Johnny Davis (Holm 1974). The few early examples of Seaweed's work

which have been identified reflect the restrained but admittedly changing Southern Kwakiutl style of the late nineteenth century. His name bears no connection with the marine algae; it is a crude anglicization of a Kwakwala word which translates literally as "Recipient of Paddling," implying that he is such a great chief that guests paddle from afar to attend his potlatches.

The Crooked Beak of Heaven mask shown in figure 58 was collected in 1914 and was made two or three years previously. Intended for the eventual use of Seaweed's new-born son, it has a special feature which allows rapid lifting and dropping of the brow to reveal flashes from a copper band concealed inside. This is an important example as the artist replaced it around 1930 (see figure 59), thus enabling us to note the development of his personal style over time.

Figure 56. Southern Kwakiutl cannibal bird mask, Mungo Martin, 9201.

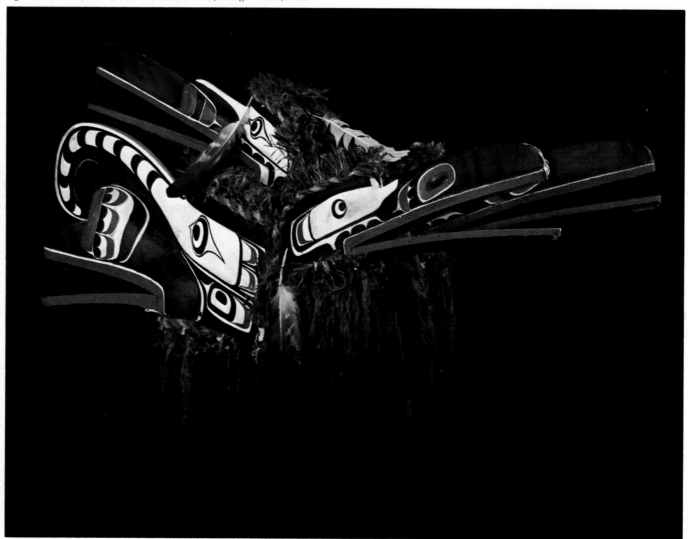

The matte finish of the early version (figure 58) suggests the artist prepared his own paint, adding graphite, vermilion and white pigments to a medium of fish egg oil. By 1930, Seaweed preferred commercial enamel paint which served to emphasize the sculptural planes and enhance the graphic effect (figure 59). In the latter example, the artist is more successful in concealing the articulated forehead element. In this mask, the break is at the eyebrow, making it impossible to detect until it is revealed in the dance.

A comparison of the structure of the eyes on both examples reveals Seaweed's personal preference in composing this detail. An outer black eyelid line surrounds an inner line in red. (In contrast, Mungo Martin did not include the red inner eyelid line as is evident in

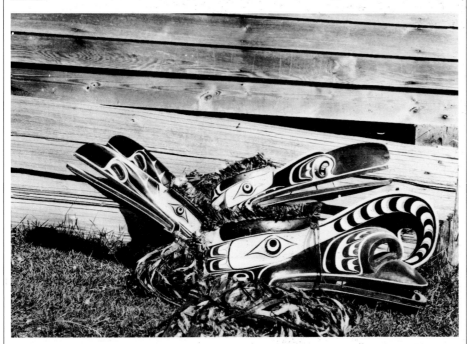

Figure 57. Southern Kwakiutl cannibal bird mask. Prototype of figure 56. Fort Rupert, C. M. Barbeau photo, 1947, NMC 103120-22, National Museum of Man.

figure 56.) Seaweed's eye consists of an eccentric pupil which does not touch the circle of the iris. Again this is in contrast with Martin's handling of this detail. Careful examination of the eye in figure 59 shows that it was constructed using a compass. Three compass points in a horizontal line are impressed into the wood; one provides the centre for the pupil while the other two are centres forming the inner and outer circles of the iris.

The compass became an important tool for Willie Seaweed; he used it not only to create eyes but also to incorporate other arcs and circles into his carvings. The three compass points are virtually a signature in Seaweed's mature work. While other Blunden Harbour and Smith Inlet contemporaries used the compass, none did so as consistently and for as long as Seaweed. Artists such as Mungo Martin spurned the compass; the eyes of his cannibal bird mask shown in figure 56 were obviously painted freehand.

As did his contemporaries, Seaweed produced the occasional non-traditional article for sale. The model totem pole shown in figure 60 exhibits his meticulous craftsmanship, despite the small size. The slight blockiness results from his starting with a piece of yellow cedar that was square in cross section. As with the full-sized poles he carved, Seaweed first painted this model white overall, permitting crisp, well-defined lines when the details were added using other colours.

Men like Willie Seaweed and Mungo Martin were not only skilled artists, they were high ranking chiefs who were fully committed to the potlatch. This required them to be orators, singers, composers, actors, and keepers of knowledge. Yet it is as artists that they are best known today, especially outside of Southern Kwakiutl society. And it was as artists that they were able to inspire a new generation of talent, one which has renewed an inheritance with equal artistic integrity.

The two-dimensional designs which flow so easily from the painter's brush were difficult to render in other media, yet women successfully and skillfully adapted certain of these to a woven format. Without question, the most spectacular examples are seen in the celebrated Chilkat blankets in which formline designs are reproduced using a sophisticated weaving technique that approaches tapestry. Basketry also allowed the weaver to experiment with graphic representation although this art forced a certain angularity of form.

Few weavers on the Northwest Coast became known by name but one West-coast basketmaker from the village of Opitsat, Mrs. Ellen Curley, achieved recognition far beyond her home. In 1904, she travelled to the St. Louis World's Fair where she demonstrated her basket weaving skills. Her trip was arranged by the museum collector

Figure 58. Southern Kwakiutl cannibal bird mask, Willie Seaweed, 1917.

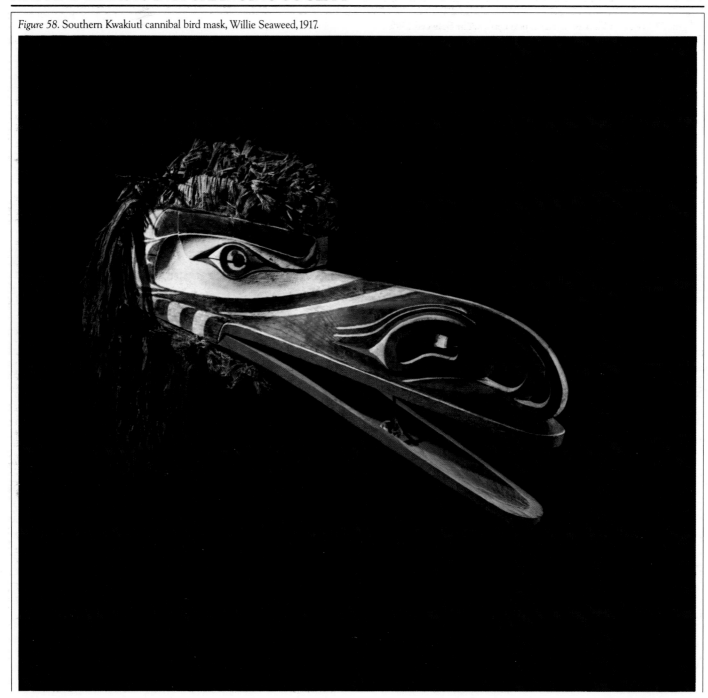

Figure 59. Southern Kwakiutl cannibal bird mask, Willie Seaweed, 15055.

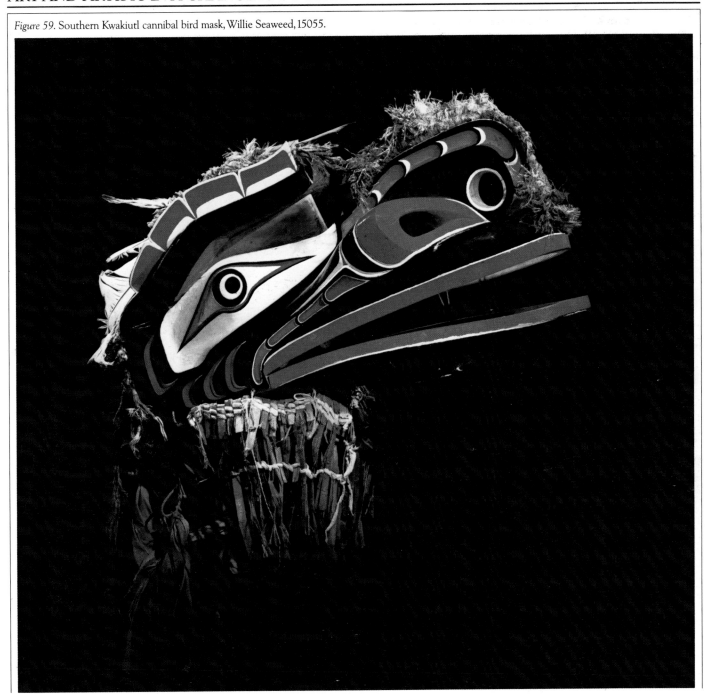

Figure 60. Southern Kwakiutl model totem pole, Willie Seaweed, 15807.

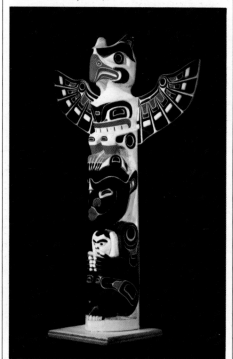

Figure 61. Westcoast whaler's hat, Ellen Curley, 9736.

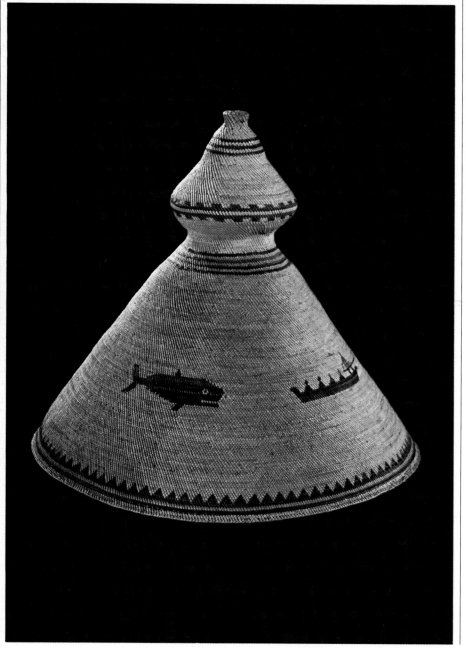

Dr. C. F. Newcombe and he later commissioned her to make a Westcoast whaler's hat for his personal collection (figure 61).

Hats such as these were worn by whaling chiefs, men like Maquinna (see figure 62) of Yuquot village who befriended both English and Spanish explorers in the late eighteenth century. The hat is conical and topped with an onion-shaped dome; the sides are decorated with scenes depicting a whale hunt. Despite the limitations of the format, both the narrative presentation and graphic rendering of the design are reminiscent of designs painted on ceremonial screens.

Figure 62. Spanish engraving featuring Westcoast chief Maquinna, from an original drawing by Tomás de Suria, 1791, PN 4806.

Indian artists in changing Northwest Coast society were subjected to many pressures. Those who practiced while native culture was still in ascendency had little to fear about the future of this sophisticated art. In fact they contributed to its further flowering because of the increased demand for their talents. But those who lived while both the art and the culture were in a state of decline bore a terrible burden. Obviously they recognized and appreciated the intellectual achievement of their art and knew that it reflected the splendour of their culture. Yet not all of them were able to place their knowledge and accomplishments into the hands of youthful successors. And not all of them were to know that in time the art would experience a rebirth and that through the art many aspects of traditional culture would be revived.

THE LEGACY PART FIVE

Peter L. Macnair

THE ART TODAY

Haida
Tahltan-Tlingit
Tsimshian
Southern Kwakiutl
Westcoast
Coast Salish

The legacy left by artists such as those mentioned in the previous section is one which has been variously nurtured among contemporary British Columbia Indian people. For most tribes, an awareness of the rules of the art was virtually lost. In a few cases craftsmen maintained a living tradition although at one point there was real doubt they would train a generation to succeed them. However a vital spark remained and, since 1950, a gradual rebirth has taken place.

Recognition of the contemporary Indian artist's importance and contribution has nevertheless been slow. Even those long committed to promotion and interpretation of the art have been hesitant to acknowledge it. In 1967 the Vancouver Art Gallery presented a major exhibit of Northwest Coast Indian art. Entitled "Arts of the Raven" it sought to present the material strictly as art (see Duff et al, 1967). Almost as a postscript to this exhibit, some thirty contemporary examples were included. These were produced by eight artists, only five of whom could claim British Columbia Indian heritage. Ironically the non-Indian participants were invited to create original pieces for the exhibit or personally select examples from among their best extant work. Two of the Indian artists, both of whom were actively participating in traditional culture at the time, were represented only by atypical curio carvings, hastily selected from museum storage shelves.

In the three years following the Arts of the Raven exhibit, several dozen young Indian artists emerged. There was a real need to publicise this growing talent so, in 1971, an earlier version of The Legacy including only contemporary works, was exhibited in the British Columbia Provincial Museum. In 1975-77, an updated version toured Canada. In the following years even greater advances took place. More artists came to the fore; a few who showed early promise faded from the scene.

Today at least two hundred Indian men and women are seriously practicing their art in British Columbia. Obviously all cannot be represented here. Certain criteria had to be established. All artists represented in this exhibit have ancestors who lived and participated in Northwest Coast Indian society. And all are artists who reached artistic maturity by clearly demonstrating that they understand and can execute the old forms of sculpture or two-dimensional design. And in most cases, they are artists who have significantly contributed to those aspects of surviving traditional culture which require the participation of art and artists.

HAIDA

As indicated earlier, the Haida were the first of the coastal tribes to produce an art for sale. The argillite panel pipes and many of the carvings which followed in this medium exhibit a complete understanding of classic sculpture and two-dimensional design. An integrity of form was maintained in this art until the 1880's because at the same time traditional art remained viable. But depopulation coupled with a conversion to the white man's lifestyle and religion resulted in a denial of all customary practices.

The last real Haida totem poles were carved and erected in the villages of Tanu and Skedans about 1878. From this point on, the creative instinct was assailed. The curio art, which continued to be encouraged by authorities, went into a rapid decline. Knowledgeable artists seemed reluctant or unable to pass on their talents and intellect. As a result, a true comprehension of the art disappeared by 1920.

Only recently have the conventions that define Haida art, both two-dimensional and sculptural, been rediscovered. The man who mastered its secrets and popularized it widely was Bill Reid. Born in 1920, it was not until the 1950's that he began to explore the form and meaning of Haida graphic art. Impressed with old jewelry worn by his Skidegate-born mother and aunts, he learned to engrave precious metal. His early bracelets, pendants, and brooches, were careful copies of extant designs, many of which were published in anthropological literature. Other important sources of inspiration were the works of Charles Edensaw, John Cross, and Charles Gladstone. As Reid's technique improved, he began to create original designs; these grew from hesitant explorations to fully knowledgeable expressions reflecting the formal rules that Bill Holm was to publish in 1965. Reid also experimented in wood and while he fashioned some unusual tools to work this material, he employed them to create the old forms in much the same way the traditional tools allowed.

Contemporary Indian artists are less restricted in their use of material, and

Figure 63. Haida screen, Bill Reid, 16639.

their exploration of subject and form, than were their precursors. Thus Reid recognized that what argillite panel pipe carvers achieved with their small and intimate forms (see figure 43) could be reinterpreted in wood and on a much larger scale. The result was a large screen carved from red cedar (figure 63) which incorporated the device of inter-twining figures employed by early slate carvers. However Reid's challenge was even greater than that of his forebears because he was working with a square rather than horizontal field and had to relate more figures to one another while maintaining a flow between them. Episodes from at least five mythic adventures are incorporated in his carving (see Appendix I, 16639), and while they can be identified discretely, together they form an integrated whole.

Reid's preferred medium is precious metal, however, and it is his work in silver and gold that has brought him most acclaim. Wishing to explore the limits of these metals, he studied European jewelry techniques and as a result introduced repoussé, chasing, soldering, and lost-wax casting to the technical repertoire of the contemporary Northwest Coast artist. All of these techniques are employed in his twenty-two carat gold box shown in figure 64.

Bill Reid's rediscovery of Haida art took place far from his mother's village of Skidegate. The bulk of portable material culture had long ago left the Queen Charlotte Islands, so it was in public and private collections that Reid had to

Figure 64. Haida gold box, Bill Reid, 13902.

find the work of his ancestors. But he was fortunate enough to visit some of the long-abandoned Haida villages where totem poles still stood, silent reminders of the vigorous and glorious past of a people decimated by fate. His debt to all of those whose end he has mourned in prose and art was more than adequately repaid in 1978 when he triumphantly erected a fine housefront pole in Skidegate village.

While Reid was always ready to share his knowledge, he had been practicing more than a decade before any aspiring Haida artist seriously sought his advice. The first to do so was Robert Davidson (born 1946). Davidson's early career was like that of many Haida craftsmen; he began carving argillite at a young age, instructed by his grandfather. Unfortunately, those working only in the black shale in the 1950's and 1960's had a limited repertoire and minimal understanding of classic artforms. As such, Davidson's work remained stunted until he met and apprenticed to Reid. Gradually Davidson came to understand form, first producing flat designs in silver modelled after the work of his great-grandfather Charles Edensaw. Since then Davidson has gone on to become a great innovator, his two-dimensional designs expressing the intellectual sharpness and controlled tension of the best of his precursors. His approach is one in which he seeks to "solve problems" presented by the graphic art and it is here that innovation flourishes.

A favourite image of Davidson's work is the dogfish. He has rendered this small

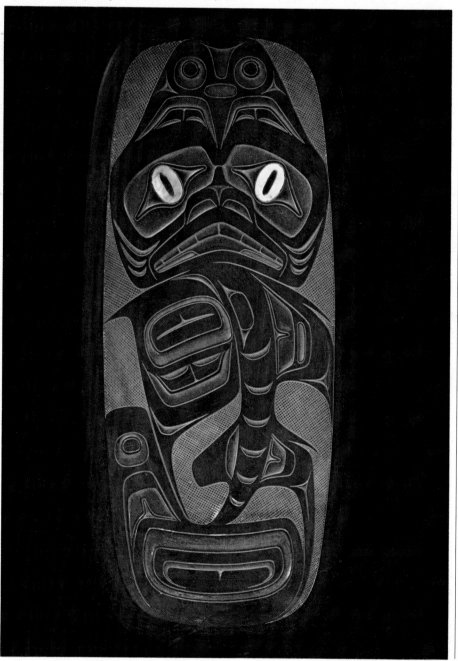

Figure 65. Haida argillite platter, Robert Davidson, 14529.

shark in many media, always with special feeling. His argillite platter (figure 65), produced in 1971, indicates the fine detail that can be achieved in this medium. Another expression of dogfish is seen in the mask illustrated in figure 66. Carved from alder, it incorporates all the classic features of Haida sculpture. Although the eyebrows, eyelid lines, nostrils, and lips, are rendered anthropomorphically, the stylized gill slits on the cheek, the triangular teeth, and the circular nostrils on the blunt forehead clearly indicate a shark. The artist has deliberately refrained from applying paint; traditional Haida sculpture usually made use of some colour, although its application was restrained, confined to highlight only certain anatomical details.

Davidson's artistic intellect is best featured in the silver bracelet shown in figure 67. In many ways it is an understatement, reduced to a few simple forms. Yet it represents a long and challenging process of experimentation with the absolute limits of Northern two-dimensional design. Entitled "whale," it conveys only the essence of this creature's head: the eye, snout and upper jaw with teeth. The head is repeated upside down and in reverse position, the two heads being separated by the cross-hatched s-form. As abbreviated as it is, the formlines express all the movement and contained tension that so characterizes the best of Northern flat design. An important feature of Davidson's personal style is the "soft" ovoid which forms the eye. It is convex on the bottom, contrary to the traditional rule. Edensaw was successful in rendering

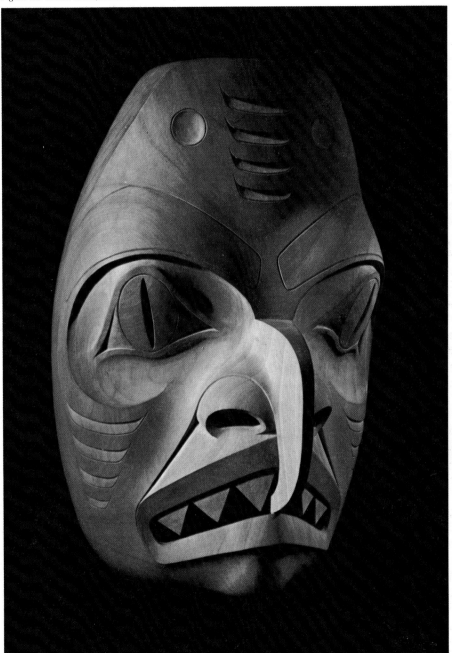

Figure 66. Haida mask, Robert Davidson, 15119.

Figure 67. Haida silver bracelet, Robert Davidson, 16601.

ovoids in this way (see figure 46). Only these two are truly effective with this form; others incorporating it, do so either inadvertently or because they have little understanding of the rules.

In 1969 Robert Davidson carved and erected a twelve-metre totem pole in his home village of Masset. This was the first significant pole to be raised on the Queen Charlotte Islands in nearly ninety years. The attendant ceremony, and others that were to follow in later years, called for the use of regalia, little of which was left among the Haida. As a result, Davidson produced a number of designs which were applied to blankets and outlined with buttons. Such an example was made by the artist's grandmother, Mrs. Florence Davidson, and is illustrated in figure 68.

Like many of his peers, Davidson has sought to contribute monumental works to his village to remind people that aspects of the ancient culture still live. The aforementioned pole is one example; another is seen in a memorial building (figure 69) constructed to honour the artist's great-grandfather Charles Edensaw. In designing this housefront, Davidson was inspired by the crest depicted on Edensaw's settee illustrated in figure 45. A comparison of the two indicates that Davidson has rearranged some of the elements while retaining the essential Edensaw design. It clearly demonstrates that the two-dimensional design can be reproduced comfortably on any scale.

While Reid and Davidson were pioneering a new understanding of two-dimensional design, one or two artists, working independently, were striving to get beyond the limited expression argillite carving fell to by 1920. The successful leader in re-establishing the integrity of argillite was Patrick McGuire of Skidegate, who died tragically in 1970. His pupil and successor was Pat Dixon, who continued McGuire's precision of engraving, understanding of classic sculptural forms, and highly polished finish, as is evident in the model argillite totem pole shown in figure 70. Although the carving has considerable character, its iconography is derived from an extant piece in the collection of the American Museum of Natural History, and copied from an illustration in Barbeau's *Haida Myths* (1953:287).

One of the few women carvers to emerge in the past decade is Freda Diesing. She was one of the first students at 'Ksan, a craft village located at Hazelton and described under the Tsimshian section which follows. She has gone on to play an important role as instructor, encouraging many young artists living in nothern coastal British Columbia. Her portrait mask (figure 71) incorporates many of the design features found on Haida humanoid masks collected in the early decades of the nineteenth century. It is assumed these represent facial paintings as applied to an individual's face during potlatch ceremonies.

The carving of gold and silver jewelry was maintained, after a fashion, among all coastal tribes throughout the twentieth century. But everywhere the designs degenerated as the rules of two-dimensional design were forgotten. Reid and

Davidson reintroduced the formal language of graphic art and all successful contemporary Haida practitioners are indebted to these two for their understanding of it.

Gerry Marks, who grew up in Vancouver, was introduced to an appreciation of Haida art by Bill Reid. He learned technique and some design from Reid but also studied formally under Freda Diesing and at the Kitanmax School of Northwest Coast Indian Art. Later he assisted Robert Davidson in the creation of the Edensaw memorial housefront (figure 69), and thus was influenced by Davidson. However, he has always attempted to achieve a distinctive, personal character in his work and this can be seen in his two silver bracelets. The bracelet produced in 1974 and shown in figure 72 indicates his interest in repoussé, a technique encouraged by Reid. At this point in Marks' career, the formline weight is relatively light and as such is reminiscent of older bracelets. His later work, (figure 73) completed in 1980, differs in a number of ways. The design is asymmetrical, no three-dimensional parts are included, and there is no hollowing on the tertiary area. But there is a notable change in the artist's style; the formline weight is much heavier. This later example reflects the current trend towards a more massive formline structure, a preference pioneered by Davidson in much of his engraved jewelry.

About 1880, the Haida began to carve circular plates and rectangular platters from argillite, decorating most of these with single crest figures. A few examples, especially those made by Edensaw, featured narrative designs. During the first two decades of the twentieth century, the production of plates continued sporadically, but these examples were generally smaller (20 to 40 centimetres in length) than earlier examples and had very pedestrian designs. Reg Davidson, brother of Robert, shows that argillite is receptive to good design and finish in the platter illustrated in figure 74. The design is slightly adapted from one produced as a silkscreen print by his fellow apprentice Don Yeomans. While argillite today remains very fashionable among certain collectors, there are few truly outstanding contemporary examples in this medium. This particular piece, as shown above, indicates the integrity of this medium at the hand of a knowledgeable craftsman.

Many present-day carvers limit their output to argillite because the material alone, for unwarranted reasons, has a magical reputation. Serious artists, genuinely interested in mastering the old sculptural and two-dimensional forms, have always turned to traditional material to escape the uncritical popularity of argillite. They are content to work the slate occasionally, producing fine pieces when they do, but they emphasize that real learning and understanding comes from fashioning wood. Reg Davidson's frog headdress (figure 75) exemplifies this. He felt a need to

Figure 68. Haida ceremonial blanket, Florence Davidson, 16607.

Figure 69. Charles Edensaw memorial house, Masset, Robert Davidson, PN 14438.

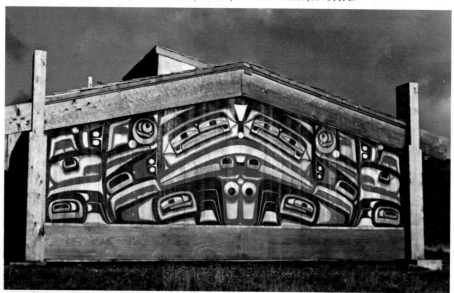

give his art meaning and as a result produced several headdresses for use in a celebration for the living Haida, sponsored mainly by his brother Robert in their home village of Masset during the 1980 spring solstice.

Another young Haida artist is Don Yeomans, born in 1958. His introduction to Northwest Coast art was through his aunt, Freda Diesing, with whom he studied in 1970-1971. In 1978 he assisted Robert Davidson in the carving of inside houseposts for the Edensaw memorial house at Masset. Yeoman's silver bracelet (figure 76) indicates a growing tendency among contemporary artists to apply a single profile design rather than the bilaterally symmetrical design which so characterized traditional jewelry (figure 46). Representation of a single figure in profile was pioneered among contemporary British Columbia Indian artists by

Robert Davidson, whose exploration of this form can ultimately be traced to similarly conceived designs drawn by his great-grandfather and illustrated in Swanton's *The Ethnology of the Haida* (1903:Plates XXII, XXIII).

The final contemporary Haida artist represented is Jim Hart, born in Masset in 1952. He is a skilled craftsman and has long been at ease working with wood although it was not until 1978 that he received an informed introduction to Haida art. In that year he apprenticed to Robert Davidson and assisted in the carving of houseposts for the Edensaw Memorial at Masset. This experience inspired him to produce the screen illustrated in figure 77. The crest depicts a shark and in it Davidson's influence can be seen, especially in the head which should be compared with that of figure 65. A careful examination of this

striking, expansive design reveals the meticulous craftsmanship exercised by this young artist in this, his first major work.

TAHLTAN-TLINGIT

Classic examples of coastal Tlingit sculpture and flat design are not included in this presentation because that tribal group does not occupy British Columbia. But at least one artist born in this province is investigating Tlingit style. He is Dempsey Bob, born in the Tahltan village of Telegraph Creek. The Tahltan people occupy a dry interior environment. They have many connections with the coast and depend heavily on the salmon which spawn on the Stikine and the Taku river systems flowing through their territory. These rivers provided economic and social routes to salt water and resulted in the acquisition, through marriage, of Tlingit crests, names, and artifacts, by the inland dwelling people.

Dempsey Bob's most successful emulation of Tlingit style is seen in the face carved on the bowl shown in figure 78. The benign smile achieved by the continuous lips on this bowl is typically Tlingit, as is the modelling of nose and cheeks. The artist has skillfully combined two-dimensional design with sculpture in this piece, as the formlines defining the crouching body attest.

The mask illustrated in figure 79 also incorporates a number of Tlingit characteristics. As well as the way in which the sculptural planes are handled, the manner in which two creatures are combined on a single mask is distinctively Tlingit. Finally, the artist has

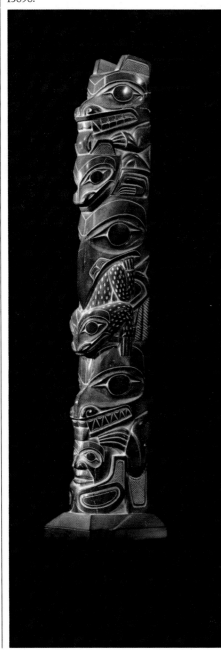

Figure 70. Haida argillite totem pole, Pat Dixon, 13898.

introduced greenish-blue as a tertiary colour; this hue was a favourite of traditional Tlingit artists and was derived from copper compounds.

TSIMSHIAN

The subtle nuances which combined to create the great masterpieces of Tsimshian sculpture and painting passed from practice about 1910, although a handful of craftsmen continued to produce rough facsimiles of the old art into the 1940's. However, so little had survived by then that the art was, for all intents and purposes, lost. The most visible reminders of past artistic achievements were seen in the many totem poles which still stood in a cluster of villages on the upper Skeena River. Concern for these, and the heirloom ceremonial regalia still in the possession of native families, spurred local residents, both Indian and white, to establish a museum in the centrally located village of Hazelton. Founded in 1958, the Skeena Treasure House was later to become the focal point for a craft village devoted to the revival of Tsimshian arts.

Severe economic and social problems faced residents of the area and in 1966 an ambitious plan was devised to revitalize the community. The result, opened in 1970, was a craft, museum, interpretation, and recreational centre called 'Ksan. There, student-artists were formally trained at the Kitanmax School of Northwest Coast Indian Art. The aim of the training programme at this school was unique in that it sought, almost exclusively, to offer a comfortable livelihood for graduates. Once in full operation however, the potential to serve the Indian community became obvious and, in time, students produced regalia and totem poles for native use.

Because there were no knowledgeable Tsimshian artists living, no semblance of the old apprenticeship system was possible. Qualified instructors, both Indian and non-Indian, were brought in to instruct under relatively formal conditions. Unfortunately none of the teachers had full command of Tsimshian artforms, especially the sculpture, and, as a result, three-dimensional objects produced at 'Ksan lack the tranquil refinement of older pieces. Nonetheless the style developed by 'Ksan artists is entirely within the Northwest Coast tradition and has the potential to grow when a full understanding of classic forms is reached.

The eagle woman mask (figure 80) carved by Walter Harris is a good example of the training approach undertaken at 'Ksan; students learned by copying older pieces. This was an entirely acceptable traditional means of instruction, so poses no conflict. The original is in the Portland Art Museum and is undocumented as to meaning, requiring the artist to find an explanation for his sensitive interpretation of the original (see Appendix I, 13918).

Walter Harris' killer whale headdress (figure 81) is an important ceremonial item, representing one of the artist's principal crests. It was worn at a pole-raising ceremony in his home village of Kispiox; during the event rain fell onto the carving, causing the highly waxed

finish to become mottled and subdued, adding character to the piece. The head-dress provides another insight into the cross-fertilization of image and form which results from a training programme employing instructors from another tribal group. While the graphic design elements are certainly Northern, the concept of a large horizontal headdress like this is not typical for the Tsimshian.

Figure 71. Haida mask, Freda Diesing, 16606.

The format reflects the fact that it was made under the instruction of Kwakiutl artist Doug Cranmer whose people carved and used masks similar in shape to this.

When used, the lower jaw, pectoral fins, and fluked tail, may all move when strings operated by the wearer are pulled. This headdress has special status for when it was used to demonstrate a family privilege at the pole-raising,

money was "fed" into the whale's open mouth.

Harris and Earl Muldoe were among the first graduates of the 'Ksan training programme, and they have continued to play an important role as instructors at the Kitanmax School. The latter also produced his first accomplished work by copying old examples. The prototype for Muldoe's wolf headdress (figure 82) is also in the Portland Art Museum and is illustrated in Gunther (1966:93). Interestingly, the copy exhibits much greater precision of finish than the prototype.

Under the instruction of Duane Pasco, the 'Ksan students learned to manufacture and decorate bent wood boxes and they became skilled in this art. They also learned to work precious metal; in the example illustrated in figure 83, Earl Muldoe has replicated one of these boxes in silver and in miniature form. Of all the instructors who taught at 'Ksan, Pasco had the greatest influence, remaining there for about two years during the critical early period of development. While his cultural origins are far from those of the Northwest Coast Indian, his long interest in and mastery of the artform made him a most appropriate teacher. It should be noted, however, that Pasco's personal style was not fully developed at this time, and while the 'Ksan artists essentially practice in his 1970 mode, he himself has moved far beyond this.

The chest created by Vernon Stephens, shown in figure 84 a, illustrates the thin, somewhat angular, formline practiced by Pasco while teaching at 'Ksan. The

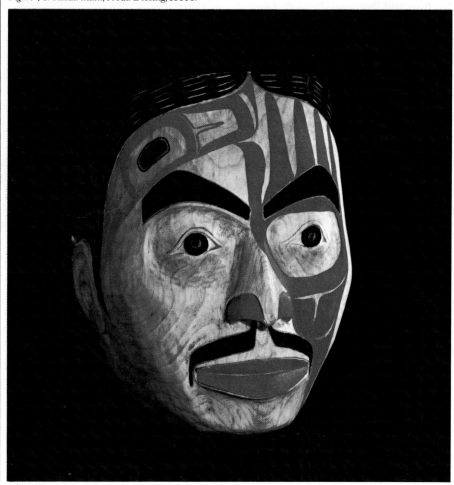

primary design on the long side is based on the standard chest as seen in figure 2d. But in Stephens' example, the artist has elected to introduce a narrative dimension, filling the width of the upper section with two beavers facing one another, separated by a grizzly bear. This kind of innovation has characterized the attitude at 'Ksan; artists there feel compelled to produce something different in every piece. The end panel design (figure 84b) is again a departure from the norm. Four separate creatures are represented in each quadrant; starting in the upper left corner and moving clockwise they are bear, eagle, beaver, and wolf. Compressing four distinct and complete designs into a rectangular design field is a device favoured by 'Ksan artists; in this panel the result is additionally successful as there is movement in the arrangement. The entire panel appears ready to rotate in a counter-clockwise motion.

Formal classroom instruction has led to a heavy dependence by 'Ksan artists on templates and other draftsman's techniques. While the traditional painter relied on templates to some extent, there came a time in his career when he abandoned his continuous need for them. This allowed a more individual expression to evolve. While the chest in question certainly is innovative in terms of gross design layout, a certain repetitiousness is evident. Part of this reflect's the artist's dependence on a single template to produce either the inner or outer lines of fourteen out of sixteen profile formline heads on the chest. Thus, expected subtle changes in

shape and size do not occur and, as a result, the heads of a variety of birds, mammals, and fishes exhibit a somewhat unimaginative similarity.

Robert Jackson is another artist trained at 'Ksan but since his graduation he has studied on his own; as a result, his formline designs are much more rounded and fluid than those of his fellow students. This is evident on his mask (figure 85) where the graphics approach the flow and feeling of those seen on the classic bent bowl in figure 10. Jackson has also attempted to recreate more accurately traditional sculptural

Figure 72. Haida silver bracelet, Gerry Marks, 14528.

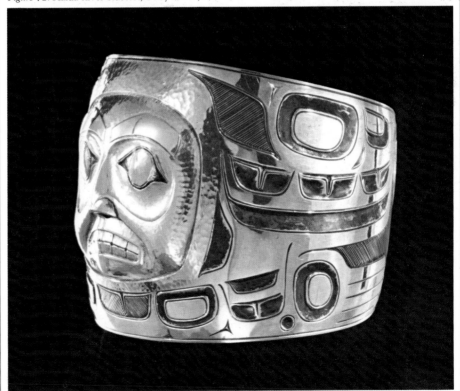

forms and has come near to this in his handling of eyes and eyesockets.

While he has lived in the Hazelton area, and is thus obviously aware of the 'Ksan style, Phil Janzé received little formal training there. He turned to the work of Robert Davidson and other Haida artists for inspiration and, like Jackson, has captured the subtle roundedness of classic Northern design in his own work as can be seen in the silver bracelet illustrated in figure 86.

Of all the contemporary Tsimshian artists, Norman Tait of the Nishga, or Nass River, division has come closest to duplicating ancient Tsimshian sculptural

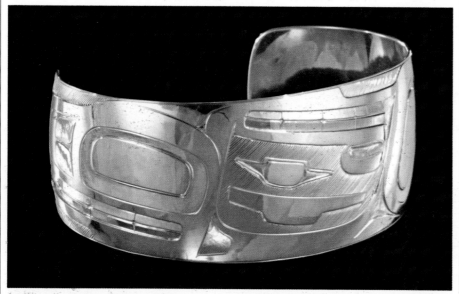

Figure 73. Haida silver bracelet, Gerry Marks, 16604.

forms. In 1970 he studied with Freda Diesing but continued, on his own, to experiment in the Tsimshian genre. Careful examination of the three faces on his eagle bowl (figure 87) demonstrates his understanding of classic Tsimshian sculpture. Tait has carved a number of totem poles in the past decade, the most significant of which he completed with his father in 1973. His monumental sculpture also comes much closer to approximating classic Tsimshian carving than does the work of other contemporary Tsimshian carvers.

SOUTHERN KWAKIUTL

Of all the tribes in British Columbia, the Southern Kwakiutl were the only ones to maintain an unbroken and viable tradition of carving and painting as the work of Charlie James, Mungo Martin and Willie Seaweed indicates. Despite rigorous prosecution under the anti-potlatch law, this tribal group maintained their ceremonial dances and attendant gift-giving, thus providing steady employment for artists. That the Southern Kwakiutl potlatch survived is a tribute to the tenacity of the human spirit. Its persistence has been important because it demonstrated to other peoples the value of the old ways and encouraged them to revive traditions once considered forgotten. And, of course, the potlatch continues as an important vehicle for encouraging and expressing the plastic and graphic arts.

Because the art was continuous, the following two artists can be considered contemporaries of both those of the traditional period and those who came to artistic maturity in the past three decades. Charlie G. Walkus, born at Smith Inlet in 1907, was trained in the customary manner. At about ten, he was carving model totem poles which he sold to fish cannery workers and the occasional tourist. By twenty, he was a recognized tribal artist, creating masks, rattles, ceremonial curtains and the like for native use. In the 1950's he turned increasingly to the production of masks for sale to non-Indians; a fine example from this period is the Bukwús mask illustrated in figure 88. It has all the attributes of a mask for use, including perforated eyes and a smoothly hollowed inside. The only exceptions which indicate it was made for sale are the lack of rigging, which means it cannot be worn, and the artist's signature inside.

Walkus' response to a request to carve a mask for The Legacy exhibit in 1971 is interesting to consider. The fact that the intent of the display was carefully explained to him in his own language may have had a bearing on his reply. He saw the commission as a great personal challenge, because he elected to carve a type of mask he had not attempted in some thirty years. The result was the cannibal bird mask representing *hokhokw*, shown in figure 89. This bird monster attendant of Bákhbakwalanoóksiwey used its long sharp beak to crack open men's skulls to consume their brains. While commissioned by a museum, this mask has since been used at potlatches, thus validating it as a tribal artifact. Both Walkus carvings demonstrate a quality of craftsmanship and attention to detail which reflects the artist's affinity to the Blunden Harbour school, so well represented by Willie Seaweed.

Another Southern Kwakiutl artist with a similar career is Charlie George Jr.. Raised in the remote village of Blunden Harbour, he was trained mainly by his father, a contemporary of Willie Seaweed. Like Walkus, Charlie George Jr. began his career by carving model totem poles and producing drawings on paper which he then sold to non-Indians. His career was tragically terminated in 1970 when he suffered a stroke although he has since made a few drawings and at least two masks using his left hand.

Charlie George's Crooked Beak of Heaven mask, shown as figure 90, again emphasizes the continuity of Southern Kwakiutl art. Produced before 1940, it indicates the preference for enamel paints at that time and relates solidly to the Blunden Harbour-Smith Inlet substyle. This mask, from the collection of the Thomas Burke Memorial Washington State Museum, was made for native use.

The most senior of the truly contemporary Southern Kwakiutl artists is Henry Hunt, who was born in 1923 in the remote village of Fort Rupert. Here, as in many other Southern Kwakiutl villages, traditional ways were kept alive, and as a child and young man, Henry Hunt lived a lifestyle that in many ways approximated that of his famous grandfather, George Hunt, native ethnographer and advisor to the anthropologist Franz Boas. Hunt's early working years were spent as a logger and fisherman; it was not until 1954 that he began to carve. In that year he apprenticed to his father-in-law, Mungo Martin, who was then employed by the British Columbia Provincial Museum. In all, Hunt spent some twenty years in the employ of the museum during which he replicated carvings from nearly every coastal tribe as well as creating many original works in the Southern Kwakiutl style.

Henry Hunt's 'Yagis mask (figure 91) illustrates his full understanding of

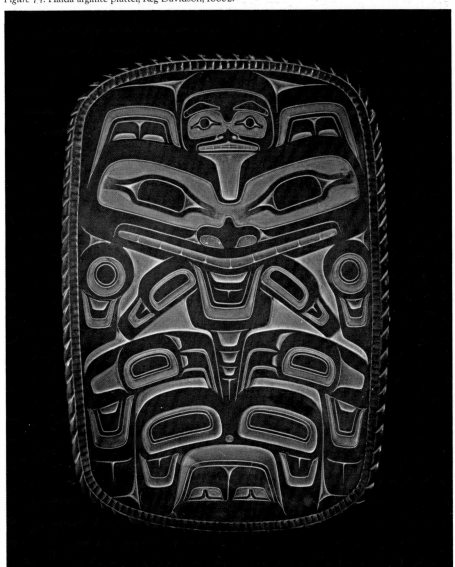

Figure 74. Haida argillite platter, Reg Davidson, 16602.

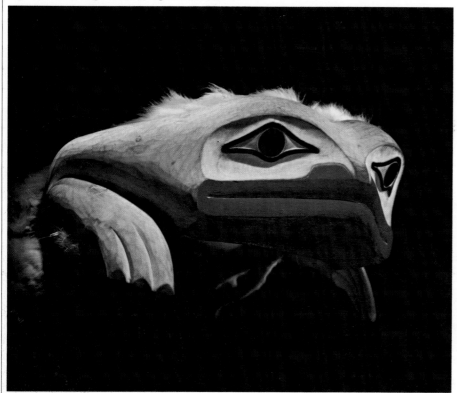

Figure 75. Haida frog headdress, Reg Davidson, 16603.

Southern Kwakiutl sculpture and painting. While heavily influenced by the personal style of his mentor, Hunt went on to tighten some of Martin's rather loosely rendered graphic elements and achieved a fine sense of proportion in his own monumental carvings. It is significant to compare the designs painted on the head of his recently made sea otter bowl (figure 92) with those of the above sea monster mask. The basic primary formline elements on temple, cheek, and jaw are similarly conceived but differences are found in secondary detail. Compared, the two illustrate the many variations available to the accomplished artist which allow even masks representing the same creature to remain distinctive.

Both examples differ from the work of Hunt's generation of teachers in one significant way. In each case, the base is left in the natural colour of the wood, rather than painted white as it is in the majority of Southern Kwakiutl carvings made between about 1910 and 1960. Henry Hunt began to render his masks and totem poles in this way about 1965 and, since then, this revived nineteenth-century fashion has achieved ascendancy among contemporary Southern Kwakiutl carvers.

Henry Hunt's eldest son Tony also received initial training from Mungo Martin. Of all the current artists in his age group, Tony Hunt is probably the only one to have been trained as a youngster by a master whose understanding of the art reaches back to when traditional culture was still dominant. As a twelve-year-old, Hunt carved and painted miniature paddles and painted designs inside cockle shells which he sold to those passers-by who stopped to watch his father Henry, and grandfather Mungo Martin, at work.

Clearly committed to transferring family prerogatives in the proper manner, Mungo Martin potlatched to give Tony Hunt the right to the Bee Dance when Tony was about ten. Because the mask and associated costume Mungo made had long since passed from family hands, Tony decided to carve his own version of the mask about 1970 while employed by the British Columbia Provincial Museum (figure 93). For some unknown reason many older bee masks in museum and private collections are hastily and crudely carved. This piece stands as one of the best examples of this type of mask extant, reflecting the artist's close and personal connection with the dance privilege. He has skillfully inserted plastic lenses from sunglasses for eyes which allow the dancer to see while performing and yet maintains the impression of a bee's eyes. Again this is a great improvement over older examples, many of which have eye holes crudely chopped or bored into the cheek area to permit visibility.

Much of the magic of Southern Kwakiutl

98

dance dramas is achieved through the use of wonderful mechanical carvings and transformation masks. The latter change suddenly in the performance when strings are carefully manipulated. Tony Hunt's sea raven mask (figure 94) provides a good example. When viewed initially, the audience is aware only of the bird. Later, when transformation takes place, a moon, represented by the central humanoid face, is revealed.

Like many of his contemporaries, Tony Hunt continues to serve the traditional needs of his community. Assisted variously by his father and other relatives, he has carved and erected two memorial poles in Alert Bay honouring his late grandfathers Mungo Martin and Jonathan Hunt. And he is currently in the process of constructing a traditional dance house in his home village of Fort Rupert. Through such actions, he and his contemporaries are contributing substantially to the continuation of traditional culture.

Another of Henry Hunt's sons, Richard, has recently emerged as an important Southern Kwakiutl artist. Born in 1951, he spent most of his life in Victoria, British Columbia, some considerable distance culturally and geographically from his parents' home village of Fort Rupert. Yet his art enabled him to re-enter the traditional life of his people. He has been carving seriously for about ten years and in this relatively brief period has produced more than three dozen significant objects for ceremonial use. These include two grave monuments, a ceremonial curtain for Mungo Martin's house, and numerous masks and head-

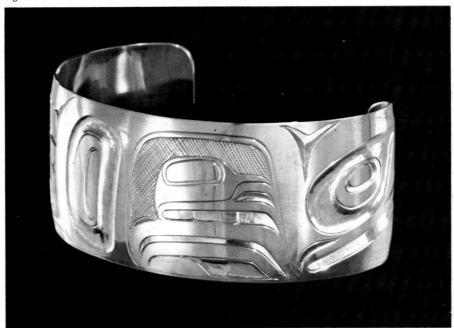

Figure 76. Haida silver bracelet, Don Yeomans, 16630.

dresses. At first his masks were worn by others skilled in dance and song. But soon those directing the ceremonial part of potlatches insisted that he perform with some of his creations. As a result, a great part of his introduction into the potlatch system was through his art. While today the art is doing much to support the system, the potlatch is in turn being preserved by the entry of young people, particularly artists, who gain admittance through such arts as carving, painting, song, or dance.

Richard Hunt's sun mask (figure 95) is a good example of a contemporary item made for traditional use. A Mamalilicoola village chief planning a potlatch approached the British Columbia Provincial Museum for the loan of a sun

mask. Because examples in the museum's permanent collection were far too fragile to use, Hunt was commissioned to produce the piece illustrated. The mask is a particularly fine example of how this contemporary artist is unwilling to compromise any detail. The carving is meticulous and exact, the painting especially well conceived. In fact, the latter indicates a personal refinement of style which, while practiced by some of his contemporaries, is seen at its best in the work of Richard Hunt. Careful examination of nearly every other Southern Kwakiutl painted carving in this exhibit reveals that the design elements on forehead, temple, cheek, jaw, and chin stand essentially as disparate units. (This is best seen in the classic rattle illustrated in figure 36; in other

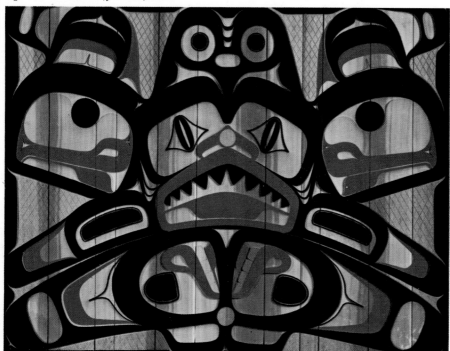

Figure 77. Haida screen, Jim Hart, 16605.

examples some of these may be joined but, if so, it is with a very thin line.) Hunt has recognized and applied the concept of a unified formline-type of painting that joins these parts in a distinct and obvious manner. The resulting form creates considerable harmony between applied design and sculpture.

The sculpin mask featured in figure 96 further exemplifies Richard Hunt's skill as a painter. Inspired by a similar mask in the collection of the University of British Columbia, Hunt's version demonstrates his recent interest in the use of enamel paint. Successful use of this glossy medium requires the kind of skilled precision so clearly established in the painting on this mask.

Like his childhood associate and close relative Henry Hunt, Doug Cranmer (born 1929) spent much of his youth fishing and logging. The very basic and practical experience of felling trees by hand and moving them to salt water, using only hand tools, cannot be undervalued in terms of discovering both the tractability and limitations of red cedar. Men like Henry Hunt and Doug Cranmer bring a special understanding to the material they work which gives them a great advantage when learning the skills of the artist.

While he is an expert carver, as the pole he recently erected in Alert Bay in memory of his late father attests, Cranmer's greatest interest and perhaps

talent lies in two-dimensional design. He has established a distinctive personal style in this, a style which is emerging in the work of his pupils. While his graphic design is essentially Kwakiutl, its fully integrated nature and medium-to-heavy weight, reflects a Northern influence, acquired perhaps while working for a three-year period with Haida artist Bill Reid.

Like a few of his contemporaries, Cranmer realized experimentation was possible even beyond the bounds challenged by his most daring ancestors. His predecessors Mungo Martin and Charlie James produced small paintings for sale, illustrating episodes from legends (see figure 53). But Cranmer has gone far beyond this, creating the laminated red cedar panel (figure 97) which illustrates the Nimpkish legend described on page 21. The principal characters in this legend are shown in the act of transformation. That the monster halibut is transforming into a man is shown by the human face emerging from the fish's mouth. The fish's pectoral fin also functions as the man's upper arm while the human leg behind it completes the image of a crouching mortal contained within the fish. The dual nature of the Thunderbird is also evident; the bird alone is easily isolated but if the bird's head and wing are eliminated, a human figure emerges, the claw-like hand and winged cape identifying the avian origins of this creature.

Large empty spaces are avoided by filling them with designs and design elements which symbolize celestial bodies, sea,

100

forests, and rocks. The sun shines over all from the upper left corner. On the upper border immediately to the right of the sun, clouds are represented by solid u-forms. Along the fish's back a representation of waves is seen and from these a beach rises sharply to a level, forested terrace. A rock on which the Thunderbird landed when it first came to earth is depicted in the lower right corner. In a very innovative fashion, Cranmer has used formline concepts and elements to depict landscape which serves to fill spaces that would otherwise remain vacant.

About 1974 Cranmer began experimenting with form in a most uninhibited manner. He produced a number of what must be considered abstract designs featuring fluid formline elements, some of which suggest the shapes of certain animals. His painting entitled "Killer Whales" (figure 98) provides an example from this period. Clearly a pod of surfacing and sounding killer whales is represented. These cavort against a kelp bed (indicated by the blue u-form elements). The beach behind the kelp is portrayed by the massive black u-forms that line the upper part of the painting. The inherent motion of these graceful marine mammals is clearly captured in the painting. Its essence is undeniably Kwakiutl, rendered in a free and untroubled manner, not frought with the contained tension sought by Northern artists such as Davidson (see figure 67).

Yet Cranmer is capable of intense introspection as revealed in the painting "Canoe" (figure 99). At first glance, the viewer might deny that this graphic

has anything to do with Northwest Coast Indian art, but philosophically, if not formally, this painting is within the tradition. To fully understand it, one must refer to the photographs of the model canoe in Appendix I, 10598.

If the painting is turned clockwise so that the blue band on the right-hand side sits horizontally, the major black form on the left (excluding the border), becomes a silhouette of the bow section of the canoe floating on a blue sea. If reversed one hundred and eighty degrees, the canoe's stern section is revealed in profile. If the painting is returned to the first position the central, black, roughly triangular area becomes one vertical half

Figure 78. Tahltan-Tlingit bowl, Dempsey Bob, 16609.

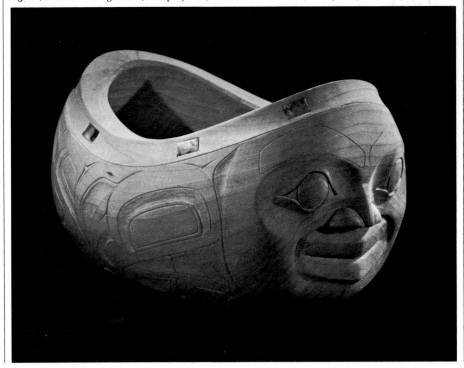

of the canoe as seen directly from a frontal elevation. The negative, that is unpainted, triangular space in the exact centre, represents a frontal elevation of the projecting bow piece. And the roughly similar design, directly opposite, represents the same view, only as seen from the stern.

When the painting is returned to its upright position, the uppermost central black element on the right becomes essentially a plan view of the gunwhale extending back from the bow. The first red element immediately to the left of this then represents the inside bottom of the canoe while the negative space between this and the gunwhale becomes

Figure 79. Tahltan-Tlingit mask, Dempsey Bob, 16610.

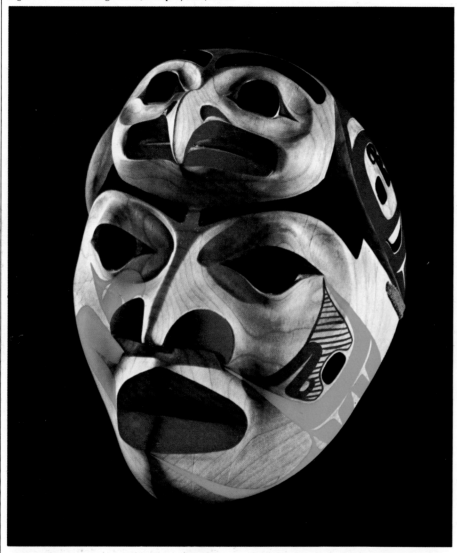

To be fully understood, this painting requires a detailed explanation in much the same way as did the bent bowl illustrated in figure 13. The reader is invited to make his or her own judgement as to the success of this innovative contemporary interpretation. Whatever the decision, the viewer must appreciate the fact that this painting shelters secrets in much the same way the bent bowl does.

Cranmer recently returned to his home village of Alert Bay where he has been instrumental in establishing an apprenticeship programme. Several of his students show real promise and the first of these to emerge was Bruce Alfred (born 1950). His bent box (figure 100) is an adaptation of a standard chest design and as such should be compared with the chest in figure 2. The device of folding the rectangle of the chest's design field onto two sides of a square box is found on several old examples, so this modern rendering is by no means unique.

The bold, medium-weight formlines reflect Cranmer's influence and produce a strong, integrated graphic. An interesting departure from the traditional norm is incorporated in this example – the salmon-trout's-head variants at the four corners are not free-floating and contained within a primary formline ovoid as is usual. Instead they have become part of the primary formline structure themselves.

The cylindrical rattles shown in figure 101 were used in the *tséyka* cycle to tame a voracious baby *hamatsa* purported to be hungrily bawling in a cradle suspen-

the sloping side. The similar, but slightly asymmetrical design elements directly to the left feature a similar view of the stern.

Finally, the central cylindrical motif in red represents the log from which the canoe was hewn, the paired vertical lines

extending above the crescents depicting cracks in the log. The circular part of this is the log in cross section while the design in black and red contained within the circle suggests an end view of the canoe which will eventually emerge from the log.

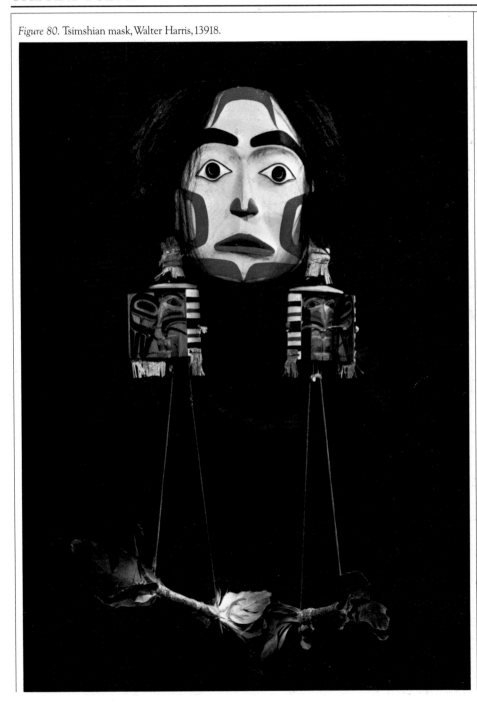

Figure 80. Tsimshian mask, Walter Harris, 13918.

ded from the roof of the dance house. Pebbles, contained within, tumble in soothing fashion when the rattle is gently shaken. The basically ovoid and u-shaped elements which decorate these cylinders represent no specific creature; they are simply abstract designs.

Calvin Hunt, born in 1956, is a second cousin of Tony Hunt and was trained by him. Calvin's approach to understanding and appreciating the art is somewhat unique. Although he is comfortable creating original pieces, he enjoys the challenge of replicating older examples in order to understand the technical and aesthetic challenges which faced artists practicing in traditional society. His own version (figure 102) of an elaborate dance costume made by Denaktok artist Bob Harris and now in the collection of the Field Museum of Natural History, Chicago, cannot be viewed simply as a learning exercise in which an extant piece is copied as slavishly as possible. Calvin Hunt is far beyond the stage where he has to duplicate older pieces. His costume must be seen as an original, for this kind of replicating is entirely within traditional experience. The original costume (figure 103) is as fantastic as the story it represents (see Appendix I, 16617).

Cooperative ventures are usual among Northwest Coast artists, especially when large carvings such as totem poles are produced. This may also apply to other items such as masks, where an artist and his apprentice, or two established artists, may work together on the same piece. A somewhat different form of cooperation is seen where a man will produce

a design to decorate a blanket, apron, tunic or other item of ceremonial clothing and a woman will create the finished product on her own. Such an example is seen in the button blanket shown in figure 104. Here the Sísioohl, or double-headed serpent, crest was conceived by Calvin Hunt while the appliqué cloth design and buttons were laid out and sewn on by Shirley Ford, daughter of artist Henry Hunt.

A somewhat different approach to learning was taken by Beau Dick. He was taught how to use traditional tools by his late grandfather and perfected his skills with them under the tutelage of Doug Cranmer and Henry Hunt. However, it was essentially on his own that he studied the nuances of sculptural and painted form, referring to objects in museum and private collections as well as illustrated examples for inspiration. Sometimes he would copy these fairly accurately, on other occasions he would create an effectively new version based on the original.

As a result of his eclectic interests, he is comfortable working in any Northwest Coast tribal style and is in fact often more capable of capturing the essence of a given tribal tradition than are those working exclusively within it. His mask shown in figure 105 is carved in the Bella Coola style. Because no Bella Coola have, as yet, successfully mastered their traditional artforms, it seems appropriate to offer this as a contemporary example of that fashion. The mythic character represented is Noohlmahl, the fool, a creature of Southern Kwakiutl mythology. The idiotic look, enhanced by the sagging eyes, huge nose, thick lips, underdeveloped chin, and simulated mucous running from the nostrils, would serve to identify this as Noohlmahl to any Southern Kwakiutl even though they might not be familiar with the details

Figure 81. Tsimshian headdress, Walter Harris, 13920.

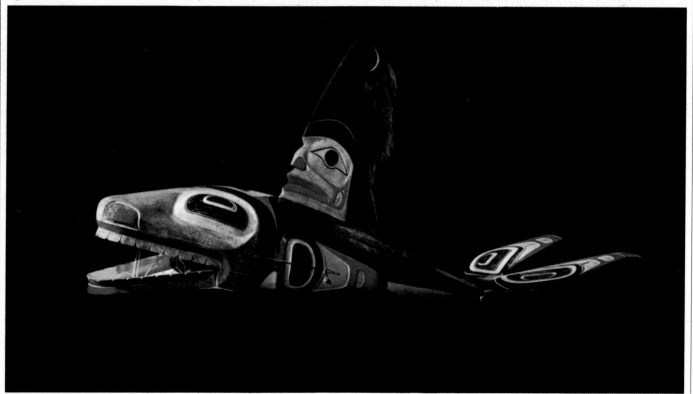

of Bella Coola sculpture and painting. Because the Noohlmahl is not a creature of the Bella Coola cosmos, this rendering is an entirely original example.

On the other hand, the severed head shown in figure 106 was inspired by a similar carving in the collection of the Museum für Völkerkunde, Berlin. The artist's only reference was a rather flat photograph of the original. In form, and carved detail, Dick's example is much like the one which inspired it. Changes on his version include the painted eyelid lines, the greenish stain overall and the

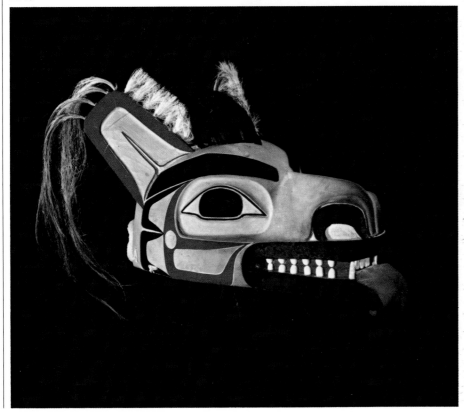

Figure 82. Tsimshian headdress, Earl Muldoe, 13917.

simulated blood running from eyes, nostrils and mouth. This was added to emphasize the function of the carving as a theatrical device. In an elaborate display of stagecraft, a female dancer is apparently decapitated; her head is then displayed in the dim firelight to an astounded audience. The ultimate intent of the drama is to bring the deceased back to life magically, which of course is accomplished through theatrical means using this carved head which simulates that of the "slain" woman.

The Southern Kwakiutl have been making jewelry from silver and gold coins since at least 1880. Silver bracelets were given away by the hundreds at potlatches; these were tied to sticks in units of ten, displayed publicly, and handed to chiefs at the appropriate point for later distribution among the women of that chief's extended family. The recent interest in Northwest Coast jewelry has inspired a great number of metalworkers. Among the Southern Kwakiutl, Russell Smith has explored silver and copper for some years and has developed a special talent with repoussé. The two copper pendants illustrated in figures 107 and 108, are the result of a laborious process of heating and hammering the copper from both sides to produce a fully sculptural form. Character is added to the face by stippling which resembles the adzed finish on monumental sculpture (see figure 38), and anatomical details are enhanced with inlay of abalone shell.

WESTCOAST ARTISTS

Symptomatic of a new assertion of their heritage, the people who occupy the west coast of Vancouver Island have recently rejected the term "Nootkan" which heretofore has been used to describe them. The word is a complete misnomer, and results from a misunderstanding on the part of Captain James Cook. Attempting to elicit the native term for what he considered an inlet, his native informants replied in their own language that indeed he could "go around" the island upon which Friendly Cove village was located. Cook then applied this term to the entire language group and it has since remained in effect.

Today the descendants of Cook's

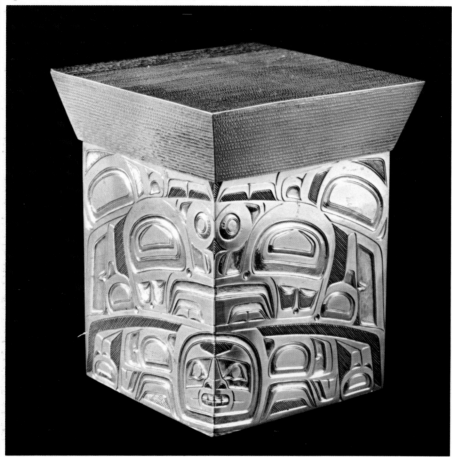

Figure 83. Tsimshian silver box, Earl Muldoe, 14082.

informants prefer to be called the "West Coast" people; here it seems easier to run the two words together as one, *viz.* "Westcoast," which accurately reflects the way in which it is pronounced. As well, this latter spelling somewhat avoids confusion with the term "Northwest Coast" so frequently applied to the peoples of the entire culture area.

As far as the survival of Westcoast art was concerned, for all intents and pur-

poses the tradition was lost. Vestiges of the sculptural and two-dimensional art were maintained by such men as Jimmy John and George Clutesi but it has really been the responsibility of young men to rediscover the art through examining traditional carvings in museum and private collections. The characteristics of Westcoast art have not yet been formally defined by scholars, but as the classic examples described in the introductory sections of this pre-

sentation indicate, there are established forms which readily identify the Westcoast style. The work of young Westcoast artists is thus important as it is instrumental in contributing to our current knowledge of the artform.

One aspect of traditional Westcoast craftsmanship remained viable without interruption. This is weaving, and Westcoast women have continued to create basketry of great charm from a combination of cedar bark and swamp grass. Baskets and other containers are popular but the celebrated conical whaling chief's hat has remained a favourite form of current weavers.

While knowledgeable artists all but passed from the Westcoast villages, traditional singing and dancing was maintained. Today one of the strengths of Westcoast ceremony and ritual lies in the fact that young men still sing and that young people still learn the intricate dances of the past. Continuity of ancient rites has meant a demand for new artifacts to replace the heirloom objects removed from the villages by collectors.

The first of the contemporary Westcoast artists to master the old forms was Joe David, born in 1946 in the isolated village of Opitsat. It was he who reintroduced the classic Westcoast face mask as seen in figure 109. In this example he has replicated the traditional sculptural form while applying a painted design which, in part, illustrates a very personal style. It shows an influence of northern flat design, which he has carefully studied, but in execution and use of colour is essentially Westcoast. The companion mask (figure 110) demon-

strates the way in which the slat-construction headdresses, so typical of this tribal group, are worn. Painted designs on both mask and headdress incorporate forms found on classic examples as illustrated by figures 18 and 39. The connection between David's work and the older pieces is obvious but it must be stressed that little more than a decade ago, no Westcoast individual was capable of producing these particular forms.

New directions in Westcoast graphics are reflected in the painted design on David's tambourine drum illustrated in figure 111. The whale in this painting is rendered expansively, somewhat unusual in Westcoast flat design. Contained within the body of the whale is a wolf's head, thus indicating the land-based counterpart of the whale. The spray spouting from the whale's blow hole has a floral quality but the elements contained within it invite comparison with designs on the headdress illustrated in figure 18. The carved drumstick depicts a cannibal bird consuming a human skeleton. This is not decoration for the sake of embellishment. The artist truly believes in the power inherent in the drum, the drumstick, and the songs which the two release when used. Representing the force of the cannibal society, the drumstick serves to make manifest that power.

Another Westcoast artist responsible for the rebirth of the art is Ron Hamilton, or Hupquatchew as he prefers to be called. Born in 1948, he developed a serious interest in Northwest Coast art while still a teenager. At first he was

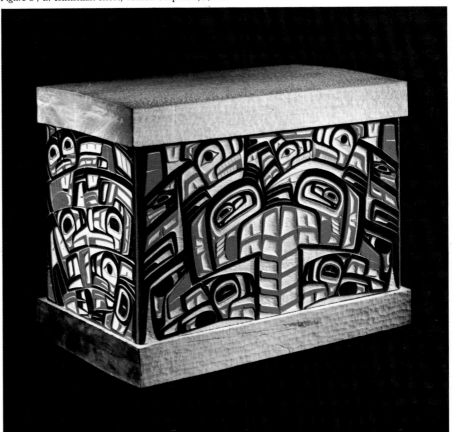

Figure 84 a. Tsimshian chest, Vernon Stephens, 14531.

largely self-taught, copying and improvising on designs from all coastal tribes. In 1971 he apprenticed to Southern Kwakiutl artist Henry Hunt and only then was exposed to someone fully skilled in the use of traditional tools. These he mastered quickly but his instruction was mainly in Kwakiutl forms. It was only after he spent two weeks working with his cousin Joe David that his interest in and understanding of Westcoast forms was stimulated. From that point on, his work came increasing-

ly to represent that tribal style. The ceremonial screen illustrated in figure 112 indicates one of his first explorations of Westcoast graphic art. The basic, but unrestrained formline structure is consistent with the work of certain Westcoast artists producing in the late nineteenth century. But Northern elements, reflecting Hupquatchew's receptiveness to all traditions at this time in his career, can be seen in devices such as the circular salmon-trout's-head which serves as the head of the figure

held in the whale's mouth. This results from his study of and interest in the work of Haida artist Charles Edensaw whose perfection of this element is seen in figure 45.

Flat design has always been Hupquatchew's forte and he gives it special

narrative and spiritual expression in many of his silkscreen prints. "The Whaler's Dream" (figure 113) is a particularly powerful example of this trend in contemporary printmaking. To appreciate it fully, one must refer to the artist's interpretation of it as reproduced in Appendix I, 15416.

Figure 84b. Tsimshian chest (side) Vernon Stephens 14531.

One of the most artistically versatile of the contemporary Westcoast artists is Art Thompson, born at Whyac in 1948. He is an innovative printmaker and has not been afraid to produce a large volume of work in this medium. His graphic art is uninhibited and flows freely, always incorporating the essence of Westcoast design.

The affinity between his human face mask (figure 114) and the classic traditional example illustrated in figure 39, is easily seen. Thompson's mask represents one of four which must be used together and are called "changing masks." All are the same size and shape but the painted designs on each are different. They appear, one after the other, over the top of a dance screen (see figure 112) and they pop up and down so quickly that in terms of movement, they seem to be the same mask. But because the painted designs on each differ, the viewer is aware of change and is thus entertained by the different expressions it appears a single mask can make.

Thompson's pair of headdresses (figures 115, 116) – one intended to be worn by a man, the other by a woman – feature bold, massive formlines, which is somewhat of a departure from most Westcoast two-dimensional design. This is most noticeable on the plumed crest of each main Haietlik, or Lightning Snake. The artist prefers this arresting formline, considering it to be the epitome of his personal style. The direct power of this painted style can be compared to the more delicate handling of line as shown on a similar type of headdress in figure 18.

Another Westcoast artist seeking to understand the old forms is Tim Paul, born at Zeballos in 1950. His human face mask illustrated in figure 117 assumes somewhat the same basic form as the classic example (figure 39) but it is much flatter. In fact, Paul's mask was inspired by a study of Westcoast masks in the collection of the British Museum, acquired by Captain James Cook. The majority of these demonstrate the same frontal flattening of planes incorporated in this contemporary example.

The Westcoast people also employed transformation masks; often these were made as slat-construction headdresses which meant they had to be seen in profile view to be fully appreciated. When in use, the headdress in figure 118 appears first as a single head. At a certain point in the dance, the performer manipulates concealed rigging, causing the second, slightly smaller head, to rise from inside the first. Finally the wooden fan is drawn open to reveal a face representing the sun.

Many Westcoast women living today make fine decorated basketry; unfortunately the work of all cannot be represented here. Instead a typical example is offered, one which is appropriate as it is a representation of a whaler's hat (figure 119). Made by Mrs. Jessie Webster of Ahousat, the weave is somewhat coarser than that seen on the Ellen Curley example featured in figure 61. The designs depict harpooners in pursuit of whales, poised to thrust their weapons. While the weaving technique requires that the graphics be simple and geometric, the essence of the whale hunt

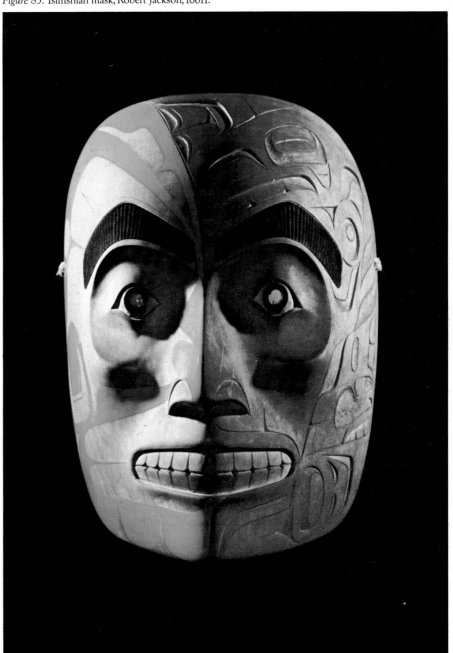

Figure 85. Tsimshian mask, Robert Jackson, 16611.

is captured in the narrative rendering. If the hat is compared to the Hupquatchew print (figure 113), it will be seen that everything pictured in the weaving is represented, in whole or in part, in the serigraph.

COAST SALISH

Contemporary Coast Salish art remains in a tenuous position, awaiting the kind of rediscovery experienced recently by the Haida, Tsimshian and Westcoast peoples. Aspiring Coast Salish artists face some difficulty because many of the highly decorated utilitarian objects used in the past are no longer in demand. As a result, they will have to adapt these to a format appreciated by and acceptable to a new kind of patron. If the ancient forms of Coast Salish design are understood and mastered, these could be successfully applied to jewelry and silkscreen prints as artists from other tribal groups have done. On the other hand, there remains a market for traditional ritual and ceremonial items among the Coast Salish themselves. Certain masks, dancer's staffs, rattles, and other carved items, are in constant use today because traditional religious practices remain important and viable. Such items are seldom seen outside the ritual context but they do serve to demonstrate that the art is continuing in a traditional environment.

One Coast Salish artist who has been practicing for more than thirty years is Simon Charlie, who was born in 1919. During his early career, he was inspired by model totem poles made by the Southern Kwakiutl artist Charlie James and reproduced them in sizes up to four metres in height. Most of his output has been of this nature – objects produced for sale to non-Indians. However, he is aware of the role of the artist in traditional society and has created certain items for ceremonial and ritual use. The Sxwayxwey mask shown in figure 120 indicates Charlie's understanding of the form and meaning of this still-important ritual object.

Rod Modeste, born in 1946, is the first young Coast Salish artist to seek seriously an understanding of traditional two-dimensional design. He is currently engaged in a study of spindle whorls (see figure 19) and plans to adapt such designs to silver jewelry. His spirit dancer's staff (figure 121) is engraved with designs representing the supernatural helpers of the dancer. These may be depicted ambiguously to prevent the casual viewer from knowing the source of the dancer's power. In this example, Modeste has incorporated some of the crescents, u-forms and v-forms found in the older art, demonstrating that the attributes of classic Coast Salish design can be relearned and applied to a culturally meaningful art.

Figure 86. Tsimshian silver bracelet, Phil Janzé, 16631.

Figure 87. Tsimshian bowl, Norman Tait, 15088.

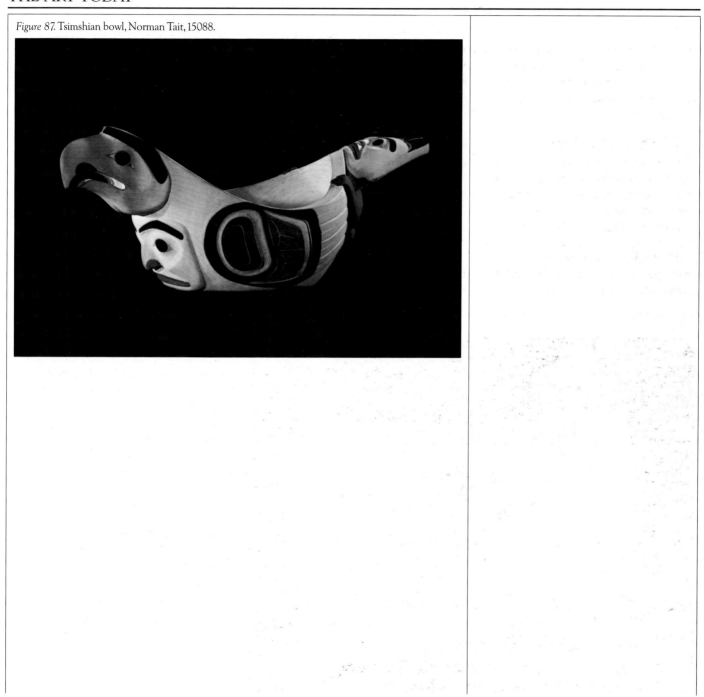

Figure 88. Southern Kwakiutl mask, Charlie G. Walkus, 14106.

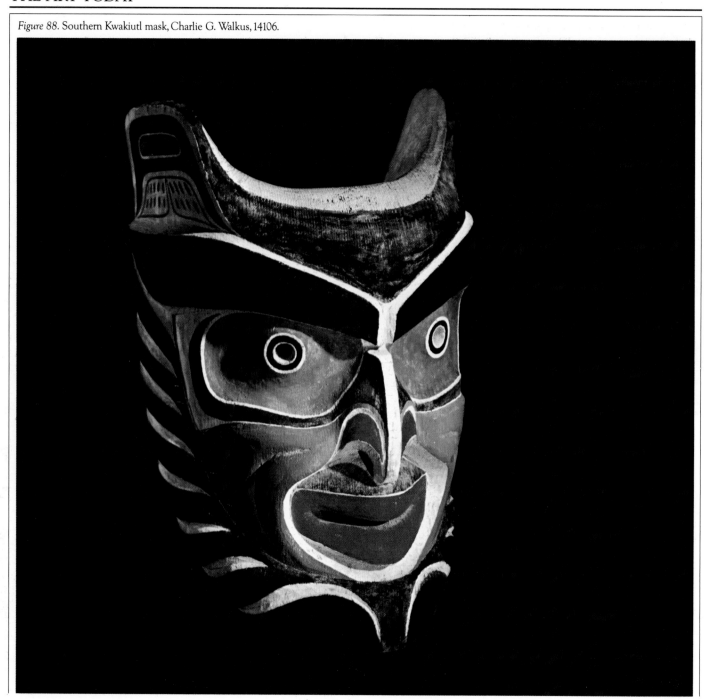

Figure 89. Southern Kwakiutl cannibal bird mask, Charlie G. Walkus, 13846.

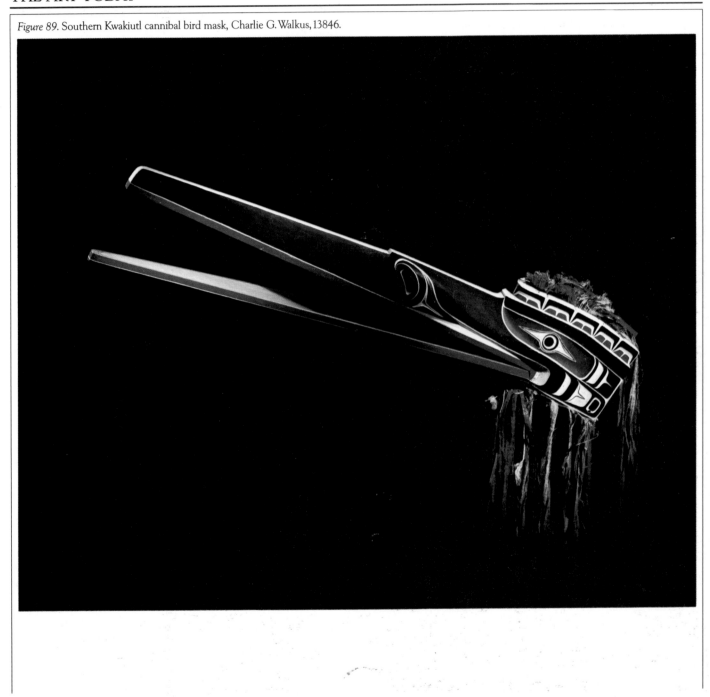

Figure 90. Southern Kwakiutl cannibal bird mask, Charlie George Jr., 25.0/2, Bill Holm photo, Thomas Burke Memorial Washington State Museum.

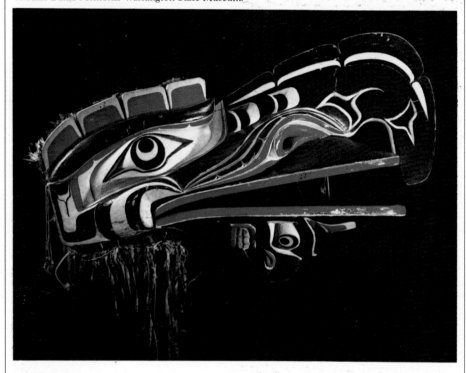

Figure 91. Southern Kwakiutl mask, Henry Hunt, 13215.

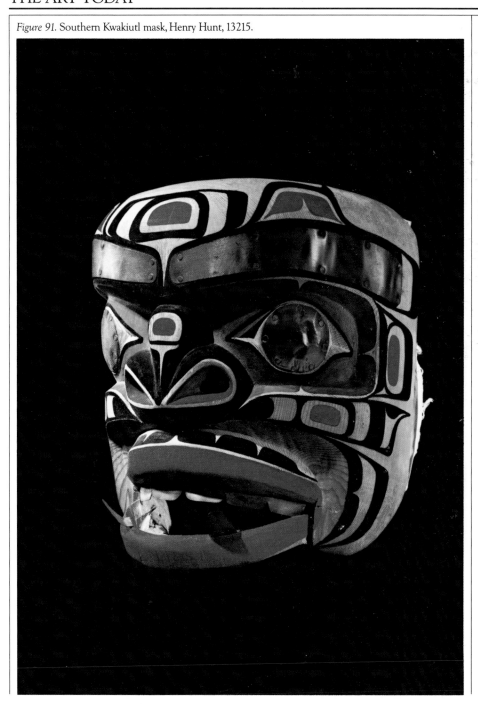

Figure 92. Southern Kwakiutl bowl, Henry Hunt, 16613.

Figure 93. Southern Kwakiutl mask, Tony Hunt, 12731.

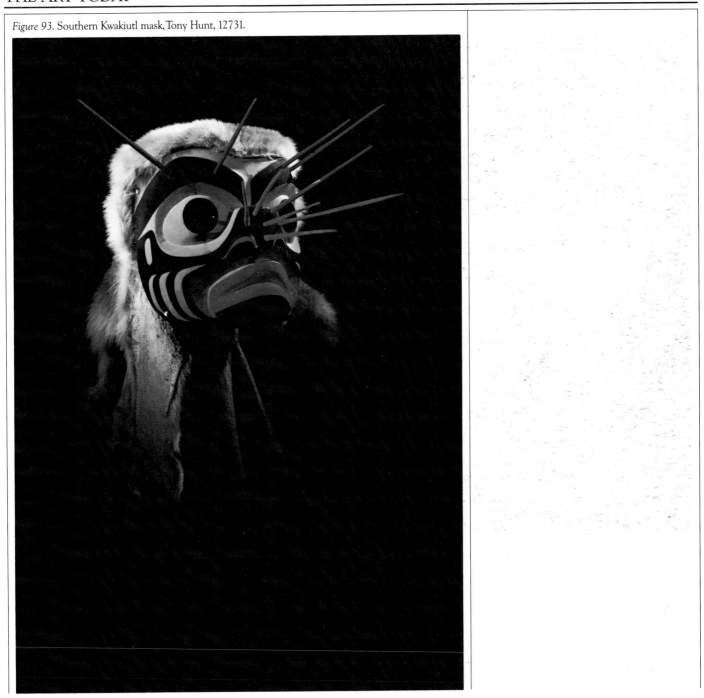

Figure 94. Southern Kwakiutl transformation mask, Tony Hunt, 13848.

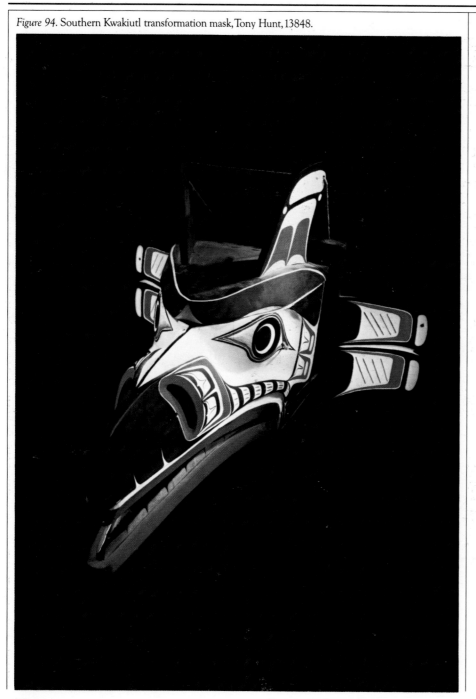

Figure 95. Southern Kwakiutl mask, Richard Hunt, 15426.

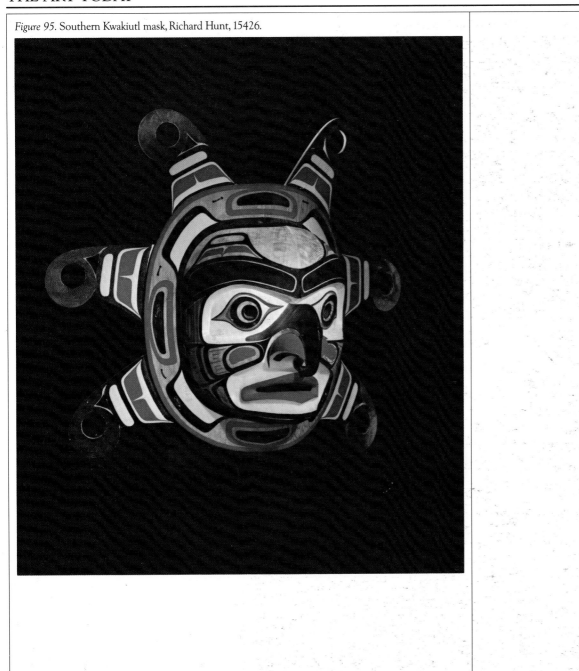

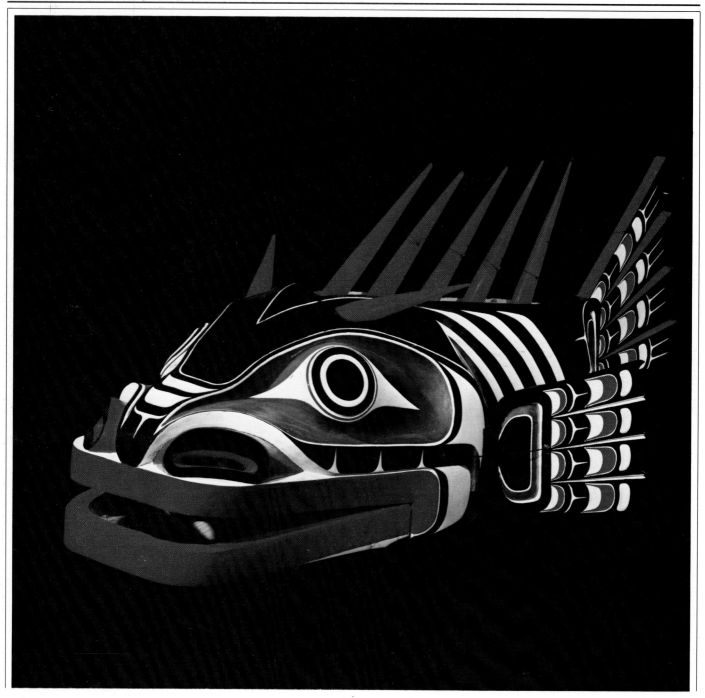

Figure 97. Southern Kwakiutl screen, Doug Cranmer, 13961.

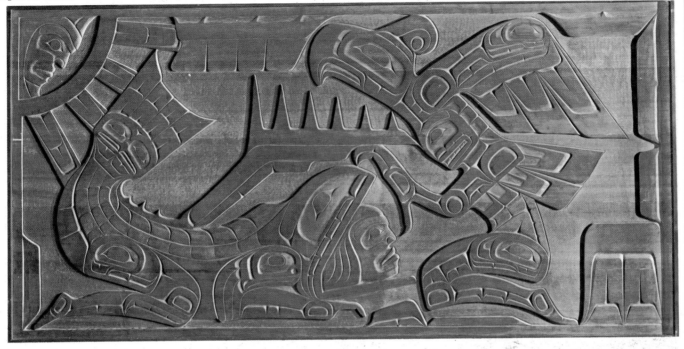

Figure 96. Southern Kwakiutl mask, Richard Hunt, 16612.

Figure 98. Southern Kwakiutl painting, Doug Cranmer, 16326.

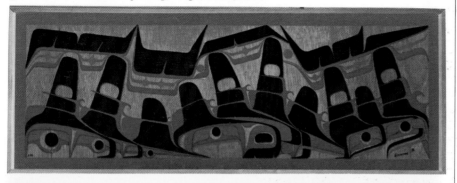

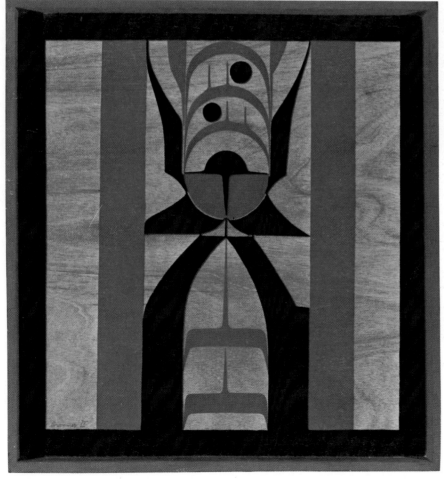

Figure 99. Southern Kwakiutl painting, Doug Cranmer, 16635.

Figure 100. Southern Kwakiutl box, Bruce Alfred, 16618.

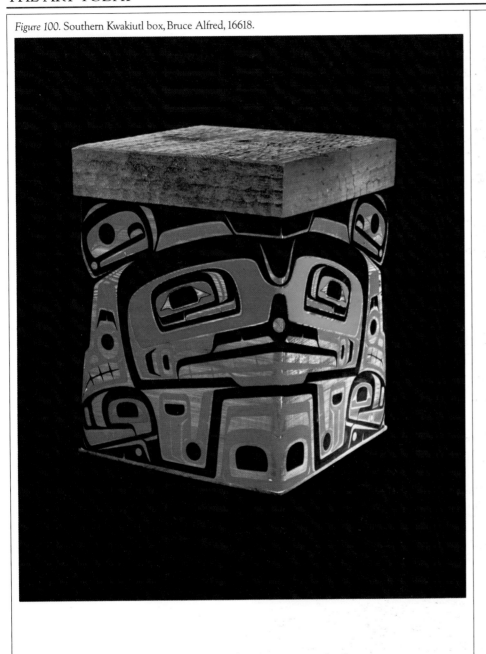

Figure 101. Southern Kwakiutl rattles, Bruce Alfred, 16619, 16620.

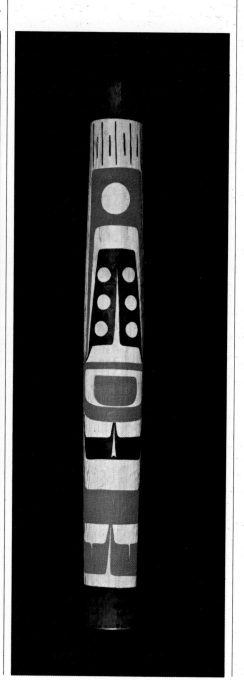

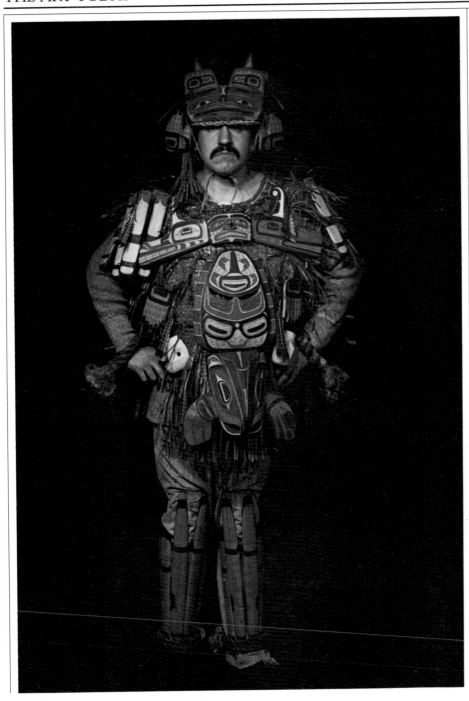

Figure 102. Southern Kwakiutl dance costume made and worn by Calvin Hunt, 16617.

125

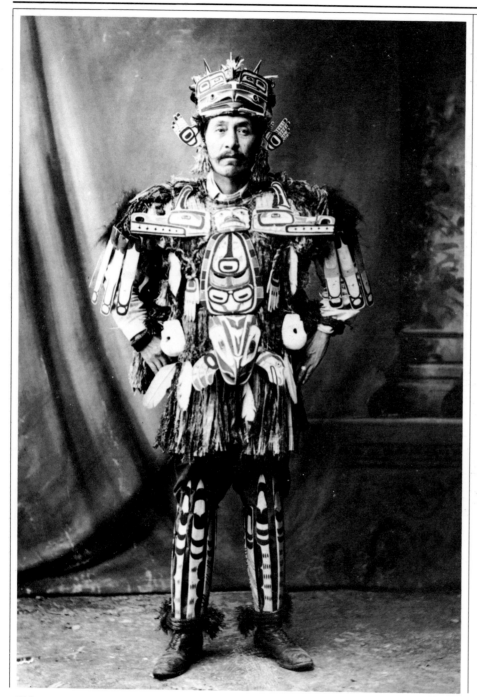

Figure 103. Southern Kwakiutl dance costume made and worn by Bob Harris. Prototype of Figure 102. St. Louis World's Fair, 1904, F.M.13583, Field Museum of Natural History.

Figure 104. Southern Kwakiutl ceremonial blanket, Shirley Ford, 16621.

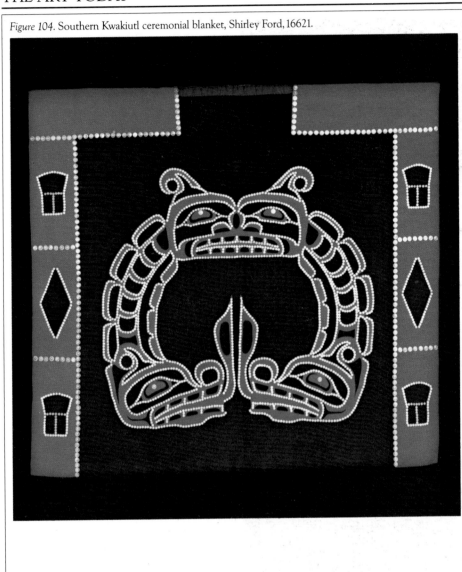

Figure 105. Southern Kwakiutl mask (Bella Coola style), Beau Dick, 16615.

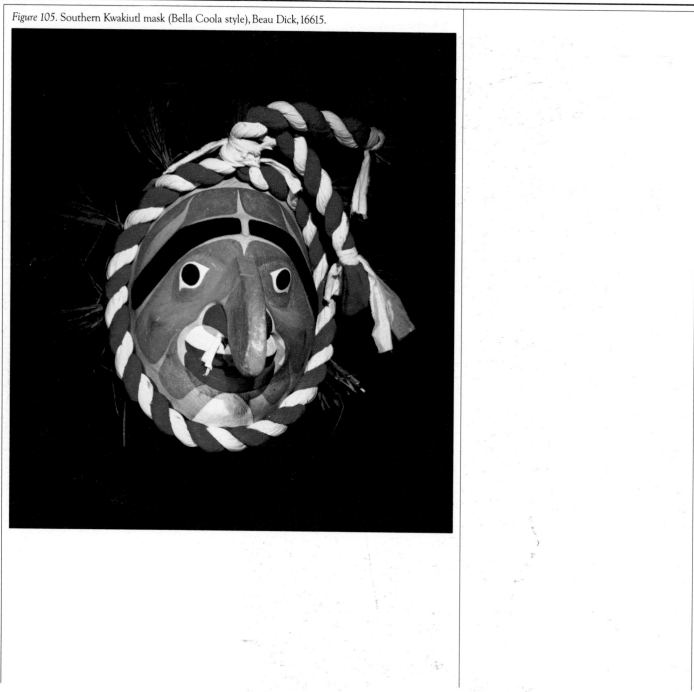

Figure 106. Southern Kwakiutl theatrical prop, Beau Dick, 16616.

Figure 107. Southern Kwakiutl copper pendant, Russell Smith, 16628.

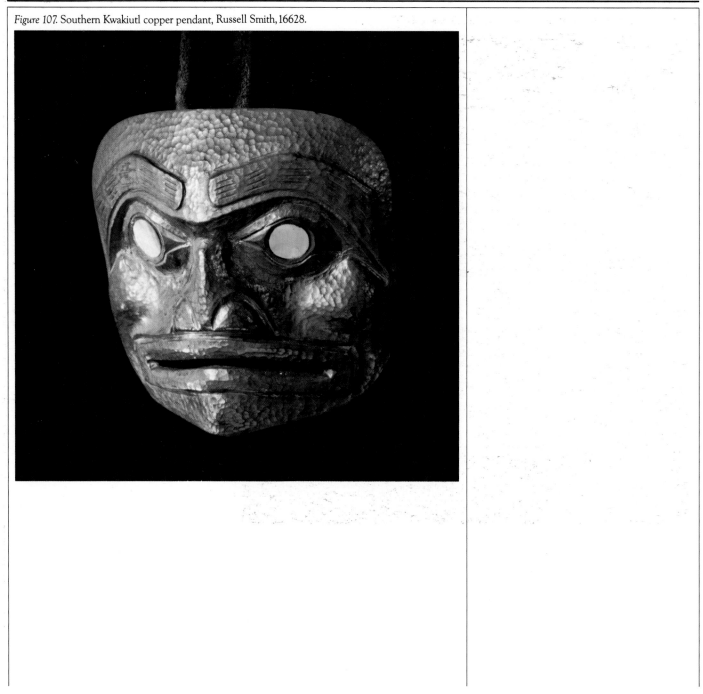

Figure 108. Southern Kwakiutl copper pendant, Russell Smith, 16629.

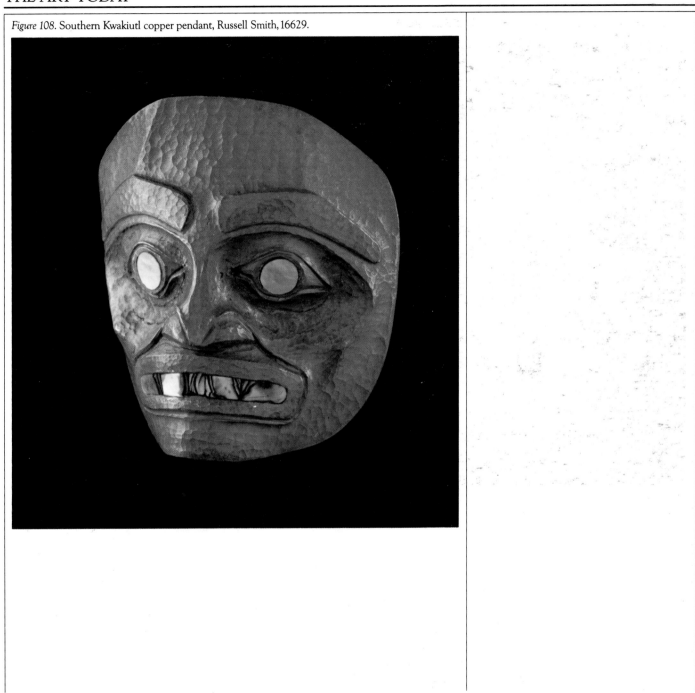

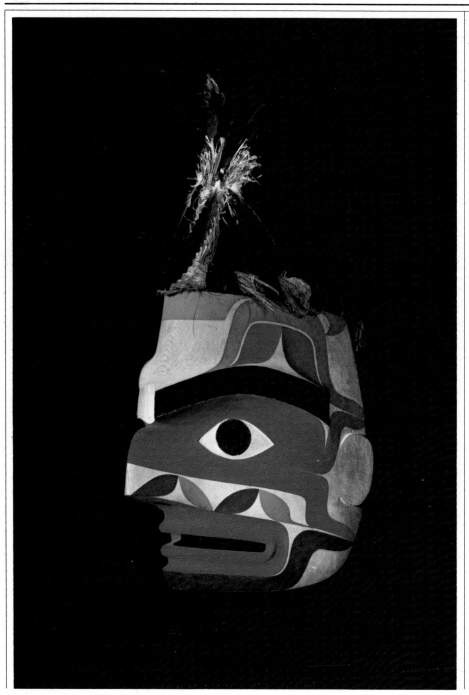

Figure 109. Westcoast mask, Joe David, 16634.

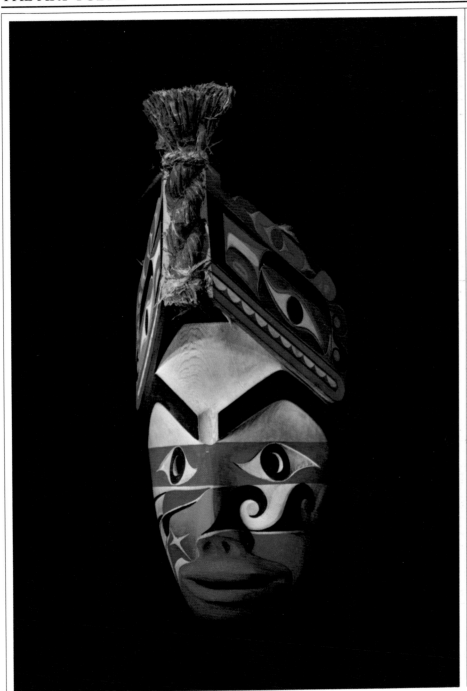

Figure 110. Westcoast mask, Joe David, 16633.

Figure 111. Westcoast tambourine drum, Joe David, 16622.

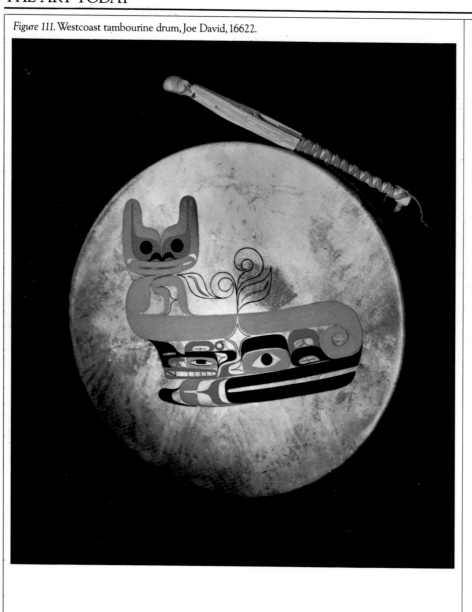

Figure 112. Westcoast screen, Hupquatchew, 13960.

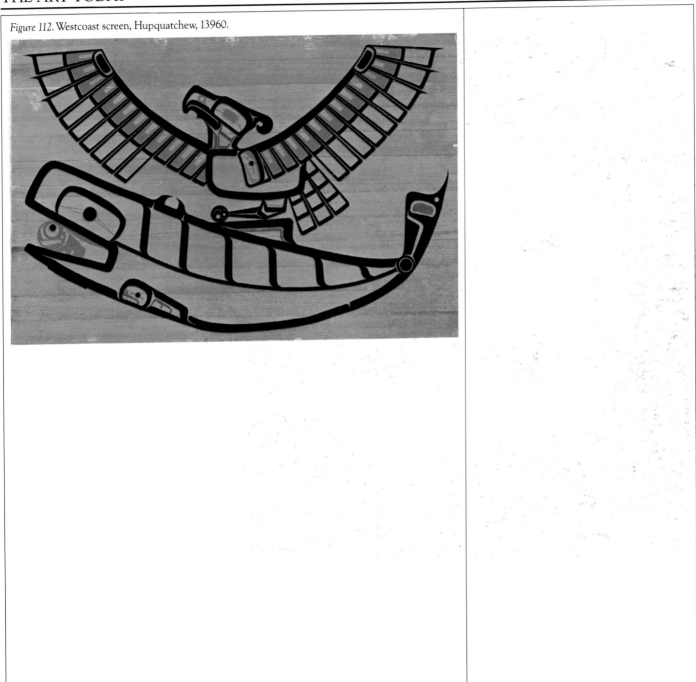

Figure 113. Westcoast serigraph, Hupquatchew, 15416.

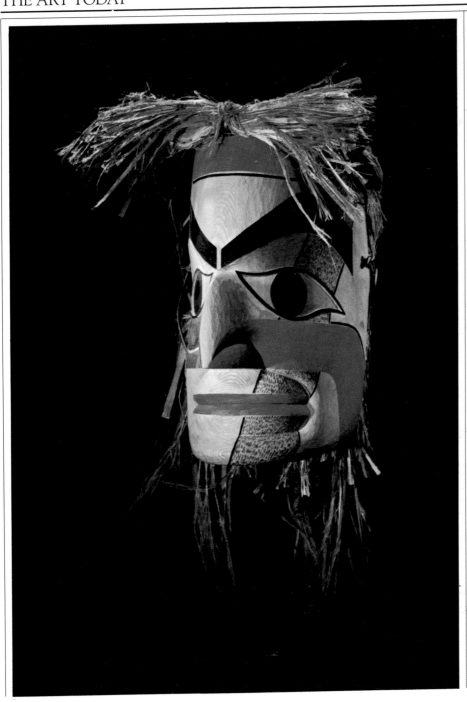

Figure 114. Westcoast mask, Art Thompson, 16624.

Figure 115. Westcoast headdress, Art Thompson, 16637.

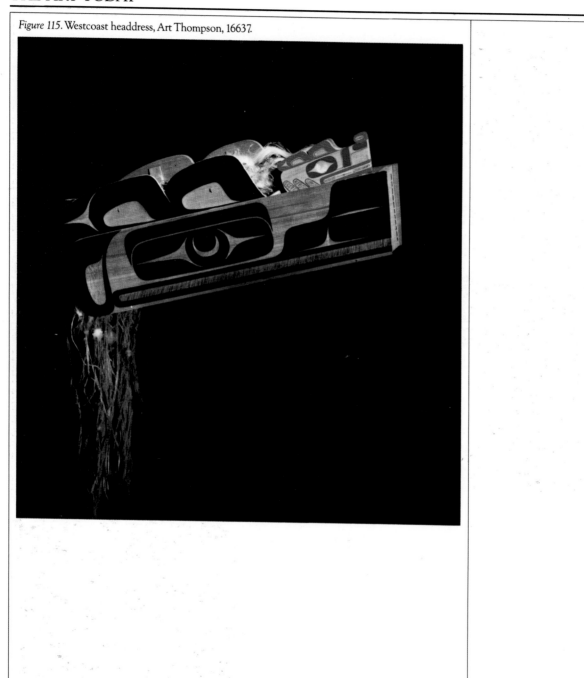

Figure 116. Westcoast headdress, Art Thompson, 16638.

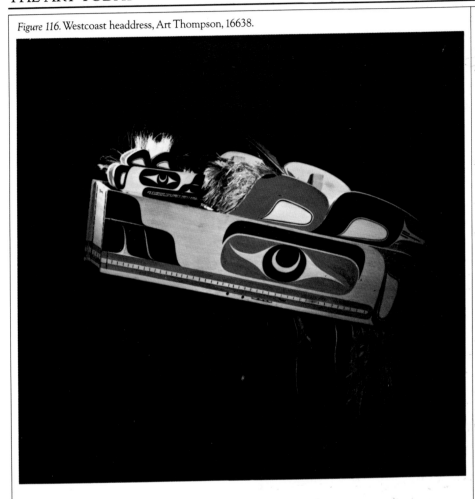

Figure 117. Westcoast mask, Tim Paul, 16632.

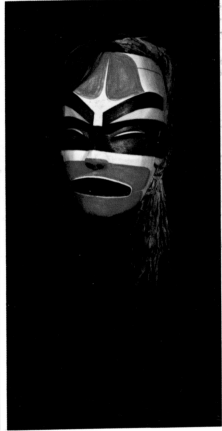

Figure 118. Westcoast headdress, Tim Paul, 16626.

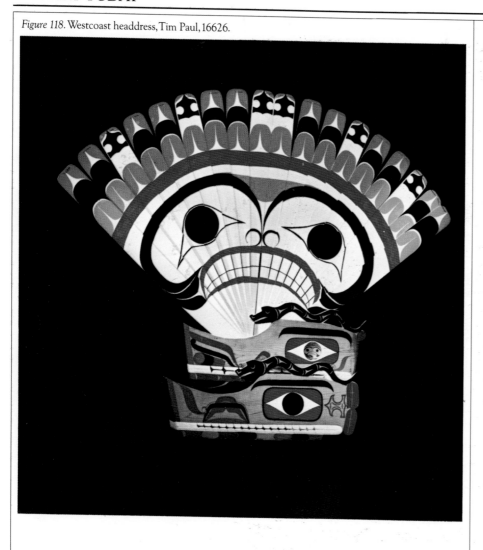

Figure 119. Westcoast Whaler's hat, Jessie Webster, 13874.

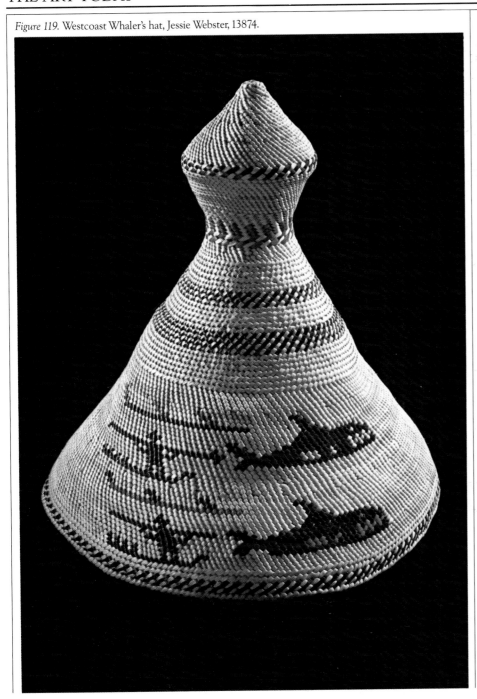

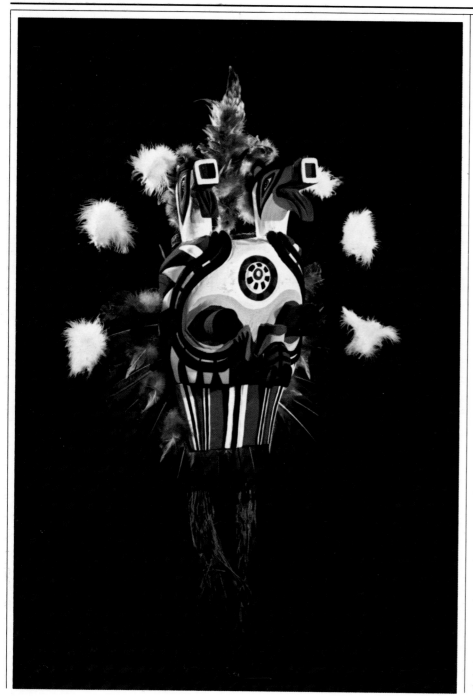

Figure 120. Coast Salish Sxwayxwey mask, Simon Charlie, 13884.

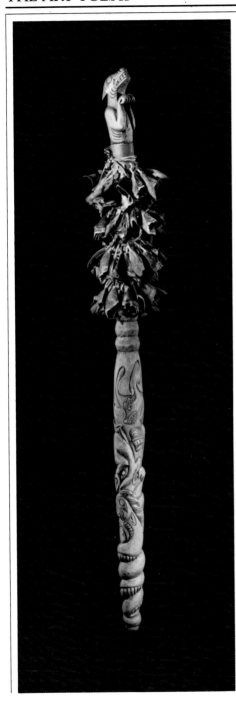

Figure 121. Coast Salish dancer's staff, Rod Modeste, 16627.

This account of The Legacy concludes with two appendices, one describing the artifacts, the other, the artists. In Appendix I the data are presented as follows:

☐ permanent catalogue number of the artifact in the British Columbia Provincial Museum (or lending institution)
☐ the name of the artist (where known)
☐ the tribal affiliation of the artist
☐ the type of artifact and the material(s) from which the artifact is made
☐ the image intended
☐ the three dimensions of the artifact in centimetres
☐ the date the artifact was made
☐ the final statement describes the cultural context of the artifact.

In Appendix II a thumbnail sketch of each artist is provided and an attempt is made to put their efforts into a historical and artistic perspective.

A P P E N D I X I

Alan Hoover and Kevin Neary

ARTIFACTS, LISTED BY CATALOGUE NUMBER

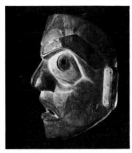

72

Artist unknown
Northern Kwakiutl

Mask, *wood*
Human
29.0 x 28.2 x 17.1

Before 1893

This mask would have been used during the ceremonies of one of a number of dancing societies at Bella Bella, called the *dloowalakha* (Returned from Heaven). The ceremonies revolve around a society member who had been inspired by a supernatural spirit and who would disappear in the midst of a dance. He thereafter was concealed for four days by other members of the society. During this time the initiate was supposed to have been taken to heaven by his spirit. The initiate would then reappear and on four successive nights perform the dance he had acquired. On the final night he would also display the regalia he had gained with the dance. This mask is an example of the type of mask obtained in this manner. The dancer would distribute goods to validate his dance and regalia. Now missing from this mask are strips of copper which originally decorated the ears, forehead, nose, cheeks and chin. This suggests that the spirit represented may have been connected with wealth, of which copper was a traditional manifestation.

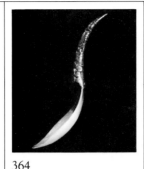

364

Artist unknown
Haida

Spoon, *mountain goat horn, cow horn*
Eagle, Wasco (Sea Wolf), beaver
35.0 x 8.7 x 6.1

Before 1895

This spoon is similar to the one discussed on page 160 and was made in the same way.

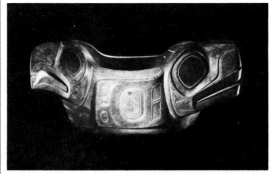

410

Artist unknown
Haida

Bowl, *wood*
Eagle and whale
34.0 x 16.3 x 13.7

Before 1893

When originally catalogued, this piece was described as a "soopallalie" dish. Soopallalie is a native confection made by whipping soapberries and water to a frothy foam.

Unfortunately an unexpected instability in this artifact necessitated its removal from the exhibition.

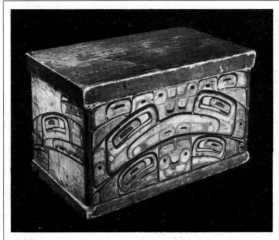

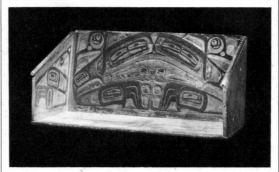

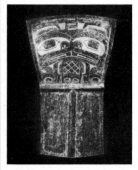

1295

Artist unknown
Haida

Chest, *wood*
Unknown
81.8 x 48.2 x 47.3

Before 1900

This chest was made in the usual Northwest Coast fashion. The four sides are made from a single large plank which was steamed and bent at the corners where grooves, or kerfs, had been made. The bottom is attached with pegs and the lid carefully fitted. Large chests like this, decorated with the owner's crest(s) or other designs, were treasured personal possessions. Sometimes they carried special names, which were explained in traditional stories, and were heirlooms. They were used mostly to store wealth goods and ceremonial, or shamanic paraphernalia. Although this chest was collected from "chief Edensaw" it is not clear whether this refers to Charles Edensaw or one of his relatives.

1296
Charles Edensaw
Haida

Chief's settee, *wood*
Frog (?)
136.5 x 64.3 x 61.3

Before 1900

Like chest 1295 (also shown on page 29) we know that this settee was purchased from "chief Edensaw." In this case we can attribute the piece, stylistically, to the hand of Charles Edensaw. The design on the seat may represent a frog, a major crest of the Eagle moiety of the Haida. Both Charles Edensaw and his uncle, Albert Edward Edensaw, whom he succeeded, were head chiefs of the Stastas Eagles from the village of Kiusta.

1396

Artist unknown
Haida

"Copper," *copper*
Beaver
94.8 x 61.4 x 3.8

Before 1911

Shield-shaped metal objects like this, commonly called coppers, were important symbols of wealth throughout the Northwest Coast and were frequently used in potlatches. An important part of the distribution of goods at a potlatch would be when one or more coppers were given to the most important guests. Each copper had an assigned value reckoned in numbers of trade blankets. This copper was collected from James Watson, the village chief of Cha-atl. It formerly belonged to chief Skedans of Koona. The design on the copper presumably represents a crest of one of its owners.

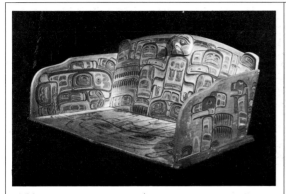

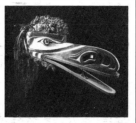

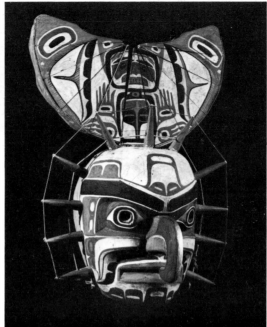

1856

Artist unknown
Northern Kwakiutl

Chief's settee, *wood*
Birds, marine creatures
225.0 x 112.5 x 76.5

Before 1900

On the back of this settee can be seen designs which represent two birds in profile bordering a central panel surmounted by a carved plaque of a bird's face. On the bottom of the settee is a design which can be identified as a marine creature, possibly a whale or a sculpin, by the fins and flukes. On the inside of both arms are identical designs which depict a whale; the heads are placed at the front ends of the panels. On the outside of the arm panels are designs which represent a bird seen in profile and another marine creature, probably a whale. A seat similar to this one was described by the collector Adrian Jacobsen in 1893 at Bella Bella: "An object that especially attracted my attention…was a 'chief's seat'

….Such a seat was placed on the floor in front of the fire, and a chief or high-ranking visitor occupied (it) in a squatting position…. Since it was not possible to buy the piece I ordered a similar one from the most renowned wood carver among the Bella Bella." Jacobsen's seat, now in the Berlin Museum, was obviously either modelled after settee number 1856 or the two were inspired by the same original. The chief's settee was photographed in 1900 at the Bella Bella light-house. It is known that the lightkeeper at that time was Captain Carpenter, an accomplished Northern Kwakiutl artist. His name was also found on the back of the settee when it was collected, indicating that he may have made it.

1908

Artist unknown
Southern Kwakiutl

Mask, *wood, twine, leather*
Sun
75.0 x 67.0 x 35.0

Before 1913

This mask represents the sun, which was the major crest of the Sisinlae family lineage of the Nimpkish tribe at Alert Bay. It was collected from a chief of the Sisinlae whose native name was Lakinhid. The right to this crest would be explained in an origin myth which in-volved an ancestor and the sun. The mask would be displayed during the *tlásulá* (secular) ceremonies which were originally related to, but distinct from, the Red Cedar Bark (sacred) rituals of the Winter Ceremony of the Southern Kwakiutl. The two rituals eventually merged to form the major portion of potlatch ceremonies. In the *tlásulá* dances, the principal performer appears dressed in a chief's regalia: frontlet headdress, dance blanket, raven rattle, and dance apron. He dances for a while and eventually leaves the house. Soon a masked dancer appears briefly. It is supposed that the first performer has been possessed by and transformed into the spirit represented by the mask. These dances are owned privileges and are ac-companied by a distribution of goods each time they are used.

1917

Willie Seaweed
Southern Kwakiutl

Mask, *wood, cedar bark, copper*
Galókwudzuwis (Crooked Beak of Heaven)
89.0 x 33.0 x 25.0 (forehead raised)

Before 1914

This mask was used during the *hamatsa* portion of the Red Cedar Bark dances. It represents Galókwudzuwis, a man-eating associate of the cannibal spirit from whom the *hamatsa* derives his power. Galókwudzuwis is identified by the hooked appendage atop the upper beak, hence the translation "Crooked Beak." The mask is worn so that it projects out and up from the dancer's forehead. His face and upper body are concealed by the fringe of cedar bark. As the dancer moves slowly, counter-clockwise, around the dance floor, the rhythm changes four times. At each change the dancer squats on the floor. Just before jumping up to resume his slow, high-stepping dance, he noisily opens and closes the articulated lower beak of the mask and raises the hinged forehead to expose a band of copper. This feature is

peculiar to this mask and symbolizes a special prerogative that belongs to the Seaweed family. The mask was purchased from Willie Seaweed in 1914. A newer mask, illustrated on page 79, made by Seaweed to replace the old one, was purchased from the artist's son in 1973. It also has the special feature of the hinged, copper forehead.

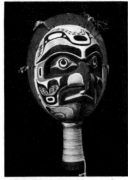

1924
Artist unknown
Southern Kwakiutl

Rattle, *wood, cedar bark, string*
Mountain hawk
31.4 x 18.4 x 17.1

Before 1914

This rattle was collected as part of a set of *hamatsa* gear from Willie Seaweed at Blunden Harbour in 1914. It does not appear to have been made by him. Rattles like this are used by attendants, *heligyas,* who surround the wild *hamatsa,* preventing him from attacking and biting people in the dance house. The sound of the rattles helps to calm the excited *hamatsa.* This *heligya* rattle is unusual in that it depicts a mountain hawk; a skull or severed head is a more common motif.

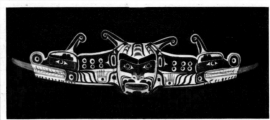

1954
Charlie James (Yakuglas)
Southern Kwakiutl

Mask, *wood*
Sísioohl
219.1 x 49.4 x 23.0

Before 1914

This large mask represents the Sísioohl, a fabulous, double-headed serpent which had a horned head at each end of a body which also had a central, horned, human head. The Sísioohl could cause all one's joints to become dislocated; its blood, wherever it touched skin, made that surface as hard as stone. The Sísioohl is involved in the histories of many Kwakiutl family groups and therefore is much represented as a crest. Ceremonial objects representing the Sísioohl frequently appeared during the Winter Ceremony in the Warrior Dances. This mask was probably intended for use in the *tlásulá* dances as a depiction of a family prerogative.

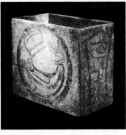

1972
Artist unknown
Southern Kwakiutl

Box drum, *wood*
Killer whale, copper
79.8 x 65.0 x 45.0

Before 1912

The usual percussion instrument on the Northwest Coast was a drum. Besides tambourine drums, planks, and hollowed logs, specially constructed boxes were sometimes used. These box drums would be suspended from the rafters and beaten with a stick or fist wrapped in cedar bark. The designs on this box drum do not represent crests. It is said that one of the designs on the ends of the drum represents a copper called "Cloudy Weather," which is also the name of a woman who appears in a myth. The killer whale designs on the sides may be purely decorative.

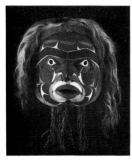

2321
Artist unknown
Bella Coola

Mask, *wood, cedar bark, hair*
Unknown
38.6 x 37.6 x 20.6

Before 1913

While this face mask appears to be humanoid, it may well represent a non-human ancestor such as the sun or some other celestial body.

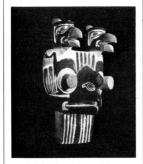

2364
Artist unknown
Coast Salish

Mask, *wood*
Sxwayxwey
44.3 x 28.8 x 16.3

Before 1913

This mask formed part of a dancer's costume, the whole of which was intended to represent the Sxwayxwey. The other parts of the costume were a cape that covered the back of the head and the shoulders, to which were added feathers wrapped around the waist, leggings of swan skin, deer hoof rattles on the ankles, and a rattle of scallop shells. When in use this type of mask would usually have large feathers fitted into the top, behind which radiated a number of down-tipped, sea-lion whiskers or wires. The rest of the mask is surrounded by a bib of cut feathers. Different village groups have their own myths to explain the origin and identity of the Sxwayxwey, but its dance was used by all for ritual cleansing and at times of life crises.

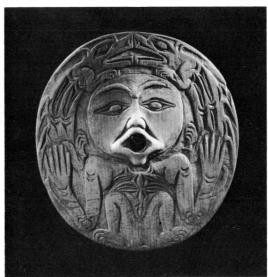

2454
Artist unknown
Coast Salish

Spindle whorl, *wood*
Human, mustelids (?)
21.4 x 20.5 x 1.9

Before 1912

This whorl, with an accompanying spindle, would have been used by a woman to spin yarn. Traditionally, the yarns were composed of either mountain goat wool or dog hair. Additional bulk was provided by adding the down of waterfowl or the fluff from the seed pods of various plants to the basic wool before spinning. During the nineteenth and twentieth centuries, sheep's wool replaced these materials. It is not known why many of these spindle whorls were so elaborately carved. The designs, which may represent a creature like an otter or mink, are common motifs on spindle whorls.

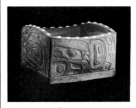

4114
Artist unknown
Haida

Bent bowl, *wood, opercula*
Mammal (?)
25.1 x 22.6 x 14.5

ca. 1850

This Haida food bowl was of a type reserved for guests at feasts and potlatches; indeed it might be included in the wealth goods distributed at a potlatch.

151

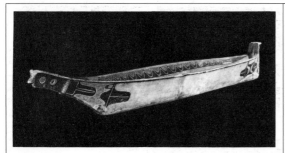

6600

Artist unknown
Westcoast

Model canoe, *wood*
Geometric design
79.1 x 14.1 x 10.4

No date

There is virtually no documentation for this canoe. It is a type which was sold to non-Indians in the curio trade, or to museums to serve as examples of canoe types. By collecting models, museums avoided the problems of transporting large items of material culture, such as houses and totem poles, as well as canoes. Although the lines of this particular model do not conform to those of a classic Westcoast canoe, the basic form is correct.

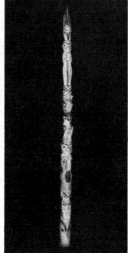

6696

Artist unknown
Tsimshian (attribution)

Ceremonial staff, *wood*
Zoomorphic figures
144.0 x 6.6 x 6.3

Before 1895

From top to bottom, figures represented on this ceremonial staff are: a whale, a human figure holding a staff, a beaver, a bird (possibly a flicker), another human figure, another beaver, and finally another whale with a small human figure between its fins. Although little is known about the use of Tsimshian ceremonial staffs, in other groups these staffs were the badge of the speaker, who acted as the chief's orator during ceremonial functions. Any other person wishing to address the assembled guests would take possession of the staff during his speech.

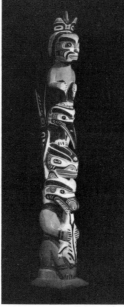

6786

Charlie James (Yakuglas)
Southern Kwakiutl

Model pole, *wood*
Zoomorphic figures
66.3 x 11.7 x 11.0

No date

At the bottom of this model pole can be seen a mammal, possibly a bear, which is holding an upside-down frog in its paws and mouth. Above the mammal is a killer whale's head whose flippers appear to the side of the raven-like bird which is standing on the whale's head. Atop the raven is a human figure clasping its knees. Above this figure's head can be seen the whale's tail. The whale's body is considered to be hidden behind the bird and human figures.

9201

Mungo Martin
Southern Kwakiutl

Mask, *wood, cedar bark, feathers*
Cannibal birds
138.0 x 57.1 x 33.0

1953

Mungo Martin made this mask to replace one he had previously owned. The prototype was carved in 1938 by George Walkus of Blunden Harbour and was sold in 1948. In 1953 Mungo carved this mask to be used at the opening of the Kwakiutl bighouse at Thunderbird Park in Victoria. The Hamatsa or Cannibal Society initiation ceremony involves the three supernatural attendants of Bákhbakwalanoóksiwey, the Cannibal-at-the-North-End-of of-the-World. Seen in this complex mask are: Crooked Beak of Heaven, Hokhokw and Raven, of which there are two. Hokhokw could crack human skulls with his long, sharp beak to consume their brains and Raven ate their eyeballs. The creatures in this mask have specific characterizations – according to Mungo this Crooked Beak is the form taken by Bákhbakwalanoóksiwey's wife when she hunted food and the Raven (facing back-

ward) and the Hokhokw (facing forward beside the Crooked Beak) are forms worn by Bákhbakwalanoóksiwey "when he flies to get food." This mask is remarkable but not unique. Usually each bird is represented by a single mask; here, in one mask, there are four birds, each with moveable lower jaws controlled separately.

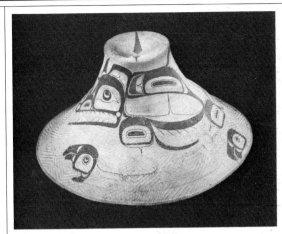

9498
Artist unknown
Haida

Hat, *spruce root*
Mountain goat
40.0 x 40.0 x 19.5

Before 1897

There are numerous examples of this type of hat in museum collections. The designs painted on them generally, as with this hat, represent one of the owner's crests. The hat was apparently reserved for special occasions because it has a cover of rough, checkerwork, black-dyed cedar bark which served to protect it when not in use. The hat belonged to a woman from Koona and bears a mountain goat design, one of the crests of the leading Raven lineage there, the Qagialsqegawai. The name of the chief of this lineage, Gidansta, was corrupted by Europeans to Skedans and it is by this name that the village of Koona is now generally known. The hat has been made from prepared spruce root. The crown and upper portion was woven in three-ply twining. The lower portion was made by the two-ply twining method and is embellished with the skip-stitch technique, resulting in the motif of diamonds within diamonds.

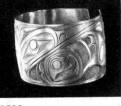

9523
Charles Edensaw
Haida

Bracelet, *silver*
Hummingbird (?)
6.5 x 5.6 x 4.1

Before 1908

Silver bracelets were originally made from beaten silver coins and worn by Haida women as items of personal decoration. One can assume that originally the designs on them represented the family crests of the wearer. Silver bracelets undoubtedly came to be one of the items of wealth distributed to guests at potlatches. It is also clear that they were, and still are, sought by non-Indians as prized examples of Haida tribal art.

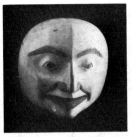

9694
Artist unknown
Tsimshian

Mask, *wood*
Moon
35.4 x 25.6 x 15.3

Before 1908

Little is known about this mask, although it is probable that it also was used as part of a *naxnox* dramatization (see 14308, page 52). Indeed, the rigging on the back suggests that it was not used as a mask, but rather as a prop which was suspended on strings in the dance house.

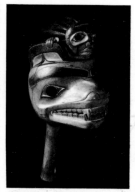

9729

Artist unknown
Haida

Rattle, *wood, hair*
Bear, man
26.5 x 13.5 x 10.5

Late 19th century

This rattle is of the type used by Haida shamans. A shaman was one who, while temporarily possessed by a supernatural being, was capable of performing various tasks such as causing or healing illness, foreseeing the future, or manipulating events. The office of shaman, although generally an inherited privilege, could be attained by anyone who was chosen by a supernatural spirit.

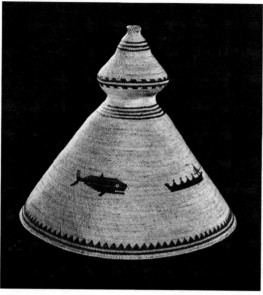

9736

Ellen Curley
Westcoast

Whaling chief's hat,
cedar bark, grass
Whales, canoes
33.5 x 33.5 x 29.3

1910

The use of hats, decorated like this one with a conical top portion and designs representing whaling scenes on the outside, may originally have been reserved for use by persons of status. Whaling was supremely important to the Westcoast people and the preparations for a whale hunt by a whaling chief and his crew were correspondingly complicated and rigorous. A successful whaler enjoyed enormous prestige. The hat is constructed entirely of a wrapped, twined weave. The warp is cedar bark and the wefts are natural and dyed grass.

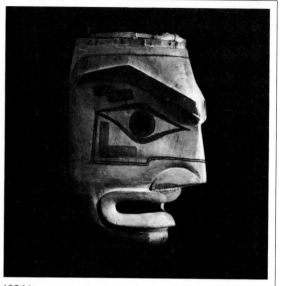

10244

Artist unknown
Westcoast

Mask, *wood*
Human (?)
42.3 x 28.4 x 22.4

Before 1922

This mask was made at Yuquot in Nootka Sound, where the first prolonged contact with Europeans on the Northwest Coast took place. A mask like this may have been used in the Westcoast Wolf Ritual or perhaps during the potlatches which generally accompanied these ceremonies.

The rigging on the top of this mask suggests that at one time it carried an extra figure or mechanical device.

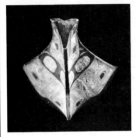 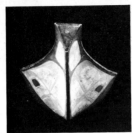

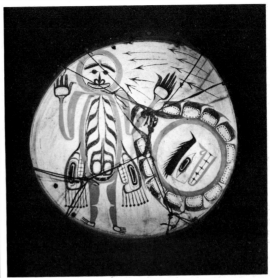

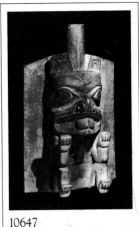

10598

Artist unknown
Haida (?)

Model canoe, *wood*
Abstract design
76.0 x 17.1 x 13.6

No date

This model shows the form of the classic northern canoe most frequently seen during the historic period. Full-sized canoes were frequently decorated, although perhaps rarely so elaborately. The other style of Haida canoe, which may have been reserved for use on special occasions, had large, decorated, wing-like projections at both bow and stern.

10630

Artist unknown
Haida

Drum and stick, *hide, gut, wood*
Narrative painting
62.4 x 62.4 x 9.0

Before 1900

Tambourine drums are composed of a circular wooden hoop, that has been steamed and bent, and a piece of wet deerhide that is stretched over the hoop. The rawhide drumhead tightens as it dries. In the damp climate of the Northwest Coast the drumhead becomes loose so the singer before using the drum tightens the skin by holding it over the fire.

10647

Artist unknown
Haida

Headdress frontlet, *wood*
Beaver
23.0 x 15.0 x 6.6

Before 1900

If finished, this headdress frontlet would have been part of a Haida chief's ceremonial regalia. Like the one shown on page 54, it would have been painted, inlaid with abalone, and attached to a headpiece which was fringed with sea-lion whiskers and carried a trail of ermine skins. During some of the dances at pot-latches, chiefs might be attired with, besides the crowning headdress frontlet, a Chilkat blanket and leggings, a dance apron, and a raven rattle. It is assumed that the carving on the headdress represents one of the chief's crests. The beaver is a common crest of the Eagle moiety of the Haida.

155

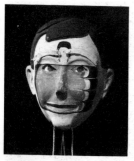

10665

Gwaytihl
Haida

Mask, *wood, string, skin (missing fur)*
Human
24.1 x 20.6 x 11.6
Before 1900

There are a number of these portrait masks made by Gwaytihl in the collections of museums throughout North America and Europe. They were apparently made for sale to non-Indians because there is no rigging attached to them for holding them on a dancer's head. However, many were rigged so that various facial features could be manipulated by strings. This mask was made so that the eyes could be moved from side to side, and the eyebrows up and down. The design on the face represents facial painting, a common practice amongst the Haida.

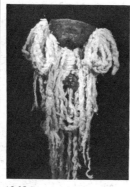

10694

Artist unknown
Coast Salish

Rattle, *mountain sheep horn, mountain goat wool, wood, abalone shell*
Unknown
94.0 x 47.0

No date

This rattle is typical of the type used by Coast Salish ritualists in connection with cleansing, naming, and life crisis ceremonies. It is likely that the designs on these rattles are related to secret ritual words which are the source of supernatural powers.

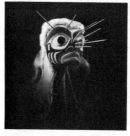

12731

Tony Hunt
Southern Kwakiutl

Mask, *wood, cougar pelt*
Bee
45.0 x 36.0 x 26.5
1967

Tony Hunt's grandfather, Mungo Martin, gave the Bee Dance and the accompanying song to Tony when he was about ten years old; the dance had descended to Mungo from his great grandfather. In the dance the bee darts around the bighouse, with arms outstretched, stopping briefly to threaten seated guests and appearing to sting them. Then the dancer disappears behind a painted ceremonial curtain and shortly reappears, without the mask, to dance more sedately. The naturalistic appearance of this mask is accentuated by transparent, dark, plastic eyes (through which the dancer sees) set in exaggerated orbits, and, of course, by the stingers.

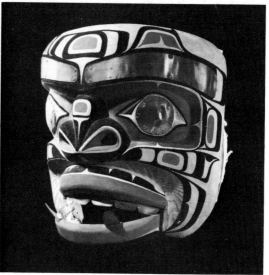

13215

Henry Hunt
Southern Kwakiutl

Mask, *wood, copper*
'Yagis
31.6 x 28.7 x20.7
1970

This mask was inspired by an older mask in the British Columbia Provincial Museum's collection which represents the sea-monster 'Yagis. This creature, whose dance is part of the Red Cedar Bark series, is a water monster which causes marine disorder. He can block up rivers, make great waves on lakes and on the sea, and can swallow or upset canoes. His dance is characterized by movements which imitate a sea mammal sounding, then surfacing and breathing. The copper teeth, eyes, and eyebrows, on this mask are indications of great wealth.

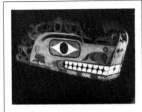

13254

Artist unknown
Westcoast

Headdress, *wood*
Haietlik (Lightning Snake)
57.0 x 24.5 x 21.0

No date

This headdress is typical of many examples known to have been used as part of the Westcoast ceremonial cycle known as the *tloquana* or Wolf Ritual. The ceremony dramatized the kidnapping of several child novices by Supernatural Wolves. The novices were later recaptured by their relatives, ceremonially purified, and allowed to display the song, masked dance, or other hereditary privileges they had acquired from the Wolves.

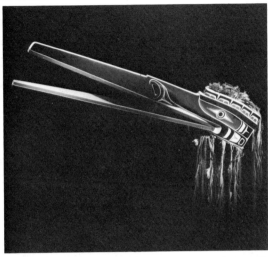

13846

Charlie G. Walkus
Southern Kwakiutl

Mask, *wood, cedar bark*
Hokhokw
148.1 x 23.0 x 19.1
(excluding cedar bark)

1971

This mask represents the Hokhokw, another of the fabulous bird-monster associates of Bákhbak-walanoóksiwey (The Cannibal-at-the-North-End-of-the-World) whose dance forms part of the *hamatsa* portion of the Red Cedar Bark series. The Hokhokw is readily identified by the long straight beak which he used to crush men's skulls so that he could consume their brains. The mask is worn, and the dance performed, in a fashion similar to that of the Galókwudzuwis. The most demanding part of these dances occurs when the performer must seat himself on the floor, move the heavy mask from side to side, and then stand up while snapping the beak.

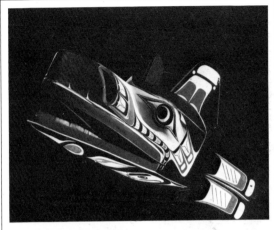

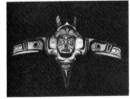

13848

Tony Hunt
Southern Kwakiutl

Transformation mask,
wood, copper, canvas, string
Sea Raven, moon
128.0 x 65.5 x 65.0 (open)

1971

Transformation masks were used by several of the coastal groups but occurred most frequently amongst the Southern Kwakiutl. These masks are graphic demonstrations of a keystone of Kwakiutl mythology–the ability of certain men and creatures to transform themselves into other beings. The Kwakiutl use these types of masks in the *tlásulá* series of dances. The dancer appears wearing the closed mask and, at an appropriate moment, the tempo of the dance song changes to accompany the imminent transformation. By pulling certain strings, the dancer causes the mask components to slowly separate until the inner carving, usually a humanoid face, is revealed to the audience.

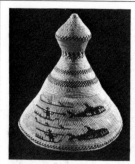

13874

Jessie Webster
Westcoast

Whaling chief's hat, *cedar bark, grass*
Whales, whalers, canoes
25.2 x 25.2 x 24.1

1971

This hat is inspired by the well known whaling chief's hat first recorded by Capt. Cook during his visit to Friendly Cove in 1778. The hat is constructed entirely of a wrapped twined weave. The warp is cedar bark and the wefts are of natural- and aniline-dyed grass.

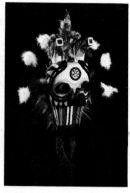

13884

Simon Charlie
Coast Salish

Mask, *wood, cedar bark, feathers, wire*
Sxwayxwey
96.4 x 71.7 x 25.6
(with attachments)

1971

This mask is a contemporary interpretation of a Sxwayxwey. The most notable features of Sxwayxwey masks are the irises of the eyes which project several inches. This mask appears to be styled to represent the "Snake-Face" type of Sxwayxwey. An animal head facing upwards forms the nose of the Sxwayxwey. A snake's body is shown curving up from this creature to the outside of the projecting irises and terminates at the bases of the two horn-like projections, carved like animals, which rise from the Sxwayxwey's head. The concentric circles on the forehead are a familar motif. The parallel lines below the nose are thought to represent the Sxwayxwey's tongue.

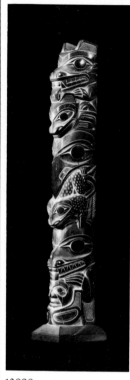

13898

Pat Dixon
Haida

Model pole, *argillite*
Top to bottom: grizzly bear, cub, raven, frog, sea bear, human
33.0 x 6.7 x 6.1

1968

Argillite carving went into decline in the 1930's and was not revived until the 1960's. Marius Barbeau's book *Haida Myths, Illustrated in Argillite Carvings* generated new interest in the art. *Haida Myths* served both as a reference and inspiration for the modern rebirth of argillite carving in which the late Skidegate artist, Pat McGuire, was eminent. McGuire reintroduced the ovoid form and some other classic sculptural elements. He also developed a new finish, highly polishing the stone with fine emery paper. He was a willing teacher, one of his notable students being Pat Dixon. Dixon's pole exemplifies the state of the art in the early 1970's; the work being a copy of an older pole illustrated in Barbeau.

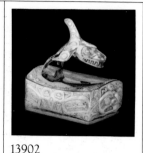

13902

Bill Reid
Haida

Bowl with lid, *gold*
Beaver, killer whale
10.0 x 9.4 x 8.2

1971

The shape of this artifact is based on a kerfed, wooden bowl. The separate lid, an elaboration of the customary cedar-bark cover, with its attached three-dimensional killer whale, complements the traditional form. The engraved and repoussé bowl is composed of a number of preformed segments soldered together. The whale was made by carving it in wax and then casting it by the lost wax method.

ARTIFACTS

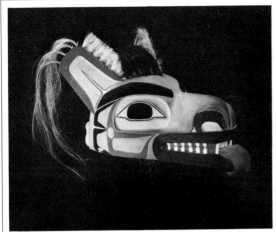

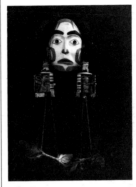

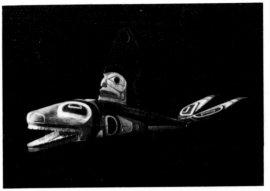

13917
Earl Muldoe
Tsimshian

Headdress, *wood, copper, bone, leather, hair*
Wolf
41.8 x 19.6 x 19.1
1970

This mask was inspired by a similar piece in the collection of the Portland Art Museum. The original, a well-documented Tlingit work,
"is very well carved in the form of a realistic wolf head with ears slanting backward, a large mouth set with animal teeth and outlined with copper, and copper nostrils. A red tongue hangs from one side of the mouth. The area on top between the ears is set with strands of finely cut baleen (whalebone) and the ears are fringed with tufts of animal's hair."
(Art in the Life of the Northwest Coast Indian. E. Gunther. Portland Art Museum.)
Muldoe's mask, while done by a Tsimshian artist, is not specifically characteristic of either Tlingit or Tsimshian tradition – the intent of the Kitanmax training being to exercise the students' carving techniques. Muldoe's mask has a more refined finish and form than does the old piece but still manages to capture some of the power of the original.

13918
Walter Harris
Tsimshian

Mask, *wood, hair, cedar bark, feathers, string*
Eagle Woman
23.1 x 19.1 x 12.7
1971

A similar mask in the collection of the Portland Art Museum was the inspiration for Harris' Eagle Woman. The older mask is without documentation and the artist has chosen to use the mask to relate a legend of a woman married to an eagle who bore two children in the marriage and then, with her children, escaped. When she came to a river she tied her children to her braided hair and swam to safety. Two handles, decorated with feathers, and attached by strings to her braid ornaments, enable the dancer to reveal magically her eagle children.

13920
Walter Harris
Tsimshian

Headdress, *wood, hair*
Killer Whale
116.0 x 66.0 x 49.8
1971

Walter Harris created this piece under the tutelage of Southern Kwakiutl artist Doug Cranmer. While the decorative design elements are Northern, the concept and overall format of the articulated whale is Southern Kwakiutl. Harris belongs to a division of the "People of the Fireweed" who claim the Killer Whale as a major crest.

This mask was worn by a member of Harris' family at the raising of his totem pole at Kispiox in 1971.

159

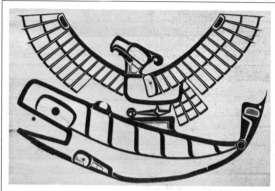

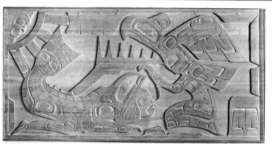

13960

Hupquatchew
Westcoast

Screen, *wood*
Thunderbird, finback whale
366.0 x 247.0

1971

Westcoast dance screens served several purposes; they could be lifted and beaten like a drum, performers could stand behind them on platforms so that only the masked and costumed upper parts of their bodies appeared to the audiences, and other dancers could be concealed behind them until their turn came to appear in public. The Thunderbird is one of the better known figures of Westcoast mythology. He was a huge man who resided high in the mountains and who would put on his bird-like dress to hunt whales as we see on this screen.

13961

Doug Cranmer
Southern Kwakiutl

Plaque, *wood*
Halibut, Thunderbird, men
304.8 x 152.4

1971

The carving on this plaque illustrates the origin myth of the Nimpkish tribe of the Southern Kwakiutl people. After the great flood, Halibut swam ashore at the mouth of the Nimpkish River. There he assumed human form and began to build a house. As he struggled to raise the massive house beams alone, he asked aloud for assistance. Upon hearing this request, Thunderbird flew down from above and, picking up the beams with his claws, put them in place. The Thunderbird then also assumed human form and with the Halibut became the first of the Nimpkish people.

On the plaque, one can see that both Halibut and Thunderbird are transforming to men showing both human and animal characteristics.

13981

Artist unknown
Haida

Spoon, *mountain goat horn, mountain sheep horn*
Raven, human, Wasco, unidentified figure
37.0 x 6.0 x 5.9

No date

The handle of a spoon like this is carved from mountain goat horn. The so-called mountain goat is actually an antelope and bears little resemblance to or kinship with the goats. The bowl is made from native sheep horn which had been heated in water and placed in a mould to achieve the proper shape. In historic times cow horn was sometimes substituted for the bowl.

14082
Earl Muldoe
Tsimshian
Box, *silver*
Unknown
11.3 x 9.8 x 9.8
1973

One of the early successes of the Kitanmax carving programme was the manufacture of bent-cornered boxes of red cedar. The students were instructed in the techniques of kerfing, steaming, bending and decoration by Duane Pasco, a non-Indian carver, who provided an important impetus to this programme. Kitanmax artists soon began to experiment in precious metals and it was logical to reproduce the box form in silver as a vehicle for two-dimensional design. Difficult metalworking and smithing techniques had to be mastered before Muldoe could create "worked wood" effects in silver. The "adzed" lid, engraved and incised elements on the box, are suggestive of the prototypic bent-cornered wooden boxes and chests.

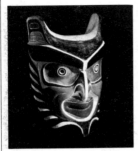

14106
Charlie G. Walkus
Southern Kwakiutl
Mask, *wood*
Bukwús
26.3 x 17.6 x 12.2
No date

This mask, because it has no rigging, was apparently made for sale and not for use. It represents a Bukwús (Wildman of the Woods or Man-of-the-Ground). The Bukwús is a small, human-like creature who moves with great leaps and bounds. He lives deep in the woods and anyone he can entice into partaking of his usual fare of snails, grubs, and toads, will be transformed into a creature like himself. He is usually seen only on deserted beaches where he hunts for cockles, his favourite food. A performer of this dance imitates the Bukwús' actions: concealing his masked face behind one arm and peering cautiously about for anyone who might be spying on him, he crouches on one knee and searches for cockles with his free hand.

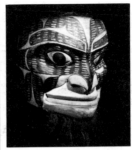

14308
Artist unknown
Tsimshian
Naxnox mask, *wood, fur (restoration), copper*
Unknown humanoid (?)
26.5 x 25.2 x 21.7
Before 1900

The stylized, dashed-feather designs and moveable features of this mask are typical of Tsimshian *naxnox* paraphernalia. *Naxnox* names were owned by family lineages and were assumed by the adult members of those lineages. *Naxnox* names would be dramatized in the masked dances which preceded potlatches, during which the audience was challenged to identify the spirit portrayed. This mask has eyes which can be rolled to three positions: open, shut, and displaying copper. Copper is a symbol of wealth. Also, the mouth is rigged so that when it is open a copper sheath can be pulled up over the teeth. Masks with moveable eyes were probably used in the "return to life" variety of *naxnox* during which the principal performer appeared to die, only to be later revived by a chief.

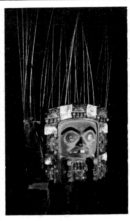

14310
Artist unknown
Tsimshian
Dance headdress, *wood, abalone, sea-lion whiskers, flicker feathers, hide, canvas, felt*
Lineage crest
21.5 x 18.7 x 18.7
(excluding whiskers)
Before 1903

Dance headdresses such as this one were the crowning portion of a Tsimshian chief's regalia whenever he appeared in his role of *wihalait* (Great Dancer) on ceremonial occasions. The other components of his regalia were a Chilkat blanket, raven rattle, dance apron, Chilkat leggings, and neck ring. The carving on the headdress represents a crest of the chief's lineage. This particular headdress was identified in a photograph taken in 1903 at the Nass River village of Gitlakdamix and probably belonged to the Wolf clan chief *kistaya'ox* (James Percival). Apparently, the crest represented is *wila'o* or "large template" (of what the carver is going to make).

14501

Mungo Martin
Southern Kwakiutl

Painting, *paper on masonite, graphite, watercolour*
Dzoonokwa, octopus sculpin
41.5 x 34.0

1956

The main figure of this painting represents a *dzoonokwa*, a wild woman who resides in the woods. Dzoonokwas appear in many family legends, and representations of them are frequently found in Southern Kwakiutl art. Dzoonokwa is portrayed as a powerful female giant covered with dark hair. She has pendulous breasts, a large head with sunken, half-closed eyes (dancers representing her, usually act as if half-asleep) and her lips are pushed forward to produce her identifying cry: "oooh!." In stories she is frequently described as carrying a basket, in which she puts children she has captured to eat. The octopus and sculpin in this painting indicate that this is a dzoonokwa-of-the-sea, as do the fins on her temple and cheek.

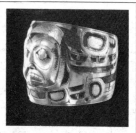

14528

Gerry Marks
Haida

Bracelet, *silver*
Human
6.7 x 6.4 x 5.2

1974

This fine bracelet depicts a human face centrally positioned with the body depicted in bilateral symmetry. The three-dimensional, low-relief face was produced by repoussé, a technique that involves hammering from back and front. The recessed, tertiary design elements on each side of the central face were produced by hammering from the front of the bracelet. Both the tertiary and ground areas of the two-dimensional design are darkened by chemical oxidization.

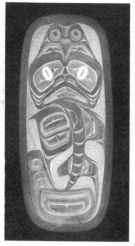

14529

Robert Davidson
Haida

Platter, *argillite, abalone shell*
Dogfish
19.8 x 9.0 x 2.3

1973

The dogfish, which is a small species of shark, has long been a favourite image of Robert Davidson. In addition to this platter, and the mask illustrated on page 89, Davidson has carved a wooden rattle, engraved at least one gold bracelet, and issued five silkscreen prints which depict the dogfish.

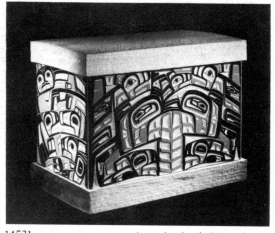

14531

Vernon Stephens
Tsimshian

Chest, *wood*
Mythological figures
86.0 x 49.5 x 64.0

1974

From the beginning, the Kitanmax School of graphic designers sought to be innovative in their flat design. Their handling of formline and secondary elements reflects clearly the influence of instructor Duane Pasco. In this chest, Vernon Stephens has transformed the main rectangular panels into a narrative design loosely depicting a Tsimshian legend, the Mountain Goats of Temlahan. A comparison of this piece with the classic chest illustrated on page 29 reveals the basic similarity between the front and back panels of each. It is in the end panels where we see Stephens' masterly attempt to depict four animal creatures, tightly interfaced, figuratively "in motion."

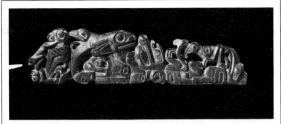

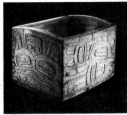

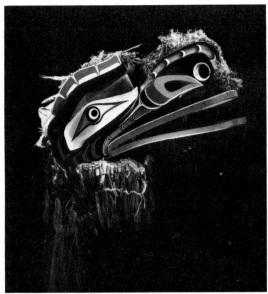

14677

Artist unknown
Haida

Panel pipe, *argillite*
Frog with human, insect, Raven-fin Killer Whale, bear, bear with tadpole (broken), eagle, grass-hopper, raven
31.2 x 7.7 x 1.8

ca. 1820–1830

Argillite is a soft carbon-aceous shale found on the Queen Charlotte Islands. Although little argillite appears to have been carved prior to contact with Europeans, a thriving industry began about 1820 in response to demands for curio items. The artform has continued to the present and remains the exclusive domain of the Haida. Although some of the creatures on this panel pipe, such as the Raven-fin Killer Whale, are identifiable as crest animals, others are not. Insects commonly occur on panel pipes, yet they are rarely seen on other tra-ditional objects which have survived from this period. The dragonfly is the only insect recorded as a Haida crest.

14678

Artist unknown
Haida

Bent bowl, *wood*
Bird
51.2 x 40.8 x 32.7

No date

This elegant food bowl has a kerfed construction, similar to the chest illustrated on page 29. The undulating, lipped rim adds to the overall grace of its form. Decorated food bowls were used on ceremonial occasions when hosts fed their guests. The engraved and/or painted design often represented the owner's crest and an occasion, such as a feast or potlatch, was an appropriate oppor-tunity to enlighten one's guests about the origin, meaning, and importance of such crest figures.

15055

Willie Seaweed
Southern Kwakiutl

Mask, *wood, cedar bark, copper*
Galókwudzuwis (Crooked Beak of Heaven)
80.2 x 36.3 x 24.4
(excluding cedar bark)

ca. 1935

This mask was carved as a replacement for the one illustrated on page 78. Both masks were carved by Willie Seaweed and both have the hinged forehead which, when raised, displays the band of copper. Copper usually signifies wealth. This mask was purchased from the artist's son in 1973.

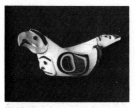

15088
Norman Tait
Tsimshian

Bowl, *wood*
Bird, man
40.3 x 20.0 x 16.0

1974

This bowl is a contemporary example of a type of food dish which was used throughout the Northwest Coast (see page 50). The carvings on these vessels in many cases were undoubtedly representations of crests or mythical protagonists, but some may have been purely decorative. In this instance carvings of a human figure and bird have been added to the basic bowl form to enhance its appearance.

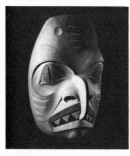

15119
Robert Davidson
Haida

Mask, *wood*
Dogfish
29.0 x 20.6 x 13.4

1974

The dogfish or shark is signified by the mask's downturned mouth, triangular teeth, gill slits on each cheek and elongated forehead with another set of gill slits. The two circles represent the nostrils which appear on the underside of the head of an actual shark. The third set of gill slits is artistic license.

15416
Hupquatchew
Westcoast

Silkscreen print, *paper, ink*
Whaling images
93.5 x 62.5

1977

This innovative narrative print is entitled *The Whaler's Dream.* The artist describes the imagery of the print as follows:

"This print illustrates some of the images that might flow through a man's mind, the last few days before he joined a whale hunt off the West Coast. During those last few days before he put to sea, his mind would be on very little else but the hunt. A canoe crewman, in his sleep, might dream of any or all of the characters or figures shown. They are all linked in some way with whaling and the sea; and some that are more closely related are shown overlapping. At the top of the print are four seal skin floats. The harpoon heads used during the whale hunt had lines attached to them. After the harpoon heads were sunk deep into the whale blubber, a certain amount of line was played out; then the sealskin floats were attached to the lines. They were used to slow the whale down if he swam seaward; and after the kill, they helped keep the beast afloat. On the left side of the panel, connected by a twisted cedar bark rope to the sealskin floats, is the whaler's harpoon. It is made up of a harpoon head, the lines running from the head, and the shaft. The harpoon heads used to be manufactured from the shell of a giant mussel and two elkhorn barbs bound together. The leader line attached to the head was braided out of sinews. The shaft was constructed of three or four sections of yew wood bound together with cherry bark. The leader line attached to the head was braided out of sinews. Below the harpoon head is the familiar silhouette of a West Coast type canoe, with its bow facing to the right. Immediately below the floats, on the right, there is Moon calling the tides to rise and set. The sea is symbolized by the series of broken blue lines, above the figure with her arm extended. Below the moon, on the right side of the print, is the whaler's paddle; it was of key importance. It was carved from a single piece of yew wood with the crosspiece added and the centre grip bound with cherry bark. The four figures filling the inner panels represent the great saddle of a fin whale; the tail of a sounding whale; lightning flashing from a dark cloud; and an active rain cloud. The centre of the design is occupied by a representation of the North Star which the whalers of old did much navigating by."

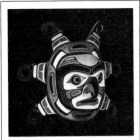

15426
Richard Hunt
Southern Kwakiutl

Mask, *wood*
Sun
56.4 x 44.4 x 23.5
1976

The sun does not figure prominently in Kwakiutl mythology, however it is included in some family histories and performs during the *tlásulá* (secular) ceremonies. A dancer, body covered by a blanket, moves majestically around the fire suggesting an ancestor who lives in the sky and who, every morning, puts on a blanket covered with shimmering abalone shells and walks across the heavens.

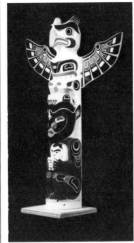

15807
Willie Seaweed
Southern Kwakiutl

Model pole, *wood*
Thunderbird, *dzoonokwa*
Human
52.8 x 35.6 x 15.3
Before 1959

This model totem pole depicts a thunderbird with outstretched wings on top of a sitting *dzoonokwa* holding a small human figure. After carving was completed, the entire pole was painted white. Additional colours, which emphasize anatomical and sculptural details were then added. Full size Southern Kwakiutl totem poles carved between about 1900 and the mid-1950's also exhibit the use of a painted white ground.

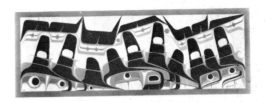

16326
Doug Cranmer
Southern Kwakiutl

Painting, *mahogany board, acrylic paint*
"Killer Whales"
122.3 x 44.8 x 4.0
1976

Because of the graphic nature of two-dimensional design, it is easily removed from the context of artifact. As a result paintings and silk-screen prints have become a popular vehicle for North-west Coast art in the past decade. In his painting "Killer Whales," Southern Kwakiutl artist Doug Cranmer has explored new directions in graphic design. Colours are allowed to overlap, u-forms come to represent clouds and a new kind of motion is introduced. In "Canoe," illustrated on page 122, an even greater abstraction is achieved, the design seeking to represent tree, log, and finished canoe.

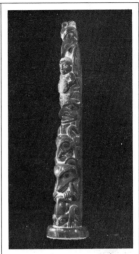

16473
Charles Edensaw
Haida

Model pole, *argillite*
Raven, man with moon, hawk-man, whale, seal, bear, frog
49.5 x 9.9 x 8.0
No date

The first argillite model totem poles were made about 1865. The early examples incorporated the form and proportions of full-size totem poles. That is, in cross section, shallow, half cylinders, with carved, essentially two-dimensional, formline figures applied to their frontal surfaces. Although this pole, probably from the period 1880–1900, has a partially hollowed back, it illustrates the trend, evident in the late nineteenth and early twentieth centuries, away from a formline structure toward fully sculptured, three-dimensional figures.

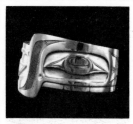

16601
Robert Davidson
Haida

Bracelet, *silver*
Whale
6.8 x 5.3 x 3.7
1979

This finely hammered and engraved bracelet depicts two whale heads in profile. In relation to one another, each profile head is upside down and moving in opposite directions. Each head is missing its lower jaw.

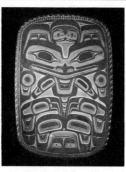

16602
Reg Davidson
Haida

Platter, *argillite*
Sea bear, killer whale
34.7 x 24.4 x 2.5
1979

A shallow, argillite platter with a bilaterally symmetrical design entitled "Sea Bear eating Killerwhale." The large bear's head, with a smaller head between its ears, dominates the upper design field. Two pectoral or side fins are at the outer edge of the platter immediately below each end of the bear's toothed mouth. Each finned and clawed rear limb joins the lower edge of the side fins. The headless body of the killer whale with its two pectoral fins extends out of the bear's mouth down through the central axis of the platter, its bilaterally symmetrical fluked tail at the bottom of the design field. A complex u-form separates the two lower lobes of the tail. The margins of the rectanguloid design field are delineated by a double border of fluting and gadrooning. The two-dimensional form-line design was derived from a silkscreen print issued by the Haida artist Don Yeomans in December 1978.

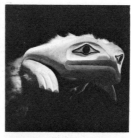

16603
Reg Davidson
Haida

Headdress, *wood, fur, ermine pelts*
Frog
22.2 x 19.2 x 12.5
(excluding train)
1979

This is a carved and simply painted frog crest headdress of alder wood. Only the frog's head and forelegs are depicted. A white, rabbit-fur cap is sewn to the wooden portion. Two rows of ermine skins are attached to the back of the cap. This headdress was used by the artist at a modern celebration entitled "Tribute to the Living Haida" which took place at Old Masset during the spring equinox in 1980.

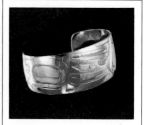

16604
Gerry Marks
Haida

Bracelet, *silver*
Whale, humans
6.5 x 5.4 x 3.2
1980

This fine bracelet was inspired by the myth entitled "The Man Who Married A Killer-Whale Woman" (Swanton 1905 a: 286–287). The myth tells of the woman's liaison with a whale, the husband's cruel revenge and the woman's subsequent fate when she walks into the sea and transforms herself into a reef. The design includes the whale's head; the woman, represented by the upside-down profile face; the whale's tail, indicated by the slanting ovoid and the split u-form as one lobe of the flukes; and the husband, by the smaller profile face placed vertically at the end of the bracelet. The husband's body is suggested by the recessed s-form, his limbs by the u-form complex below the teeth.

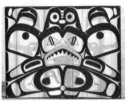

16605
Jim Hart
Haida
Screen, *wood*
Dogfish
277.0 x 213.8 x 4.1
1979

Screens such as this were used as ceremonial partitions. The design on this screen represents a dogfish and is the first attempt by the artist at a large-scale graphic in wood.

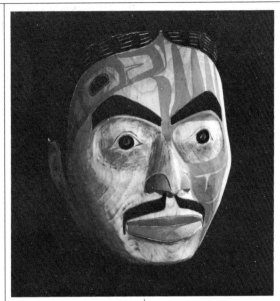

16606
Freda Diesing
Haida
Mask, *wood*
Human
23.1 x 19.6 x 13.9
1980

This face mask of a human male is made from alder wood. The red design that begins below the left ear and turns to surround and project above the left eye is an arm and hand that holds a paintbrush. The latter is depicted above the right eye and eyebrow.

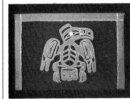

16607
Florence Davidson
Haida
Button blanket, *wool,*
buttons
Raven
191.0 x 128.0
1975

This is a button blanket of blue wool cloth with an applique design rendered in red wool cloth and pearl-finish, plastic buttons. The top and sides of the blanket have a continuous band of red wool cloth embellished with buttons. The design, created by Mrs. Davidson's grandson, Robert Davidson, depicts a bilaterally symmetrical frontal view of a bird's body with its head in profile.

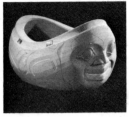

16609
Dempsey Bob
Tahltan-Tlingit
Bowl, *wood, abalone shell*
Human
22.9 x 17.0 x 12.0
1980

This oval **alder bowl** is carved in the form of a man crouching on his hands and knees. At one end is the face with a smiling expression and around the rest of the bowl is the body depicted in a stylized formline design which contrasts markedly with the realism of the face. The rim is slightly hollowed and is inlaid with eight evenly spaced rectangles of abalone shell.

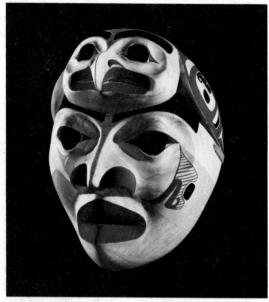

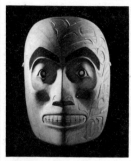

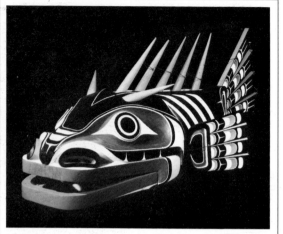

16610
Dempsey Bob
Tahltan-Tlingit

Mask, *wood*
Hawk Dancer
23.0 x 17.5 x 12.7
1980

This mask represents a human dancer wearing a hawk headdress. In the centre of the dancer's forehead is the hawk's head with a wing on each side. The blue, split u-forms with the pointed extensions, on the right cheek depict feathers. The red profile face and blue u-forms on the left cheek suggest a wing. The idea for this mask came from stories told to the artist by his grandmother, of dancers portraying different animals. This mask is a conscious attempt to emulate the old Tlingit style.

16611
Robert Jackson
Tsimshian

Mask, *wood*
Human
24.0 x 18.2 x 11.7
1979

This mask depicts a male slave whose face was burnt in a fire. The left half of the mask, with the engraved design that is stained red, represents the burnt wrinkled skin. The other side of the face, with the painted blue design, portrays smooth, unburnt skin. The mask was inspired by a traditional story told the artist by his grandmother.

16612
Richard Hunt
Southern Kwakiutl

Mask, *wood*
Sculpin
154.5 x 45.2 x 42.0
(closed)
1980

A similar piece in the collection of the Museum of Anthropology at the University of British Columbia inspired this sculpin mask. During the *tlásulá*, or secular, dance sequence of the potlatch a performer wearing a button blanket and chief's headdress disappears from the big-house. His attendants return holding his dancing paraphernalia and announce that he has been spirited away. After a time, a masked performer enters the house – the mask representing the creature which has captured the dancer. This sculpin mask is worn on the upper back of the dancer who is bent forward at the waist.

The articulated anatomical parts–the dorsal spines, pectoral fins, tail and lower jaw–can be manipulated by the dancer.

16613

Henry Hunt
Southern Kwakiutl

Bowl, *wood*
Sea otter with urchin
52.0 x 27.6 x 21.0

1980

This dish has been carved to represent a sea otter in a characteristic pose. After diving and removing a sea urchin from a rock, an otter will return to the surface and float on its back to eat the urchin. This particular motif of a sea otter and urchin was popularized in a drawing created by Mungo Martin at about the same time as his *dzoonokwa* and octopus (see page 74).

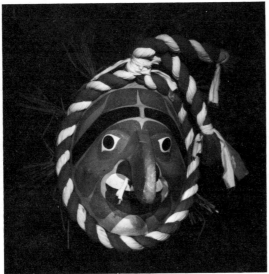

16615

Beau Dick
Southern Kwakiutl

Mask, *wood, cedar bark, cloth*
Noohlmahl (Bella Coola style)
30.2 x 23.8 x 23.5
(excluding bark and cloth)

1980

Another creature who figures in the Red Cedar Bark dances of the Southern Kwakiutl is the Noohlmahl. The origin of the Noohlmahl prerogative is explained in the story of a man who encountered some of these creatures while he was in the woods and who eventually returned to his village acting and looking like one of them. Noohlmahls are characterized by their large noses, their unclean, snot-covered bodies, and by their boisterous, uncontrollable, and contrary behaviour. They are considered to be messengers of the *hamatsa* and persons who were possessed by their spirit acted as a sort of police during the *hamatsa* dances. Any breach of decorous behaviour, or reference to or touching of their noses by members of the audience would spur the Noohlmahl into violent, foolish, or destructive behaviour. Noohlmahl masks are easily identified by their large noses and by the braided cedar bark (represented on this mask by cloth) about their faces. Interesting features of this mask are the pieces of cloth in the nostrils which are attached to the back of the mask by elastic bands. These serve to emphasize the contemporary usage of these masks in which the dancer circles the dance house crying "whee! whee!" and pretends to wipe his nose and throw the snot at the assembled guests.

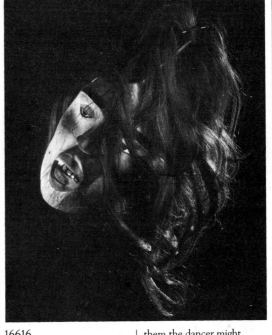

16616

Beau Dick
Southern Kwakiutl

Toogwid prop, *wood, hair*
Human head
32.0 x 18.7 x 16.9

1980

This prop would be used in a portion of the Red Cedar Bark dances in which a *toogwid* power is displayed. The performer, a woman adorned with hemlock branches, enters the house singing a song in which she claims great supernatural powers. After three unsuccessful attempts to call her power, she succeeds, on the fourth, in displaying some wondrous prerogative. These performances perhaps mark the high point of Southern Kwakiutl stagecraft, for in them the dancer might appear to be burned in a fire, have a spike driven through her head or a spear through her body, or she might summon apparently animate creatures from the ground, out of boxes, or through the roof. This particular prop is inspired by a performance during which the woman would appear to be beheaded, and her severed head (actually a prop like this one) is held up for all the audience to see. After any of these displays of power, the woman would reappear, unscathed as an affirmation of her control of the supernatural.

16617
Calvin Hunt
Southern Kwakiutl

Dance costume, *wood,
cedar bark, raffia, rope,
card, worked skin, feathers,
bear pelt*
Sísioohl, killer whale with
seal, human skulls
89.0 x 77.0 x 13.0 (tunic)
36.9 x 31.4 x 28.2
(headdress, excluding
cedar bark)
1979

This dance costume was
inspired by a similar one
made in 1904 for the Field
Museum in Chicago by Bob
Harris of the Southern
Kwakiutl village of
Tsadsisnukwomi. This dance
costume was the special
prerogative of the K'ek'aenook
clan of the Awaitlala tribe
and was used in the *hamatsa*
portion of the Red Cedar
Bark dances. The acquisition
of the various prerogatives
displayed on the costume is
explained in stories des-
cribing the exploits of
Xaniats'amg'il.akw, one of the
clan ancestor-heroes. The

headdress represents
Quaquani (Sandhill Crane)
on top of a killer whale's
face. The coat is constructed
to represent a tunic of
elk-skin armour. Across the
top front of the coat is a
representation, in carved and
painted wood, of the
fantastic, double-headed
serpent Sísioohl. Down the
front and back of the coat
are carved and painted pieces
which represent a killer
whale. Note that the whale
on the front of the coat
holds a seal in his mouth.
The carved and painted
wood strips on the shoulders
and shins represent flippers.
The carved skulls on the
front and back of the
costume represent people
killed in battle by the original
owner of the costume.

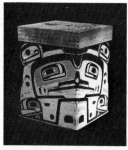

16618
Bruce Alfred
Southern Kwakiutl

Box, *wood*
Unknown
42.8 x 33.6 x 33.6
1979

This kerfed, bent box is
similar to a traditional
Northern formline decorated
box, with its thick, flat-
topped lid. The older style
of Southern Kwakiutl box
has a thin, flanged lid, a
different type of kerfing
which has a vertical cut on
the outside of the kerf, and
no painted formline design.
The exterior decoration of
traditional Southern
Kwakiutl, and Westcoast,
boxes is an unpainted,
patterned design, produced
by sets of shallow, parallel
grooves running at angles to
one another. The grooves
were produced with a curved
knife.

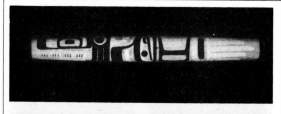

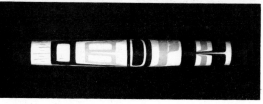

16619
Bruce Alfred
Southern Kwakiutl

Rattle, *wood, pebbles*
Abstract
60.0 x 8.0 x 8.0
1979

16620
Bruce Alfred
Southern Kwakiutl

Rattle, *wood, pebbles*
Abstract
58.5 x 7.0 x 6.5
1979

Each rattle was made from a
cylinder of red cedar which
was split lengthwise, shaped,
and hollowed. Pebbles were
placed in the hollow, the two
pieces were then glued
together and later painted.
These rattles are associated
with a dance privilege owned
by certain Southern Kwakiutl
families. During the dance,
attendants use the rattles in
an attempt to calm a

voracious and noisy baby
hamatsa who is suspended in
a cradle above the dance
floor. Instead of a real child,
theatrical devices are em-
ployed to create motion and
crying sounds in the cradle.

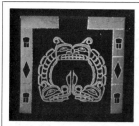

16621
Shirley Ford
Southern Kwakiutl

Button blanket, *wool, cotton, buttons*
Sísioohl, coppers
168.0 x 150.0

1979

This blanket of black wool cloth was made with a Sísioohl design of red felt applique, decorated with pearl-finish, plastic buttons. The centre portion of the top edge of the blanket is bound with a dark blue cotton fabric while the rest of the top edge and both side edges have a wide band of red felt applique trimmed on the inside edges with a solid row of buttons. Each side border has cut-out (reverse applique) designs of two coppers with a diamond-shape between. The design was created by Mrs. Ford's second cousin, Calvin Hunt.

16622
Joe David
Westcoast

Drum and stick, *rawhide, wood, worked skin*
Whale, cannibal bird, human skull
44.2 x 44.2 x 6.6 (drum)
33.8 x 2.5 x 2.4 (stick)

1979

The tambourine style drum has come to be the preferred musical instrument at contemporary Westcoast gatherings. These drums are almost always decorated. In this example a whale is illustrated. The drumstick depicts a cannibal bird holding a human skull with vertebrae in its beak.

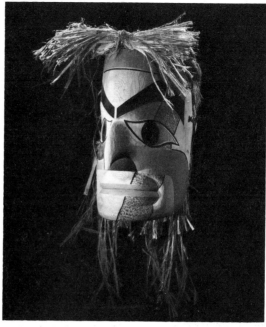

16624
Art Thompson
Westcoast

Mask, *wood, cedar bark*
Human
31.2 x 21.4 x 18.8
(excluding cedar bark)

1979

This carved and painted mask of red cedar has a human-like face and cedar bark "hair." The face is simple, almost triangular in cross section, with a high forehead, a slightly hooked nose, a distinctive eye form, and bold, asymmetrically designed face painting.

16626
Tim Paul
Westcoast

Transformation headdress, *wood, mirror*
Haietlik (Lightning Snake), sun
149.8 x 121.5 x 38.6 (open)

1980

A carved and painted complex Haietlik headdress; the larger head has a smaller one inside which has an articulated, painted fan attached. At one moment in the dance, when the dancer is resting with his back to the audience, the inside head is raised up and the fan with its sun design opened. The dancer then displays this transformation to the audience and at the next pause returns the fan to its closed position and lowers the smaller head. The performance is then completed with the headdresses in their initial position. The Haietlik are Feathered Serpents who are simultaneously "Lightnings."

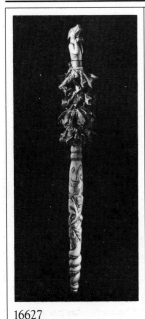

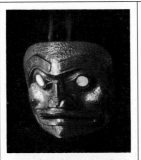

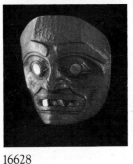

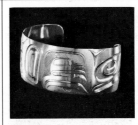

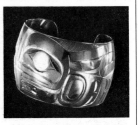

16627
Rod Modeste
Coast Salish
Dance staff, *wood, leather, deer hooves, buckles*
Wolves, serpents
109.3 x 6.0 x 6.0
1980

Coast Salish people today maintain a powerful dancing complex in which initiates are inspired by a spirit power and seek to manifest this in song and dance. Dancers become possessed; this altered state is induced, in part, by the rhythmic shaking of short staffs to which deer hoof rattles are attached. Figures carved on the staffs are representations of spirit helpers. Sometimes these are deliberately rendered in an ambiguous manner so that the uninitiated cannot identify the supernatural aide.

16628
Russell Smith
Southern Kwakiutl
Pendant, *copper, abalone shell*
Human
5.4 x 5.2 x 1.9
1980

16629
Russell Smith
Southern Kwakiutl
Pendant, *copper, abalone shell*
Human
4.9 x 4.6 x 2.2
1980

These copper pendants are engraved and formed by repoussé. The eyes of both pendants, and the mouth of one, are inlaid with lustrous abalone shell. The stippled surface of each face, produced by a fine hammering technique, evokes the finish applied to figures on totem poles with the D-adze.

16630
Don Yeomans
Haida
Bracelet, *silver*
Raven
5.9 x 4.9 x 2.5
1980

This bracelet illustrates a raven. The foot is below the body, which is portrayed as a profile face, followed by the wing and tail. The lower edge of the bracelet below the raven's head is shaped to the form of the bird's beak. The orientation of the design, the weight of the formline, and the use of the soft ovoid with a convex lower margin, as the eye of the bird and the joint of the tail, indicate the influence of Yeoman's teacher, Robert Davidson.

16631
Phil Janzé
Tsimshian
Bracelet, *silver*
Flying frog
6.0 x 5.1 x 3.8
1980

This engraved bracelet illustrates the flying frog, a crest belonging to the Frog-Raven clan in each of the three divisions of the Tsimshian. A Gitksan myth describes these creatures as "frogs of the lake who fly away on moth-like wings." The design is arranged asymmetrically. The head is shown full-face with protruding tongue and front legs underneath, a short wing to the left and a more detailed wing and the rest of the body, including the webbed rear foot and tail in profile, to the right.

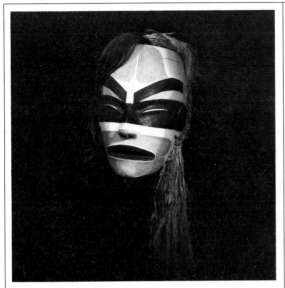

16632
Tim Paul
Westcoast
Mask, *wood, cedar bark, hair*
Human
25.0 x 18.9 x 14.5
1980

This carved and painted red cedar mask depicts a dead warrior. Although the mask was inspired by an old piece collected by James Cook from Friendly Cove in 1778, it differs from the original in that the "hair" is comprised of both human hair and shredded cedar bark, and in the bold, red and black, facial designs. The fine sheen of the black colour was made by adding powdered graphite to the paint.

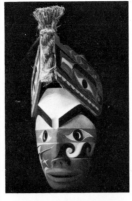

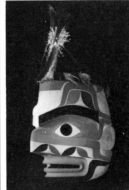

16633
Joe David
Westcoast
Mask, *wood, cedar bark, feathers*
Young man with Haietlik headdress
38.0 x 22.0 x 18.0
1979

16634
Joe David
Westcoast
Mask, *wood, cedar bark, hair, feathers*
Speaker
29.9 x 28.4 x 22.4
1979

The small human face mask represents a boy wearing a *haietlik* mask. The boy is getting his young man's name in the *tloquana* (Wolf Ritual), a ceremony which marks his entrance into adulthood. The boy's father, represented by the larger mask, is the speaker who explains to the assembled guests the history and meaning of his son's new name. The ochre band, across the eyes of each human mask, indicates that the people the masks represent are nobles. Commoners wear a black band across the eyes. The twisted cedar bark is emblamatic of the Wolf Ritual. According to the artist these two masks do not represent a specific dance or prerogative, but refer to an idea or concept that explains an aspect of Westcoast ceremonialism.

16635
Doug Cranmer
Southern Kwakiutl
Painting, *mahogany board, acrylic paint*
"Canoe"
63.2 x 60.3 x 4.3
1978

This painting is discussed on page 165 in the context of Cranmer's other painting, "Killer Whale."

16637
Art Thompson
Westcoast

Headdress, *wood, cedar bark, feathers, mirrors, hair*
Haietlik (Lightning Snake)
60.9 x 25.4 x 22.7

1978

16638
Art Thompson
Westcoast

Headdress, *wood, cedar bark, feathers, hair*
Haietlik (Lightning Snake)
57.5 x 27.7 x 22.8

1978

These carved and painted headdresses are made from a number of flat red cedar boards sewn and glued together. They represent the Haietlik, as do the smaller heads that rise out of the nose of the larger figures. They were inspired by a dream that occurred to an old-time Nitinat artist. In the dream a Haietlik rose up out of a river. Suddenly a small Lightning Snake appeared, dancing on the nose of the larger one. These headdresses have been used in dances at Nitinat on the west coast of Vancouver Island and at Neah Bay on the Olympic Peninsula, U.S.A. When they are used one is worn by a woman, the other by a man.

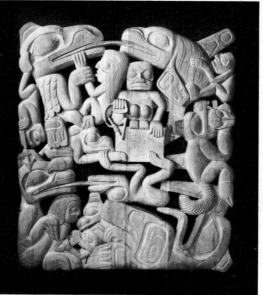

16639
Bill Reid
Haida

Screen, *wood*
Mythological figures
213.0 x 190.3 x 14.6

1967

Several of the creatures which appear in Haida myths can be seen in this screen. In the upper left corner a representation of Raven, the trickster, who is shown half-transformed into a human, can be seen. To the right of Raven is a halibut fisherman and his wife; the fisherman is crouched atop his decorated fish box and holds a halibut hook and line: his wife is being grasped by Raven. To the right, at the top, is a depiction of the myth in which the strong man Konakadet rode the back of a killer whale. The group of figures in the lower left of the screen refer to the Bear Mother myth in which a young woman is kidnapped by a bear who forced her to marry him. She gives birth to half-human, half-bear twins before her brother and his dog rescue her. Here the bear is seen clutching the woman who faces her children. Atop the bear's head is the brother with his spear and dog. The other figures illustrated are a frog (whose tongue is joined with the bear's), an eagle lying on its back at the bottom of the screen, and a Wasco (Sea Wolf) at the right edge, with a small creature in its jaw.

25.0/2
Charlie George Jr.
Southern Kwakiutl

Mask, *wood, cedar bark*
Galókwudzuwis (Crooked Beak of Heaven)
81.3 x 45.7 x 27.9

Before 1940

This fine Crooked Beak of Heaven mask serves as a more modern example of the type. It can be compared with the older Crooked Beak mask made by Willie Seaweed approximately fifteen years earlier, illustrated on page 79. The piece is now in the collection of the Thomas Burke Memorial Washington State Museum.

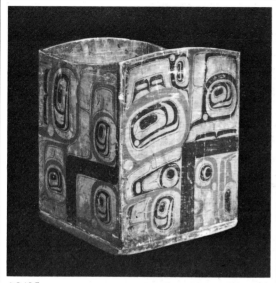

A8435

Artist unknown
Haida (?)

Bent bowl, *wood*
Unknown
41.1 x 33.8 x 33.8

No date

This bowl was made by kerfing and bending a plank and then attaching the separate bottom. It differs from a typical Northern box in having an undulating rim that curves up on the ends and down on the sides. Boxes have horizontal rims and, when complete, wooden lids. A number of bowls in museum collections have tight-fitting, cedar-bark covers. This bowl was donated to the University of British Columbia Museum of Anthropology by Mrs. Grace Frost who may have acquired it while serving as a nurse in Masset between 1920 and 1945, for the Department of Indian Affairs.

Alan Hoover and Kevin Neary

ARTISTS, LISTED ALPHABETICALLY

ARTISTS

Bruce Alfred
b. 1950

Artist Bruce Alfred, of Alert Bay, has been working in Northwest Coast art for approximately two years. He spent a year studying flat design with Doug Cranmer. and has worked briefly on sculpture with Richard Hunt and artists associated with the Arts of the Raven Gallery. Alfred has produced masks and plaques as well as kerfed bent boxes.

Dempsey Bob
b. 1948

Tahltan-Tlingit artist Dempsey Bob, a member of the Wolf clan, was born at Telegraph Creek on the Stikine River. He began carving about 1970, first studying with Freda Diesing at Prince Rupert and later, in 1972 and 1974 at 'Ksan. Although he works in silver and gold, his preferred medium continues to be wood. Dempsey Bob's bowls and masks are executed with a deft and sure hand, smoothly integrating sculpture and two-dimensional design as they trace the artist's exploration of the old Tlingit style.

Simon Charlie
b. 1919

Coast Salish artist Simon Charlie began carving in his teens, mainly as a hobby. He is largely self taught but has worked with tradition-ally trained artist Henry Hunt at the British Columbia Provincial Museum. In ad-dition to carving such traditional objects as the Sxwayxwey mask seen in this exhibit, Simon Charlie has carved several large sculptures which can be seen at sites along the highways of southern Vancouver Island.

Doug Cranmer
b. 1927

Nimpkish artist Doug Cranmer was born at Alert Bay. Although in his youth Cranmer watched resident carvers Arthur Shaughnessy and Frank Walker at work, his first formal instruction came from Mungo Martin in the mid-1950's. At about the same time, Cranmer met Bill Reid and agreed to work with him at the University of British Columbia produc-ing seven large carvings as well as two Haida-style houses. This association gave Cranmer an opportunity to gain from Reid an under-standing of Northern two-dimensional design, important in the evolution of Cranmer's own mature flat design. After completing the project at University of British Columbia in 1962, Cranmer helped operate a Vancouver retail shop, *The Talking Stick.* This was an important first attempt to market quality material through an outlet that was both owned and controlled by Indian people. Cranmer has also contributed significantly as a teacher; at

'Ksan in 1970, the Vancouver Centennial Museum in 1973, and in Alert Bay beginning in 1977. About 1975, Cranmer began a series of experimental paintings that can best be described as abstracts. Although a Northern influence is present in Cranmer's work, it is basically Southern Kwakiutl and distinctively personal.

varied background of experience has allowed David to independently, and in concert with his cousin Ron Hamilton, rediscover and redefine the old Westcoast tradition of sculpture and design.

Ellen Curley
?

Mrs. Curley was a Westcoast basketmaker from the village of Opitsat. In 1904, Mrs. Curley accompanied Dr. C. F. Newcombe and seven other native Indians, to the St. Louis World's Fair where she and the one other woman in the party demonstrated their basket-making skills. In 1910, Dr. Newcombe commissioned Ellen Curley to weave the hat that is illustrated on page 80. Unfortunately little else is known about the life of this accomplished weaver.

Joe David
b. 1946

Joe David was born in the small Clayoquot village of Opitsat on the west coast of Vancouver Island. Although much of his childhood was spent in Seattle, he maintained a positive connection with his cultural heritage through his late father Hyacinth David. In the late sixties, after attending art school and working as a commercial artist, David turned his attention to Indian art. Following this personal decision, he met Duane Pasco, a recognized student and teacher of Northwest Coast art, and Bill Holm, the well-known Northwest Coast scholar. David began attending Holm's classes at the University of Washington and between 1971-1973 was apprenticed to Pasco. Both Pasco and Holm stimulated David to explore the style of a number of Northwest Coast traditions. This

Florence Davidson
b. 1895

Mrs. Davidson was born and lives in the Haida village of Old Masset on the Queen Charlotte Islands. She first assisted her mother sewing button blankets as a child. It was not until 1952 that she again made a blanket. Since then, she thinks she has made approximately fifty blankets. Mrs. Davidson is also a basket-maker, although for the last few years she has not been active due to arthritis. She has woven both cedar-bark and spruce-root baskets and hats. Florence is a respected Haida elder whose father was Charles Edensaw and whose grandson is Robert Davidson.

Reg Davidson
b. 1954

Reg Davidson was born at Masset on the north coast of the Queen Charlotte Islands. He began carving argillite in 1972. Davidson first carved in wood while an apprentice to his older brother, Robert Davidson, during the carving of the Charles Edensaw memorial housefront and associated houseposts in 1977 and 1978. In addition to his work in argillite and wood, Reg Davidson has produced several silkscreen prints.

Robert Davidson
b. 1946

Davidson began carving argillite as a teenager in his home village of Masset on the Queen Charlotte Islands. In 1966 he met, and became an apprentice to, Bill Reid. He returned to Masset in 1969 to carve and erect a forty-foot totem pole. His pole was the first to be raised on the Queen Charlotte Islands in approximately ninety years. Davidson's work exhibits both a high degree of craftsmanship and a thorough understanding of traditional Haida sculpture and design. His work is often highly innovative, particularly his many fine pieces in silver. Robert Davidson's understanding of Northern two-dimensional design is such that he consciously pushes his designs to find new solutions to the old Haida problem of not merely filling the given space but relating the design to the total space as well as controlling the shape of the ground or negative space.

Beau Dick
b. 1955

Beau Dick was born in the isolated Southern Kwakiutl village of Kingcome. While attending school in Vancouver he became interested in painting, subsequently producing several large canvasses in a naturalistic style depicting Southern Kwakiutl mythological figures and ceremonial dancers. He has studied Northwest Coast design and sculpture with Doug Cranmer and Henry Hunt. Beau Dick has carved a number of fine masks in different tribal styles, often basing them on illustrations of old specimens in museums.

Freda Diesing
b. 1925

Born in Prince Rupert, Haida artist Freda Diesing has been carving since the late 1960's. She was one of the first students at 'Ksan, receiving instruction in sculpture and design from Bill Holm, Tony Hunt and Robert Davidson. In addition to carving and designing many masks and bowls, as well as a large double mortuary pole for the city of Prince Rupert, Diesing has found time to instruct young Haida and Tsimshian artists on the principles of Northern Northwest Coast art.

Pat Dixon
b. 1938

Haida argillite carver Pat Dixon was born on the Queen Charlotte Islands in the village of Skidegate. He moved to Vancouver in 1966 where he established a working relationship with fellow Haida carver Pat McGuire (1943–1970). Dixon acknowledges McGuire's influence but suggests that it should not be over-emphasized. He credits the positive effects of Bill Holm's book *Northwest Coast Indian Art: An Analysis of Form* on his understanding of flat design. Pat Dixon works exclusively in argillite and over the years has produced many model poles, platters, pendants, and brooches for avid argillite collectors.

Charles Edensaw
(Tahaygen)
b. ca. 1839, d. 1920

Born in Skidegate, Edensaw spent much of his adolescence at Kiusta and Yatza on the northwest corner of the Queen Charlotte Islands. It was probably there, under the tutelage of his uncle Albert Edward Edensaw, chief of the Stastas Eagles, that young Tahaygen acquired his considerable knowledge of Haida art and mythology. In 1882, the Stastas Eagles moved to Masset where, in 1884, Tahaygen was baptized Charles Edensaw after Prince Charles, the "Bonnie" prince of Scotland. Edensaw is important for a number of reasons. First he was an accomplished craftsman, but so were many other fine Haida artists. What makes Edensaw so significant is that he had contact with many anthropologists and collectors which resulted in a large corpus of well-documented, often commissioned, works. Edensaw is thus the first professional Haida artist whose work we can identify.

Shirley Ford
b. 1943

Shirley Ford is the daughter of Henry Hunt. She made her first two button-blankets in 1974 for the Hunt family memorial potlatch that was held in Comox for her mother Helen Hunt who had died in 1972. In addition to these, which remain part of the Hunt family ceremonial regalia, Shirley Ford has sewn three other blankets including the one that appears in this exhibit.

Charlie George Jr.
b. 1910, d. 1982

Nakwaktokw artist Charlie George Jr.'s work is part of an unbroken continuum identified as the Blunden Harbour-Smith Inlet substyle. In fact it is difficult to separate his work from other artists in the continuum, including that of his father and teacher, Charlie George Sr. Charlie George Jr.'s career spanned the period between the 1930's and the late 1960's. He was an artist who produced masks, rattles, and other items for use in Southern Kwakiutl ceremonies. In addition to these items that were used in potlatches, Charlie George Jr. carved model poles and face masks for sale to non-Indians. In 1970 the artist suffered a stroke that paralyzed his right side and ended his career.

Gwaytihl
d. 1912 (?)

Although little is known about this artist we can identify his work because Dr. I. W. Powell, British Columbia's Commissioner for Indian Affairs (1872–1890), recorded his name. In 1881, Powell purchased a group of artifacts, made for sale, from a Masset carver he identified as Quaa-telth. These pieces form a part of many similar artifacts found in museums throughout North America and Europe. They include portrait-like masks, many with moveable parts, wooden shaman figures, several distinctive rattles combining a bear's head with human figure, and a few headdress frontlets. Except for the frontlets, and possibly the rattles, all the artifacts that have been identified as the work of Gwaytihl were produced for sale to non-Indians.

Walter Harris
b. 1931

Walter Harris was first trained in the principles of Northwest Coast art at 'Ksan in 1969. His principal instructors were Doug Cranmer and Duane Pasco. Harris works in both metal and wood, producing pieces for sale to the public as well as ceremonial objects which have been used at feasts celebrating the traditional rights and prerogatives of the Gitksan people. A pole carved by Harris was erected at Kispiox in 1971. This pole was a replica of an old one that had long ago disappeared from Harris' home village.

Jim Hart
b. 1952

Jim Hart was born and raised in the Masset area of the Queen Charlotte Islands. He first became interested in art while a highschool student, carving small, non-Haida sculptures in mahogany. Hart began experimenting with Haida design on his own, but his first real understanding of the art came later, in 1978, when he and seven other young Haida apprentices, under the direction of Robert Davidson, carved four inside house posts for the Charles Edensaw memorial that now stands in the village of Old Masset. Although Hart has carved a few objects in argillite, his favourite material remains wood. He is particularly interested in creating functional pieces such as spoons, bowls, and paddles. Hart is presently (February 1980) assisting Bill Reid in the completion of a large, yellow cedar sculpture titled "The Raven and the First Men."

Calvin Hunt
b. 1956

Calvin Hunt began carving as a young teenager under the informal guidance of Henry and Tony Hunt. In 1971 he apprenticed with his second cousin Tony Hunt at the Arts of the Raven Gallery, an association that he maintains as a carver today. Hunt works primarily in wood but, along with three other Northwest Coast carvers, has recently completed a course in stone carving. Calvin Hunt has issued eight silkscreen prints, his first in 1976. His favourite medium remains wood, particularly large, monumental sculpture.

Henry Hunt
b. 1923

Henry Hunt was born at Fort Rupert on the north end of Vancouver Island. He began carving, part time, at the British Columbia Provincial Museum in 1954. Hunt became chief carver in 1962 after his father-in-law, Mungo Martin, died. He remained with the Museum until 1974. Hunt's career has resulted in a prodigous output of a great variety of pieces, both for sale to non-Indians and for traditional ceremonial use. Much of Hunt's time at the Museum was spent carving totem poles, both with his mentor Mungo Martin and later with his oldest son Tony Hunt. Henry Hunt's artistic skills and his considerable experience as a totem pole carver have made him without equal as a contemporary designer and carver of monumental Southern Kwakiutl sculpture. Perhaps his greatest triumph is the thirty-five-foot totem pole that he and his son Tony Hunt carved in 1970–1971 as a memorial to Mungo Martin. This fine pole was the first to be erected in the Alert Bay graveyard in many years. Since then four other memorial carvings have been placed there as monuments to the dead. In a sense, Henry and Tony Hunt's memorial to Mungo Martin sparked the revival of a slumbering tradition.

Richard Hunt
b. 1951

Born in Alert Bay on Cormorant Island off the northeast coast of Vancouver Island, Richard Hunt has lived most of his life in Victoria. He began carving with his father, Henry Hunt, at thirteen. After graduating from highschool in 1971 he spent a year working with his brother Tony at the Arts of the Raven Gallery. Hunt began working at the British Columbia Provincial Museum in 1973 as an apprentice carver with his father and is now the Museum's chief carver. His job often involves making traditional ceremonial items – masks, frontlets, rattles – for use in potlatches. Richard Hunt is an excellent mask maker. In particular, he has achieved an overall integration of the individual design elements that form the two-dimensional decoration of the masks' facial planes, unsurpassed in contemporary Southern Kwakiutl art.

Tony Hunt
b. 1942

Born at Alert Bay, Tony Hunt lived at Fort Rupert on northern Vancouver Island until his family moved to Victoria in 1952. As a youngster he received instruction in carving and dancing from his grandfather Mungo Martin. In 1962, after the death of Mungo Martin, he became the assistant carver at Thunderbird Park, working with his father Henry Hunt. Tony Hunt continued to carve for the British Columbia Provincial Museum until 1972 when he resigned to devote his full attention to the Arts of the Raven Gallery which he had opened in 1970. Hunt's purpose in establishing the Gallery was to provide a facility for the production and sale of better quality Northwest Coast art, a need that was obvious, given the wretched material that was being sold in many retail stores a decade ago. As well as marketing carvings, jewelry, and silkscreen prints, the Arts of the Raven Gallery trained a number of new artists. Today Hunt's operation markets the work

of several artists who produce on a piecework basis at the associated Raven Arts workshop. The workshop also provides space for an active teaching program, sponsored by the British Columbia Indian Arts and Crafts Society. Hunt, who is a board member of the Indian Arts and Crafts Society, instructs both beginning and intermediate wood carving and design. In addition to his success in the promotion and production of quality Northwest Coast art, Tony Hunt maintains an active connection with his Southern Kwakiutl heritage. He has carved and erected a pole in honour of his grandfather, Jonathan Hunt, and has also potlatched to legitimize the ceremonial names and privileges that he claims.

**Hupquatchew
(Ron Hamilton)
b. 1948**

Westcoast artist Hupquatchew was born at Ahaswinis, a small Opetchesaht reserve at the head of Barkley Sound on the west coast of Vancouver Island. He began to design seriously in 1965, was apprenticed to Henry Hunt in 1971, and continued to work as a carver with the British Columbia Provincial Museum until 1974 when he returned to his home in the Alberni Valley. Once home, Hupquatchew immersed himself in the ceremonial and social life of his community, spending time increasing his knowledge of Westcoast song and ritual. Hupquatchew restricts his commercial activities to the production of silkscreen prints, preferring to make such traditional forms as masks, rattles, and drums, exclusively for the use of Indian people. Hupquatchew, along with his cousin Joe David, has been a modern pioneer in the rediscovery and redefinition of traditional Westcoast sculpture and design.

**Robert Jackson
b. 1948**

Gitksan artist Robert Jackson was born at Port Edward, near Prince Rupert, British Columbia. After carving on his own for about ten years, Jackson received some instruction in design at the Kitanmax School of Northwest Coast Indian Art in 1973, continuing on as a carver with 'Ksan until 1976. Jackson works in wood as well as gold, silver, and ivory. He is just beginning to explore the medium of silkscreen printing. In addition to carving, Robert Jackson owns the Sky Clan Art Shop in Prince Rupert.

**Charlie James
b. ca. 1870, d. 1938**

The son of a Fort Rupert Indian woman, Charlie James, or Yakuglas, is best known for the many small model totem poles he carved to sell to non-Indians. In addition to these tourist artifacts which grace many private and public collections in North America, Charlie James produced many traditional objects for Southern Kwakiutl patrons. Such a commissioned piece stood in front of the late Peter S. Smith's house at Kalokwis on Turnour Island (figure 52). Charlie James was instrumental in establishing what might be termed the Fort Rupert substyle of Southern Kwakiutl art. This substyle, distinct from that of the Blunden Harbour-Smith Inlet carvers, was developed and elaborated by his stepson Mungo Martin and is carried on today by Mungo's descendants, the Hunt family of carvers.

**Phil Janzé
b. 1950**

Although Phil Janzé was born in Hazelton in north-central British Columbia, it was in Bella Bella that he first became intrigued by Northwest Coast design. After seeing Stanley George working in silver, Janzé began to engrave seine boats and seagulls on beaten-out dimes and quarters. In 1970–1971, back in Hazelton, Vernon Stephens lent Janzé some engraving tools and designs. During 1971–1972, while living in Vancouver, Janzé met and was stimulated by Norman Tait and Gerry Marks. Besides working in gold and silver, Janzé has produced work in ivory, bone, and mountain goat horn. He has issued five silkscreen prints.

Gerry Marks
b.1949

Gerry Marks grew up in Vancouver, largely unaware of Haida artistic traditions. After meeting Bill Reid and discovering, at twenty, the fine metalwork of his grandfather John Marks, he began to focus his energy on understanding this tradition. Marks began a formal study of Northwest Coast design with Freda Diesing at Prince Rupert in 1971. He later spent time at the Kitanmax School of Northwest Coast Indian Art at Hazelton. Through self-study and contact with other artists, Marks developed his metalworking skills, paying particular attention to the technique of repoussé. In 1977, Marks carved a twenty-five-foot totem pole with Francis Williams and spent four months in Masset, his mother's village, working with Robert Davidson on the Charles Edensaw memorial housefront that had been commissioned by National Historic Sites of Canada.

This experience has renewed Gerry Marks' understanding of the importance of wood carving to his own artistic development, particularly as it brings him back to an appreciation of the work of the traditional Haida master carvers.

Mungo Martin
b. ca. 1881, d. 1962

In 1947, the University of British Columbia persuaded Mungo Martin to come to Vancouver to oversee the restoration of totem poles. Although Mungo had been a practising artist all his life, having learned his craft from his stepfather Charlie James, in his sixth decade he embarked on a new career that was to continue until his death in 1962.

In 1952, Mungo came to Victoria to begin a replication program of old poles that had stood in the British Columbia Provincial Museum's outdoor display in Thunderbird Park. Originally conceived as a three-year program, the work in Thunderbird Park continues today with its head carver the late Chief Martin's grandson Richard Hunt. Mungo's importance as an artist is perhaps overshadowed by his pre-eminence as a teacher of the old ways. Mungo was a tutor to his son-in-law Henry Hunt and his grandson Tony Hunt, both of whom worked with Mungo at Thunderbird Park. Mungo also taught the Haida artist Bill Reid the traditional woodworking techniques of the Southern Kwakiutl, and worked with Doug Cranmer, the grandson of Mungo's second wife Abayah.

Rod Modeste
b. 1946

Coast Salish artist Rod Modeste was born at Malahat, a small village on the southeastern coast of Vancouver Island. He began carving in 1965, making small, wooden totem poles. In 1978, Modeste spent three months at the British Columbia Provincial Museum as an apprentice to Richard Hunt and Tim Paul. Modeste began engraving silver in July, 1979. Except for the short apprenticeship, learning the techniques of traditional Northwest Coast wood carving, Rod Modeste is largely self-taught.

Earl Muldoe
b. 1936

Gitksan artist Earl Muldoe began studying Northwest Coast art with Duane Pasco in 1969. Although Muldoe is perhaps best known as a silversmith, he does a considerable amount of wood carving. As well as a number of wooden panels and poles commissioned by private and public institutions, Muldoe has carved two large totem poles which were erected in 1971 and 1973 at Kispiox village. Muldoe lives in Hazelton and continues to work through 'Ksan.

Tim Paul
b. 1950

Tim Paul, a member of the Hesquiat Band, was born at Zeballos on the west coast of Vancouver Island. He began to involve himself seriously in Northwest Coast art in 1975, receiving instruction from carvers working out of Tony Hunt's Arts of the Raven Gallery. In 1977, Paul began working as the assistant carver in British Columbia Provincial Museum's carving programme in Thunderbird Park. Tim Paul has been concentrating over the past year on integrating his understanding of two-dimensional design with traditional Westcoast sculpture.

Bill Reid
b. 1920

No other contemporary Northwest Coast artist has received the critical acclaim accorded Bill Reid. Reid's reputation as an artist derives in part from the pivotal role he has played in the rebirth of Northern Art. In 1948, when Reid decided to emulate his grandfather, Charles Gladstone, and become a silversmith and goldsmith, he did so not only by training as a jeweller but by studying and analyzing old pieces stored in museums. As an expert jeweller he introduced complex traditional European jewellery techniques (e.g. repoussé) to the manufacture of Northwest Coast metalwork. In fact, no other Northwest Coast artist who works in precious metals has the range of techniques that Reid commands. In analyzing museum specimens, Reid, along with Bill Holm, has been largely responsible for the modern understanding of the principles of Northern two-dimensional design. Thus Reid was the first Northern artist born in the twentieth century to comprehend the formal rules of this complex intellectualized art tradition, the principles of which had been lost to the few remaining Haida artists who practised their craft in argillite and silver. Another facet of Reid's role in the revitalization of Northern art has been that of a communicator, but a communicator with a difference, someone inside the art yet with skills honed by ten years in the broadcasting industry. Bill Reid's abilities as a wordsmith have provided us with a passionate inside look at this art, a counterpoint to Bill Holm's formal analysis. Not only has Reid shared his understanding of Haida art with the public through the written word, film, and his work in wood, silver, gold and other more or less exotic materials, he has also passed on his skills to younger artists. While it can be argued that Reid's stature as an artist must await a critical judgement of his work, something that has not yet been done, without question he is the bridge between the likes of Charles Edensaw and Robert Davidson. In this role, as connector, link, an active intelligence that has revived and carried on a remarkable art tradition, Bill Reid's greatness is secure.

Willie Seaweed (Hiłamas)
b. ca. 1873, d. 1967

Chief of the Nakwaktokw Kwakiutl from Blunden Harbour, Seaweed was a professional artist who participated in the development of Southern Kwakiutl art from the "restrained" style of the 19th century to the "baroque period which reached its culmination in the cannibal bird masks of the 1940's and 50's" (Holm 1974). Some eighty-five pieces have been attributed to Willie Seaweed. Perhaps his best known work is the widely illustrated Dzoonokwa and Thunderbird pole that stands in the graveyard at Alert Bay.

Russell Smith
(Awasatlas)
b. 1950

Russell Smith was born at Alert Bay and now lives in Vancouver. He first became interested in carving about 1970 while living in Seattle. There, under the direction of Bill Holm, he assisted with the restoration of the Southern Kwakiutl bighouse from Gilford Island that stands in the Pacific Science Centre. Awasatlas began carving small wooden masks for sale in 1970. In 1972, with encouragement from Lloyd Wadhams, he began working in silver, doing his first experiments with repoussé in 1977. His metalwork has been influenced and directed by his association with Bill Reid, Phil Janzé, Gerry Marks and the visiting English silversmith and goldsmith, Peter Page, who gave a workshop at the Vancouver Centennial Museum in 1977. In addition to instruction from Doug Cranmer and Larry Rosso,

Awasatlas' wood carving and design has been influenced by his admiration for the work of Charlie James and Arthur Shaughnessy (1884–1945), particularly the latter who, incidently, carved the inside houseposts of the Gilford Island bighouse.

Vernon Stephens
b. 1949

Gitksan artist Vernon Stephens lives and works in Hazelton where he teaches at the Kitanmax School of Northwest Coast Indian Art. Although Stephens carves masks and other three-dimensional objects, his main interest is two-dimensional design. His approach is unique, adapting the traditional elements of two-dimensional design in such a way as to produce non-traditional, realistic silhouettes of animal and human figures.

Norman Tait
b. 1941

Norman Tait was born in the Nishga village of Kincolith on the lower Nass River. He began carving seriously in 1970, studying design with Freda Diesing and silver engraving with Gerry Marks. In 1973, Tait and his father, Josiah Tait, completed a pole for the village of Port Edward. A second pole was carved in 1975 for the Coast Tsimshian community of Port Simpson. The following year, Tait participated, at the University of British Colombia Museum of Anthropology, in the restoration of a totem pole from the Nass River village of Gitex. Perhaps stimulated by the experience of working with this fine old pole and, as a result, becoming increasingly aware of old Tsimshian pieces, Tait has proceeded to concentrate on defining the nuances of style that are the essence of Tsimshian sculpture and design.

187

Art Thompson
b. 1948

Art Thompson, who was born at the Nitinat village of Whyac, is best known as an innovative printmaker, introducing new colours and subject matter to the silk-screen medium. Besides working in wood he has lately turned his energies to engraving silver, often achieving an innovative application of Westcoast two-dimensional design. Art Thompson became active as a silkscreen print designer in 1973–74. He studied Westcoast design with Ron Hamilton and Joe David.

Charlie G. Walkus
b. 1907, d. 1974

Charlie G. Walkus was born at Takush Harbour in Smith Inlet, a member of the Gwasila tribe. His father, George Walkus, an accomplished carver, was a contemporary of Willie Seaweed. Walkus began carving as a young boy, making model totem poles to sell to tourists. He continued to make art for sale through-out his life but he also carved and painted legitimate ceremonial art for Southern Kwakiutl clients. His work can be seen as part of the continuum now identified as the Blunden Harbour-Smith Inlet substyle.

Jessie Webster
b. 1909

Westcoast basketmaker Mrs. Jessie Webster lives in the small village of Ahousat. Although she began making small baskets when she was only seven years old, Mrs. Webster feels that she did not really begin to make "good" baskets until some time later. In addition to watching her mother, she was taught by the late Mrs. Nellie Jacobsen (d. ca. 1967) who, according to Mrs. Webster, was the best basketmaker in Ahousat.

Don Yeomans
b. 1958

Don Yeomans was born in Prince Rupert. His father is a Masset Haida and his mother a Cree from Slave Lake, Alberta. He first studied with his aunt, Haida carver Freda Diesing, in 1970–1971. Yeomans continued working on his own until 1976 when he enrolled in the fine arts program at Vancouver Community College. In 1978 Yeomans participated in the carving of four Haida inside houseposts. This project was supervized and directed by Robert Davidson. Yeomans has also been influenced by Gerry Marks, Phil Janzé, Beau Dick and Norman Tait. Yeomans remains primarily interested in wood although he has worked in metal and has designed a number of silkscreen prints.

BIBLIOGRAPHY

BIBLIOGRAPHY

Abbreviations used:

AA American Anthropologist, Menasha.
ABCM Anthropology in British Columbia Memoirs, Victoria.
AES-P Publications of the American Ethnological Society, New York.
AMNH-B Bulletin of the American Museum of Natural History, New York.
AMNH-M Memoirs of the American Museum of Natural History, New York.
AMSP AMS Press, New York.
BAE-AR Annual Report of the Bureau of American Ethnology, Smithsonian Institute, Washington, D.C.
BAE-B Bulletin of the Bureau of American Ethnology (AP – Anthropology Paper), Smithsonian Institute, Washington, D.C.
BCPM-AR British Columbia Provincial Museum, Annual Report, Victoria.
BCS B.C. Studies, University of British Columbia, Vancouver.
JRC Johnson Reprint Corporation, New York.
MAES Monographs of the American Ethnological Society, New York.
NMC National Museums of Canada, Ottawa.
NMC-B National Museums of Canada, Bulletin, (AS – Anthropological Series), Ottawa.
NMM National Museum of Man (National Museums of Canada), Ottawa.
USNM-R Report of the United States National Museum, Washington, D.C.

Adam, L.
1936 "North-West American Indian Art and Its Early Chinese Parallels," *Man*, Vol. 26, No. 3.

Arima, E. Y.
1975 "A Report on a West Coast Whaling Canoe Reconstructed at Port Renfrew, B.C." History and Archaeology, No. 5, National Historic Parks and Sites Board, Ottawa.

Bancroft-Hunt, N.
1979 *People of the Totem*. Orbis Publishing: New York.

Barbeau, Marius
1929 "Totem Poles of the Gitksan Upper Skeena River, British Columbia," NMC-B, No. 61, A.S., No. 12 (Reprinted in NMC Ethnology Facsimile Series).
1950 "Totem Poles," Vol. 1 and 2, NMC-B, No. 119, A.S., No. 30.
1953 "Haida Myths Illustrated in Argillite Carvings," NMC-B, No. 127, A.S., No. 32.
1957 "Haida Carvers in Argillite." NMC-B, No. 139, A.S., No. 38.

Barnett, Homer G.
1955 *The Coast Salish*. University of Oregon Press: Eugene.

Boas, Franz
1895, 1897 "The Social Organization and Secret Societies of the Kwakiutl Indians." USNM-R, (Reprinted JRC, 1970).
1897 "The Decorative Art of the Indians of the North Pacific Coast." AMNH-B, Vol. 9, pp. 123–76.
1898 "The Mythology of the Bella Coola Indians." AMNH-M, Vol. 2, Pt. 2, (Reprinted AMSP, 1975).
1900 "Facial Paintings of the Indians of Northern British Columbia." AMNH-M, Vol. 11, pp. 13-24.
1902 "Tsimshian Texts." BAE-B, No. 27, (Reprinted AMSP, 1974?).
1909 "The Kwakiutl of Vancouver Island." AMNH-M, No. 8. (Reprinted AMSP, 1975).
1912 "Tsimshian Texts" (New Series). AES-P, Vol. 3, (Reprinted AMSP, 1974).
1916 "Tsimshian Mythology." BAE-AR, No. 31 (Reprinted JRC, 1970).
1927 "Primitive Art" Oslo and London: Instituttet Sammenlignende Kulturforskning, 8. (Republished in paperback by Dover, New York, 1955).

Boas, Franz & George Hunt
1903–05 "Kwakiutl Texts." AMNH-M, Vol. 5, Parts 1–3 (Reprinted AMSP, 1975).
1906 "Kwakiutl Texts." Second Series. AMNH-M, Vol. 14, Part 1. (Reprinted AMSP, 1975).

Cleaver, Elizabeth
1969 *The Mountain Goats of Temlaham*. Oxford University Press: Toronto.

Clutesi, George
1967 *Son of Raven, Son of Deer, Fables of the Tse-shaht People*. Gray's: Sidney, B.C.
1969 *Potlatch*. Gray's: Sidney, B.C.

Codere, Helen
1950 *Fighting with Property*. MAES, No. 18.
1966 *Kwakiutl Ethnography*. University of Chicago Press: Chicago.

Collins, H. B., Frederica de Laguna, Edmund Carpenter and Peter Stone
1972 *The Far North: 2000 Years of American Eskimo and Indian Art*. National Gallery of Art: Washington, D.C.

Conn, R.
1979 *Native American Art*. Denver Art Museum: Denver.

Craven, Margaret
1967 *I Heard the Owl Call My Name*. Clarke, Irwin: Toronto and Vancouver.

Curtis, Edward S.
1915 "The Kwakiutl." The North American Indian, Vol. 10, University Press: Cambridge, Mass. (Reprinted JRC, 1970).

Davis, R. T.
1949 *Native Arts of the Pacific Northwest*. Stanford University Press: Stanford.

Dixon, G.
1789 *A Voyage Round the World: But More Particularly to the North-west Coast of America*. G. Goulding: London. (Reprinted 1968, N. Israel, Amsterdam).

Drucker, Philip
1951 *The Northern and Central Nootkan Tribes*. BAE-B, No. 144.
1965 *Cultures of the North Pacific Coast*. Chandler: San Francisco.

Duff, Wilson
1952 "The Upper Stalo Indians." ABCM, No. 1.
1956 "Prehistoric Stone Sculpture of the Fraser River and Gulf of Georgia." Anthropology in B.C. No. 5.
1964 "The Indian History of British Columbia: Volume 1, The Impact of the White Man." ABCM, No. 5.
1967 *Arts of the Raven*. Vancouver Art Gallery: Vancouver.
1975 *Images Stone B.C.* Hancock House: Saanichton.

Duff, Wilson and Michael Kew
1957 "Anthony Island, A Home of the Haidas." BCPM-AR.
1973 "A Select Bibliography of Anthropology of British Columbia." Revised by Laine Ruus and Frances Woodward. BCS, No. 19, pp. 73-121.

BIBLIOGRAPHY

Emmons, George T.
1907 "The Chilkat Blanket." Memoirs of the American Museum of Natural History, Vol. 3, pp. 329-400.

Ernst, Alice H.
1952 *The Wolf Ritual of the Northwest Coast.* University of Oregon Press: Eugene.

Garfield, V. E., P. S. Wingert and Marius Barbeau
1950 "The Tsimshian: Their Arts and Music." AES-P, No. 18.

Gunther, Erna
1966 *Art in the Life of the Northwest Coast Indians.* Superior Publishing: Seattle.

1972 *Indian Life on the Northwest Coast of North America as Seen by the Early Explorers and Fur Traders During the Last Decades of the Eighteenth Century.* University of Chicago Press: Chicago.

Haberland, W.
1979 *Donnervogel und Raubwal: Indianische Kunst der Nordwestkuste Nordamerikas.* Museum fur Volkerdunde und Christians Verlag: Hamburg.

Haeberlin, Hermann K.
1918 "Principles of Esthetic Form in the Art of the North Pacific Coast." AA, Vol. 20, pp. 258-64.

Halpin, M.
1973 *The Tsimshian Crest System; a Study Based on Museum Specimens and the Marius Barbeau and William Beynon Field Notes.* Ph. D. Thesis. University of British Columbia: Vancouver.

Harris, Christie
1966 *Raven's Cry.* Illustrated by Bill Reid. McClelland and Stewart: Toronto.

Hawthorn, Audrey
1956 *People of the Potlatch.* Vancouver Art Gallery: Vancouver.

1967 *Art of the Kwakiutl Indians.* University of Washington Press: Seattle.

1964 "Mungo Martin: Artist and Craftsman." The Beaver, Summer, pp. 18-23. Winnipeg.

1979 *Kwakiutl Art.* University of Washington Press: Seattle.

Holm, Bill
1965 *Northwest Coast Indian Art; An Analysis of Form.* University of Washington Press: Seattle.

1972 *Crooked Beak of Heaven.* University of Washington Press: Seattle and London.

n.d. *Some Tentative Thoughts on Tribal Form Characteristics of Humanoid Faces in Northwest Coast Sculpture* (Mimeographed)

1972 "Heraldic Carving Styles of the Northwest Coast." American Indian Art: Form and Tradition: An Exhibition Organized by Walker Art Centre, Indian Art Association, Minneapolis Institute of Arts. Dutton: New York.

1974 "The Art of Willie Seaweed, A Kwakiutl Master. *The Human Mirror,* Richardson, ed. Louisiana State University Press.

Holm, Bill and Bill Reid
1975 *Indian Art of the Northwest Coast.* Institute for the Arts, Rice University: Houston.

Inverarity, R. B.
1950 *Art of the Northwest Coast Indians.* University of California Press: Berkeley.

Jacobsen, Adrian.
1977 *Alaskan Voyage: 1881–1883.* Trans. by Erna Gunther, University of Chicago Press: Chicago.

Jenness, Diamond
1955 "The Faith of a Coast Salish Indian." ABCM, No's. 2 & 3.

Kaufmann, C.
1969 *Changes in Haida Indian Argillite Carvings 1820 to 1910.* Ph.D. Thesis. University of California: Los Angeles.

Kew, J. M.
1970 *Coast Salish Ceremonial Life: Status and Identity in a Modern Village.* Ph.D. Thesis. University of Washington: Seattle.

King, J.C. H.
1979 *Portrait Masks from the Northwest Coast of America.* Thames and Hudson: London.

Krause, A.
1956 *The Tlingit Indians.* Translated by Erna Gunther. University of Washington Press: Seattle.

de Laguna, Frederica
1972 *Under Mount Saint Elias: The History and Culture of the Yakutat Tlingit.* Smithsonian Contributions to Anthropology, Vol. 7, Parts 1-3.

Lévi-Strauss, Claude
1943 "The Art of the Northwest Coast at the American Museum of Natural History." Gazette des Beaux-Arts, Vol. 24, pp. 175-82.

Lobb, A.
1978 *Indian Baskets of the Northwest Coast.* Graphic Arts Center: Portland.

McFeat, Tom (ed.)
1966 *Indians of the North Pacific Coast.* Carleton Library No. 25. McClelland and Stewart: Toronto.

McIlwraith, T. F.
1948 *The Bella Coola Indians.* University of Toronto Press: Toronto.

Malin, E.
1978 *A World of Faces.* Timber Press: Portland.

Malin, E. and N. Feder
1969 *Indian Art of the Northwest Coast.* Denver Art Museum: Denver.

Milwaukee Public Museum
1966 *Masks of the Northwest Coast.* Milwaukee Art Museum: Milwaukee.

National Museum of Man
1972 *'Ksan, Breath of Our Grandfathers.*

Niblack, Albert P.
1888 "The Coast Indians of Southern Alaska and Northern British Columbia." USNM-R. pp. 225-386.

Reid, B. and A. deMenil
1971 *Out of the Silence.* Amon Carter Museum: Fort Worth.

Sapir, Edward and Morris Swadesh
1939 "Nootka Texts." William Dwight Whitney Linguistic Series, Linguistic Society of America. University of Pennsylvania: Philadelphia.

Siebert, Erna and Werner Forman
1967 *North American Indian Art.* Hamlyn: London.

Smyly, John and Carolyn
1973 *Those Born at Koona.* Hancock House: Saanichton.

Société des Amis du Musée de l'Homme
1969 *Masterpieces of Indian and Eskimo Art from Canada.* Paris.

Steltzer, U.
1976 *Indian Artists at Work.* J. J. Douglas: Vancouver.

Stewart, H.
1979 *Looking at Indian Art of the Northwest Coast.* University of Washington Press: Seattle.

1979 *Robert Davidson: Haida Printmaker.* Douglas and McIntyre: Vancouver.

Sturtevant, William C.
1974 *Boxes and Bowls: Decorated Containers by Nineteenth Century Haida, Tlingit, Bella Bella, and Tsimshian Indian Artists.* Smithsonian Institution Press: Washington, D.C.

BIBLIOGRAPHY

Suttles, W. P.
 1955 "Katzie Ethnographic Notes." ABCM, Nos. 2 & 3.

Swanton, John R.
 1905 "Contributions to the Ethnology of the Haida." AMNH-M, Vol. 5, Part 1, (Reprinted AMSP).
 1905a "Haida Texts and Myths." BAE-B, No. 29. (Reprinted JRC, 1970).
 1908 "Haida Texts – Masset Dialect." AMNH-M, Vol. 14, Part 1. (Reprinted AMSP, 1975).
 1909 "Tlingit Myths and Texts." BAE-B, No. 39. (Reprinted JRC, date unknown).

Wardwell, A.
 1964 *Yakutat South: Indian Art of the Northwest Coast.* The Art Institute of Chicago: Chicago.
 1978 *Objects of Bright Pride.* The American Federation of Arts and the Centre for Inter-American Relations: New York.

Wright, R.
 1977 *Haida Argillite Pipes.* Masters Thesis. University of Washington: Seattle.